THE LIFEBOAT SE
SOUTH E...T
ENGLAND
STATION BY STATION

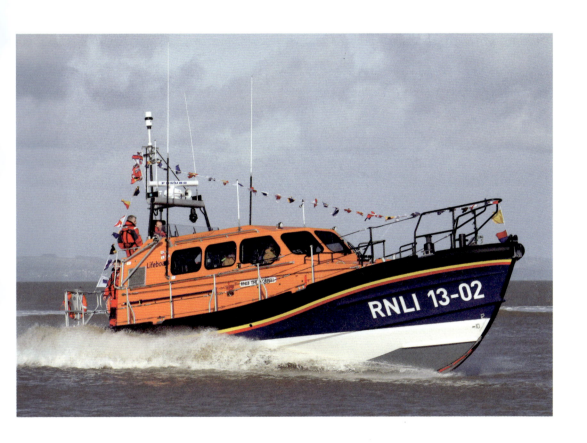

NICHOLAS LEACH

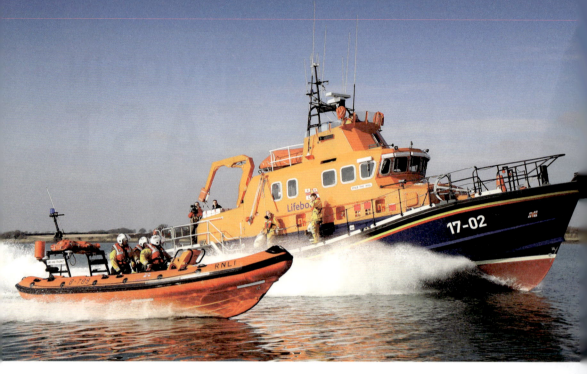

First published 2014
ISBN 978 1 4456 1750 3 (print)
ISBN 978 1 4456 1757 2 (ebook)
Amberley Publishing
The Hill
Stroud
Gloucestershire GL5 4EP
www.amberley-books.com

Copyright © Nicholas Leach 2014

Typesetting by Nicholas Leach
All images by Nicholas Leach unless stated
Printed in the UK

The right of Nicholas Leach to be identified as the Author of this work has been asserted in accordance with the Copyrights, Designs and Patents Act 1988. All rights reserved.
No part of this book may be reprinted or reproduced or utilised in any form or by any electronic, mechanical or other means, now known or hereafter invented, including photocopying and recording, or in any information storage or retrieval system, without the permission in writing from the Publishers.
British Library Cataloguing in Publication Data.
A catalogue record for this book is available from the British Library.

cover 16m Tamar lifeboat Irene Muriel Rees (ON.1299) at Walton & Frinton, one of the six lifeboat stations in Essex.

page 1 The waterjet-driven 13m Shannon lifeboat The Morrell (ON.1309) from Dungeness off the Kent coast.

this page The relief 17m Severn lifeboat The Will (ON.1201) and Atlantic 75 Sure and Steadfast (B-789) heading back to Harwich following a medical exercise involving several agencies.

Acknowledgements

Many people have assisted with this book, and I am very grateful to them all. John Harrop provided some unusual and rare old postcards illustrating aspects of nineteenth-century lifeboat work, and Peter Edey supplied various photos of modern lifeboats.

Around the coast, numerous lifeboat crew members and station personnel have assisted, and I am grateful to the many people who have made me so welcome at the lifeboat stations of Norfolk, Suffolk, Essex and Kent. The following are just a few: Robin Rafferty, Hunstanton; Allen Frary, Wells; Paul Russell, Cromer; Cedric Cox, Happisburgh; John Fox, Lowestoft; Steve Saint, Aldeburgh; Paul Smith, Harwich; James Mackie, Southend-on-Sea; Robin Castle, Sheerness; Peter Baker, Margate; Ian Cannon, Ramsgate.

At the RNLI Headquarters in Poole, I am grateful to Barry Cox and Elise Chainey at the RNLI Heritage Trust for facilitating my research and answering many questions at various times; also, to Nathan Williams for supplying photographs for possible inclusion; and finally thanks to Tim Ash, the RNLI's Public Relations Manager for the East of England, who has kept me informed of the latest developments and happenings in the area.

Nicholas Leach,
Lichfield
February 2014

CONTENTS

Map of south-east England's lifeboat stations 4
Part One • Lifeboat Heritage in the South East 5

The first lifeboats............ 6
Independent lifesavers 10
The East Anglian beachmen.. 14
The RNLI takes over 16
Nineteenth-century lifeboat work.................... 18
Nineteenth-century disasters. 22
Past and present Wells 25
Early motor lifeboats........ 26
Motor lifeboats take over 28
Past and present Lowestoft .. 31
Wartime service............ 32
Rebuilding after 1945 36
Past and present Aldeburgh.. 39
Past and present Cromer 40
Inshore lifeboats............ 41
The modern era 45
New stations, new methods.. 50

Part Two • Norfolk, Suffolk, Kent and Essex Lifeboat Stations 53

Hunstanton 54
Brancaster 57
Wells...................... 58
Blakeney................... 62
Sheringham................. 63
Cromer..................... 66
Mundesley.................. 71
Bacton 71
Happisburgh................ 72
Palling..................... 74
Winterton 75
Scratby.................... 75
Caister 76
Great Yarmouth 80
Gorleston.................. 81
Corton 85
Lowestoft.................. 86

South Broads 89
Pakefield 90
Kessingland................ 91
Southwold.................. 92
Dunwich.................... 95
Sizewell/Thorpeness 95
Aldeburgh 96
Bawdsey/Orford/Woodbridge.. 100
Harwich 101
Walton and Frinton 106
Clacton-on-Sea 109
West Mersea............... 112
Burnham-on-Crouch 113
Southend-on-Sea 114
Tower..................... 118
Teddington 119

Chiswick................... 120
Gravesend 121
Sheerness 122
Whitstable................. 125
Margate 126
Kingsgate.................. 130
Broadstairs 131
Ramsgate.................. 132
North Deal................. 135
Walmer 136
Kingsdowne 139
Dover 140
Folkestone................. 144
Hythe and Sandgate 145
New Romney 146
Littlestone-on-Sea.......... 147
Dungeness................. 148

Appendices 152

1 • Bibliography............ 152
2 • Independent lifeboats ... 153
3 • Lifeboats on display..... 156
4 • Lifeboat types.......... 159
Index...................... 160

3

Lifeboat stations in south-east England

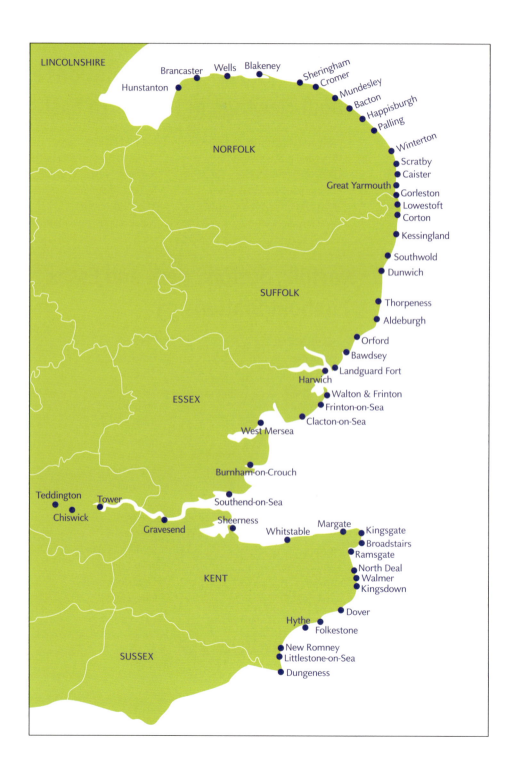

PART ONE

Lifeboat Heritage in the South East

Introduction to Part One

The lifeboat stations along England's south-east coast are, on the whole, operated by the Royal National Lifeboat Institution (RNLI), which was founded in 1824 and today maintains a network of 237 lifeboat stations around the coasts of the United Kingdom and Ireland. A number of independent lifeboats are also operated.

This book looks at all those lifeboat stations, past and present. It is divided into two parts: the first gives an overview of lifeboat history along England's East Anglian and south-east coast, and shows how sea rescue services have developed since the late eighteenth century; the second provides brief histories of each lifeboat station in the area, past and present.

The lifeboats stationed in East Anglia were among the first anywhere in the British Isles. The number of stations in operation increased during the nineteenth century, but then reduced with the introduction of motor lifeboats, which had a greater range, in the twentieth. Many outstanding medal-winning rescues have been undertaken, some of which are described, but not all can be included due to space.

Today's RNLI lifeboat fleet is made up of fast all-weather and inshore lifeboats, which provide a network of search and rescue cover. The aim is to reach any point fifty miles from the coast within three hours in fair weather, and ninety-five per cent of all casualties within thirty minutes of launching.

above The 48ft 6in Ramsgate type lifeboat Greater London (Civil Service No.3) (ON.704) being launched on 8 July 1929 at Southend-on-Sea following her naming by Prince George. (By courtesy of RNLI)

below The modern lifeboat station at Southend-on-Sea operates three ILBs and a hovercraft, and relief Atlantic 75 Leicester Challenge II (B-777) is pictured with the famous pier as a backdrop.

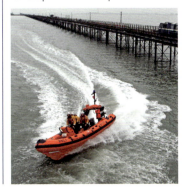

5

The first lifeboats

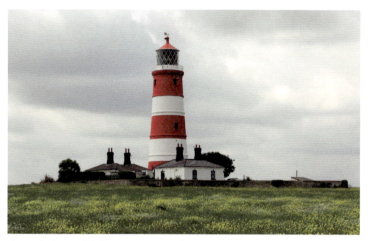

above The famous lighthouse at Happisburgh was one of several on the Norfolk coast. This tower was built in 1791 and is one of the oldest original lighthouses still in existence.

below The North Country type lifeboat, with steering oars at both ends, was built by the South Shields boatbuilder Henry Greathead. North Country type boats similar to this were built for use at Bawdsey and Lowestoft.

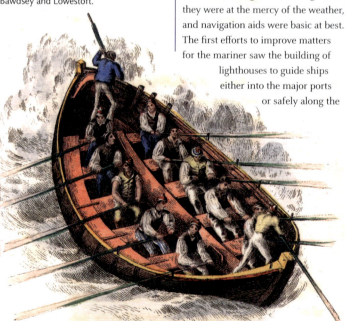

During the seventeenth and eighteenth centuries the expansion in coastal trade and shipping activities along England's east coast was considerable. The Industrial Revolution meant increased demand and thus greater movement of goods, many of which were transported along the east coast, either to or from the nation's burgeoning capital, in small ships.

Inevitably some of those coastal traders came to grief. As sailing vessels, they were at the mercy of the weather, and navigation aids were basic at best. The first efforts to improve matters for the mariner saw the building of lighthouses to guide ships either into the major ports or safely along the treacherous east coast trade route, which was infamous for its shifting sandbanks that claimed many ships. In the seventeenth century, lights were shown from towers built at Hunstanton, Cromer and Winterton in Norfolk, at Lowestoft and Orford in Suffolk, and at North and South Foreland and Dungeness in Kent. These lighthouses were among the earliest built in Britain.

Considering the density of shipping using the sea lanes off East Anglia and the Thames Estuary, it is surprising that the first lifeboats in East Anglia, Essex and Kent were not more numerous, as was the case in the North East. Instead, lifeboat provision was a somewhat haphazard process and those lifeboats that were built for service on England's south-eastern coasts had mixed fortunes. The following describes in chronological order the lifeboats that were built and operated during the first two decades of the nineteenth century.

Suffolk

The first lifeboats in Suffolk were partly funded by Lloyd's insurance agency in London, whose support made a significant difference in early lifeboat provision. During the first decade of the nineteenth century Lloyd's set up a fund which encouraged the building and operating of lifeboats as a way of countering ship losses. This provided an impetus to early lifeboat building, and helped pay for almost thirty lifeboats down to the 1820s, many of which were built by the South Shields boatbuilder Henry Greathead on the Tyne. With others, he designed a boat 30ft in length with a curved or rockered keel. It was rowed by twelve oars, steered from the stern by an oar, and the hull was covered with cork.

The first lifeboats in Suffolk were built by Greathead, and were operated at Lowestoft and Bawdsey. The idea of stationing a lifeboat at Lowestoft was

The first lifeboats

below Model of the Greathead-built lifeboat that was stationed at Bawdsey and Woodbridge. This model possibly came from Greathead's own workshop and illustrates the construction and hull form of the design, characterised by the curved keel.

proposed by local man Robert Sparrow and the Revd Francis Bowness, Rector of Gunton. They raised a subscription to pay for a lifeboat, and by October 1800 a boat had been ordered. The lifeboat was the sixth to be built by Greathead, and arrived in the town in February 1801. In early March she was taken out by twelve men for trials deemed to be successful, with the crew reporting she was 'well calculated to answer the purpose intended'.

A few weeks after launching the fund for the Lowestoft boat, Sparrow and Bowness opened a second subscription to provide another lifeboat, this time for Bawdsey, at the southern end of the county's coast. The Bawdsey boat was Greathead's seventh, and arrived at her station in March 1801. Although both Suffolk boats had been funded mainly by local subscriptions, financial help from Lloyd's had been forthcoming in the form of a £50 contribution.

With a second boat, the foundations for the future Suffolk Humane Society were laid, while the originators suggested a third boat could possibly be built, for Southwold, Dunwich or Aldeburgh. However, despite these grand plans, the lifeboat at Lowestoft soon proved to be of no use as those who were to man her disliked her design, despite their approval of her at the initial trials, and could not be persuaded to go out in her.

As conditions varied from coast to coast, the Greathead, or North Country, type proved to be poorly suited to the flat Lowestoft beach, over which launching it was both tiring and time-consuming. Gilfred Lawson Reed, of Trinity House, reported to a Parliamentary Committee of 1802 that Greathead's boat 'would answer upon any, except a Rocky Coast ... and that the Lifeboat may be launched from any beach'. At Lowestoft, however, where Reed went out in the lifeboat, he admitted that 'the Sailors of Lowestoffe expressed an Unwillingness at first to go to Sea in the Lifeboat', and that 'the Lifeboat has been out only Twice'. She was thus moved to Gorleston in 1802, but was liked no better there.

The failure of the boat at Lowestoft in 1801 reflected local preferences. The crew was made up of beachmen who were familiar with large sailing lifeboats, whereas Greathead's boat was

below A well-known lithograph drawing of the Lowestoft lifeboat Frances Anne going out to the brig George, of London, in a heavy south-westerly gale on 22 October 1820. The brig's crew of twelve were safely landed on Lowestoft beach. The lifeboat was under the command of Lt Samuel Thomas Carter, with a crew made up of local pilots and beachmen.

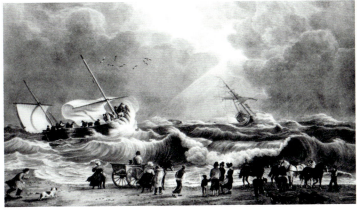

7

The first lifeboats

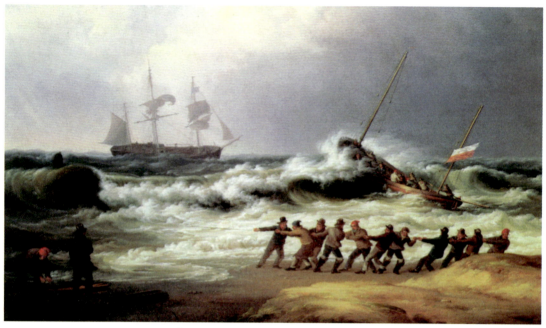

above A contemporary painting entitled 'Lifeboat going off to a vessel'. This is probably the Lowestoft lifeboat Frances Ann being towed through the surf by a haul-off warp, which is being manned by a shore team on the beach.

more akin to the cobles of England's north-east coast. The Lowestoft beachmen had no experience of cobles, or the other designs from which the Greathead lifeboat had been derived, preferring the beach yawl, a clinker-built craft with a long, light hull, stem and stern alike, that was usually sailed.

To overcome the distrust of the Lowestoft pilots and beachmen, a new lifeboat was built in 1807, along the lines of the yawl. It was designed by Lionel Lukin, a London coachbuilder who was born in Essex and, along with Greathead, can lay claim to the title 'inventor of the lifeboat'. As Lukin was in Lowestoft in 1806, he became involved in the building of the boat, overseeing its construction at the local boatyard of Batchelor Barcham, according to his 'Unimmergible' plan by which a boat could be made unsinkable.

This boat, named *Frances Ann*, was the first sailing lifeboat to be built and, as such, was a notable advance in sea rescue provision. She was also the first boat to be built according to the wishes of the men who were to form the crew,

and set the template for the subsequent Norfolk & Suffolk type, which became the main lifeboat type on East Anglia's coast during the nineteenth century.

Frances Ann enjoyed considerably more success than her predecessor at Lowestoft and was well liked, serving until 1849 and saving eighty-five lives. One of her finest rescues came on 13 January 1815 when she saved the master and two seamen from the sloop *Jeanie*, of Hull, which was wrecked on the Holm Sand off Lowestoft. She was sailed through heavy, breaking seas onto the sands to reach the casualty.

At Bawdsey the lifeboat came under the control of the Suffolk Humane Society, which had been formed at Kessingland on 7 January 1806. In February 1804 the boat had been used to save eight people from the brig *Pallas*, of London. By 1825, having been launched twice and saved thirteen people, it was transferred to nearby Woodbridge.

Norfolk

The first lifeboat in Norfolk was the boat that was moved to Gorleston in

The first lifeboats

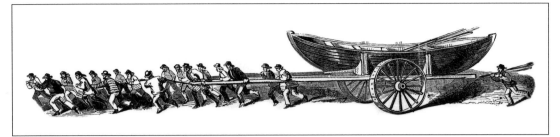

1802 from Lowestoft. It was not liked at its original station, and was liked no better at Gorleston. It was never used and in 1807 was sold. The other early lifeboat in Norfolk was built for Cromer, also by Greathead, and was delivered to the town in 1805.

The double-ended boat, which was probably 25ft long by 8ft 6in in beam, had a rockered keel and would have been well suited to being launched through the surf off the town's beach. The boat was paid for through a subscription fund which, administered by a local committee led by Lord Suffield, George Wyndham, local merchant Thomas Mickleburgh and Benjamin Rust, had raised £734 12s 0d by January 1805. This boat was used for at least five rescues before being transferred to Wells in 1830.

The Cromer boat performed a fine service in November 1810, saving fifteen from the brig *Anna*, of Sunderland, with the crew undertaking 'exertions that call for the highest praise'. But on the same night another brig had been wrecked near Mundesley and nothing could be done to help her because of the strength of the seas. The vessel went to pieces and all ten of her crew were drowned. So the Cromer committee resolved that a lifeboat should be obtained for Mundesley, when funds permitted, and a subscription drive began.

A small beach boat was fitted up temporarily as a lifeboat until a local subscription, organised by Joseph Gurney of Norwich and supplemented by a grant from Lloyd's, enabled the first lifeboat to be obtained in March 1811. The boat, of the North Country type and built in Sunderland, pulling ten oars, measured 26ft 8in by 9ft 4in, and was kept in a boathouse and initially managed by the Cromer committee. It was used in 1819, going to the aid of *Endeavour*, of Sunderland, and a number of other vessels which had been driven into shallow water.

Ramsgate

The earliest lifeboat to be stationed in Kent was funded and managed by the Trustees of the Royal Harbour at Ramsgate. The Trustees bought a lifeboat built by Henry Greathead in 1802 to operate out of the Harbour of Refuge. However, few details of the boat have survived, there is no record of it ever being used and it had been removed before 1824.

above A contemporary drawing of a North Country lifeboat, the type brought to Cromer in 1804 by the local committee. The two-wheeled trolley was not supplied when the boat came to Cromer, and the boat was probably manhandled across the beach. Launching lifeboats using manpower alone, as was the case on the flat exposed beaches of Norfolk and Suffolk, required considerable effort, strength and no little bravery on the part of the shore crews.

below The second Cromer lifeboat, in service from 1830 to 1858, is credited with saving at least fifteen lives and performed at least four rescues. She was similar in form to the first lifeboat and was based on the Greathead design, but was slightly larger and pulled twelve oars double-banked. She was funded through the efforts of the Norfolk Shipwreck Association, which was founded in November 1823 and managed lifeboats at Cromer and Mundesley, as well as establishing stations elsewhere in Norfolk.

Independent lifesavers

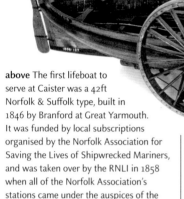

above The first lifeboat to serve at Caister was a 42ft Norfolk & Suffolk type, built in 1846 by Branford at Great Yarmouth. It was funded by local subscriptions organised by the Norfolk Association for Saving the Lives of Shipwrecked Mariners, and was taken over by the RNLI in 1858 when all of the Norfolk Association's stations came under the auspices of the national body. (By courtesy of the RNLI)

Independent rescuers

LOWESTOFT • 11 October 1827 • Gold medal awarded to Lt R. B. Matthews, who helped save the master and crew from the ship Lord Duncan using the Manby mortar apparatus.

WINTERTON • November and December 1830 • Gold medal awarded to Lt Thomas Leigh who, within the space of a month, went out in boats on two separate occasions to save crews from two brigs caught in bad weather.

WINTERTON • 20 March 1833 • Gold medal awarded to Lt Thomas Leigh for taking out the lifeboat to save sixteen from the ship Crauford Davison, which was wrecked in a heavy gale on Winterton Beach.

SOUTHWOLD • 4 December 1848 • Silver medal awarded to Acting Coxswain John Fish who took out the private lifeboat Solebay to save two men from the schooner Ury, which was aground on the Barnard Sand.

BROADSTAIRS • 5 January 1857 • The American ship Northern Belle ran aground near Thanet in blizzard conditions, but no lives were lost thanks to heroic rescue efforts. At 3 a.m., on a bitterly cold morning, the ship got into difficulty near Broadstairs, going ashore on a dangerous ledge below the Foreness Point, at Kingsgate. Despite the severe conditions, the Mary White and Culmer White lifeboats were both hauled overland by horse-drawn trailer, against the blizzard, to a point where they could be launched. Mary White rescued seven of the American crew, and then Culmer White, having arrived with a fresh crew, made two further journeys, on the first attempt rescuing fourteen, and then returning to save the Captain and the Pilot.

Despite the founding of the Royal National Institution for the Preservation of Life from Shipwreck (RNIPLS), the national body responsible for rescue at sea, in 1824, the establishment and management of lifeboats and lifeboat stations in East Anglia, Essex and Kent was undertaken largely by independent bodies, with involvement by the national body during the first half of the nineteenth century minimal. However, some of the local organisations often had a degree of help from the nascent RNIPLS.

Norfolk Association

One of the more notable, and successful, of the independent organisations was the Norfolk Association for Saving the Lives of Shipwrecked Mariners (Norfolk Association for short), which was founded at a meeting in Norwich in November 1823. Lord Suffield, a leading member of the Cromer committee, realised the need for an association 'for preserving the lives of shipwrecked mariners on the whole line of the coast of Norfolk'; one which was independent of the beachmen yet relied on them for manning the boats. Suffield had been greatly involved in the Cromer lifeboat, described above, and also in getting a lifeboat at Mundesley.

The Norfolk Association went on to place lifeboats at Winterton (1823), Hunstanton and Blakeney (1824), Great Yarmouth (1825), Wells (1830), Bacton (1843), Caister (1845) and Palling (1852), although the organisation's finances were always tight, particularly by the 1840s. At the Cromer Regatta of 1845, difficulties were hinted at, with a local report stating, 'Though crews are never wanting, subscriptions frequently are.'

By the 1850s the financial troubles had worsened, making it increasingly difficult for the Norfolk Association to execute its duties. Take over by the national body was inevitable and fortunately the newly renamed Royal National Lifeboat Institution (RNLI) was in a position to take on the stations by the late 1850s. Negotiations with the RNLI began in late 1857, and by the end of the year the Association had passed over control of its stations. The Association had operated nine lifeboats, but as most were in rather a poor condition by 1858, the national body's first task was to put them into a more efficient state of readiness.

Another development in Norfolk, unusual but noteworthy, occurred at Sheringham, where a private lifeboat was built, independently of both the RNIPLS and the Norfolk Association. The Sheringham boat, a 33ft 6in by 10ft 2in craft, was paid for by the Upchers, a wealthy local family who took more than a passing interest in the safety of the local fishermen. Launched on 14 November 1838, the lifeboat was named *Augusta* after the youngest of Mrs Upcher's six children, who had died of tuberculosis aged twenty.

Augusta was deemed to be such a success that, when she was retired in 1893, the Upchers funded a second lifeboat at Sheringham, despite the fact that the RNLI had stationed a lifeboat at the town since 1867. This new boat, named *Henry Ramey Upcher* and like

10

Independent lifesavers

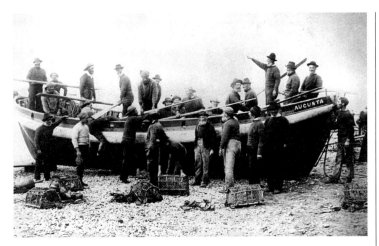

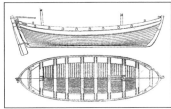

left and above The lifeboat Augusta at Sheringham was unlike any existing lifeboat design, and was based on the lines of the crab boats which the fishermen used for their daily work. She was, however, much bigger, measuring 33ft 6in in length. She had sixteen oars and, like the crab boats, set a dipping lugsail on a single mast. She was built by Robert Sunman, the Sheringham wheelwright and boatbuilder, at a cost of £150. It was stated that 'she never lost a single man, and there is scarcely a family in Sheringham of which at least one member does not owe his life to the old boat'.

her predecessor built locally, remains in existence and on display. She undertook her last launch in August 1945, despite having retired from active service more than a decade previously.

Suffolk Association

When the RNIPLS was founded in 1824, it was recommended that a district association be established in Suffolk. This organisation, founded on 16 October 1824 at a meeting in the Shire Hall at Bury St Edmunds, was not just a local branch of the National Institution but an independent county association similar to that in Norfolk. It was known as the Suffolk Association for Saving the Lives of Shipwrecked Seaman, and when it was founded there were already lifeboats at Lowestoft, Bawdsey and, to the south, Landguard Fort (described below).

The Suffolk Association paid for repairs to boats, placed life-saving mortars at a number of places, and agreed rewards and fixed rates of pay for crews who went out in the lifeboats. But its involvement in founding new stations and building new lifeboats was relatively limited, although it had two boats built in the 1820s by William Plenty of Newbury, the first type to be adopted by the RNIPLS, which went to Orford and Sizewell Gap.

The Suffolk Humane Society was also involved in running lifeboats in Suffolk, and continued to manage the Lowestoft lifeboat *Frances Ann* throughout, as well as establishing stations at Pakefield (in 1840) and Aldeburgh (1851). Independently of the county organisations, a lifeboat was operated at Southwold by the Southwold Lifeboat Society, which took delivery of the first of its two lifeboats in 1841. The 40ft type, similar to *Frances Ann* at Lowestoft, was built

LIFE BOAT.

The expediency of a LIFE BOAT at the Port of SOUTHWOLD having been made obvious, not only by frequent Wrecks on the Barnard Sand, of Vessels to which no assistance can be given by the Pakefield or Lowestoft Life Boat, when the tide is ebbing and the wind adverse, but also by the recent loss of several Lives from a Vessel which foundered between Walberswick and Dunwich. A general Meeting of the Inhabitants of Southwold and of the Nobility, Gentry and others in its Vicinity, will be held at the TOWN HALL on Friday, the 18th of December instant, at 2 o'Clock in the afternoon, to take into consideration the means to be adopted to establish a Life Boat at the said Port.

The Right Honourable the Earl of Stradbroke has obligingly consented to take the Chair.

SOUTHWOLD,
12th December, 1840.

BYE, PRINTER, SOUTHWOLD.

left The Southwold Lifeboat Society was formed in 1841 after a meeting which was convened by this public announcement. The Society operated two lifeboats, with a certain degree of success, before being taken over by the RNLI in 1854.

11

Independent lifesavers

below Diagram of the 1821-built lifeboat Ipswich, which was based at Landguard Fort. It was one of two lifeboats constructed in the early 1820s for service in and around Harwich harbour. The Landguard boat performed only one rescue, on 19 February 1824, going to the collier brig Malvina, of Newcastle, bound for Southampton, which had gone ashore on the Platters, off Felixstowe harbour mouth. Her crew helped to bring the casualty into harbour. The other lifeboat, Braybrooke, based at Harwich, was out of action by 1829 having been vandalised and neglected, with nobody taking sufficient interest in the boat to keep it maintained and in good working order.

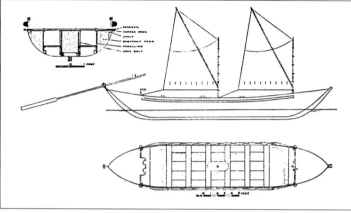

below The Plenty type lifeboat was the first standard type used by the RNIPLS. Two boats of this design were stationed in Suffolk, one serving at Orford and then Woodbridge, and the other at Sizewell, Aldeburgh and Thorpeness. Another Plenty type boat served at Dymchurch. Although the boats were built and funded by the RNIPLS, their operation was largely independent of the national body.

by William Teasdel at Great Yarmouth and, together with the boathouse, the Society spent £400 on the set-up. The boat was named *Solebay* and served at Southwold until 1855.

By the time the RNLI took over in Suffolk during the 1850s, lifeboats were operating from Lowestoft, Pakefield, Southwold and Aldeburgh, and the somewhat hand-to-mouth existence endured by those running these boats was considerably eased by the national body's intervention, which went on to provide new lifeboats at each station.

Harwich and Orwell

In Essex the impetus for having a lifeboat built for Harwich came as a result of several shipwrecks, with consequent loss of life, close to Harwich harbour. In reporting the shipwrecks, the *Suffolk Chronicle* for 18 November 1820 stated, 'It cannot be too deeply lamented, that ... the establishment of Life-Boats, on this parts of our coast, has been so much neglected.'

Subsequent correspondence resulted in the formation in 1821 of the Essex Life Boat Association, with the town's mayor, Anthony Cox, playing a prominent role. The Association had a lifeboat built locally, by the boatbuilder George Graham, and this was stationed at Harwich. Named *Braybrooke*, it was officially launched on 12 September 1821, and was kept afloat at Harwich.

Meanwhile, another subscription was being raised at Ipswich, independently of that at Harwich, for a lifeboat at Landguard Fort, at the entrance to the Suffolk side of Harwich harbour. This boat, built by Jabez Bayley at Ipswich, was officially launched on 4 April 1821, and was known as the 'Orwell Lifeboat'.

However, these two boats performed relatively few services, and on several occasions other boats were used for rescue work in the area when a ship got into difficulty, notably one of the local salvaging smacks. These craft were better suited to going to the outlying sandbanks than the lifeboats, which were too small to cover long distances.

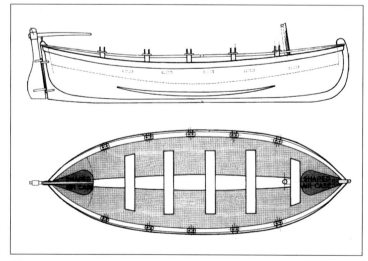

12

Independent lifesavers

Although the Landguard boat came under the control of the Suffolk Association, which provided financial support and had the boat widened, an investigation into the suitability of the station in October 1825 concluded the lifeboat was 'of no use whatever'.

Kent lifeboats

In Kent fewer independent lifeboats were built than in East Anglia. The RNIPLS provided a lifeboat for Dymchurch in 1826, while the Dover Humane Society had a 37ft twelve-oared boat built to a local design for service at Dover in 1837. What happened to this boat is not known, but the Society had another lifeboat built, by T. C. Clarkson of London, in 1852. This was taken over by the RNLI in April 1855 when the station passed to the national body's control.

In the 1850s the Cowes boatbuilder White funded and built small surf boats, two of which were sent to Broadstairs in 1850 and 1853, with another going to Margate in 1857. The Broadstairs boats performed a fine service in January 1857 when they went to the American ship *Northern Belle*, which was caught in a gale while anchored off Kingsgate. *Mary White* saved seven from the ship, and *Culmer White*, in two separate trips, rescued a further sixteen from the ship.

At Margate, the lifeboat was bought by the boatmen, aided by local subscriptions, and was fitted out locally, being named *Friend of All Nations*. She was a 33ft by 6ft 9in craft with extra buoyancy provided by air cases and cork wales around the sides. This boat lasted until 1877, when she was damaged beyond repair while on service, but was replaced by another boat of the same name. This was the first of two further lifeboats that were operated at Margate by the local boatmen, both named *Friend of All Nations*. The best known of these was that built in 1878, which tragically capsized in December 1897 (see p.23).

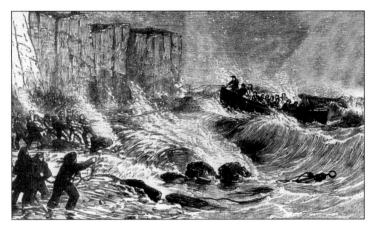

above A contemporary drawing of the Broadstairs lifeboats rescuing the crew of the ship Northern Belle in 1857, a service which resulted in more than twenty people being saved. Both of the boatmen's lifeboats, Mary White and Culmer White, were involved in the rescue.

below The first Margate surf lifeboat Friend of All Nations on her carriage in the harbour. She was the first of three such boats to serve the town.

Frinton-on-Sea

Although by 1900 virtually all of the stations in the South East had been taken over by the RNLI, the operation of independent lifeboats continued when a lifeboat was acquired for use at Frinton-on-Sea in 1901 by the Cooks, a family who moved from Lowestoft to Frinton in 1900. The Cooks bought an old RNLI lifeboat which had served at Caister, named Godsend, renamed her Sailor's Friend, and used her for rescue and salvage work until 1907. They then ordered a new lifeboat, also named Sailor's Friend (pictured), which was built at Harwich by J. & H. Cann. Financial problems overtook the Frinton operation by 1914. In 1917 the boat sank at its moorings and, although it was raised, it was sold soon afterwards and converted into a yacht.

13

The East Anglian beachmen

below The beach at Palling in the late nineteenth century, with the lifeboat house on the far left and various small yawls drawn up on the beach. The Palling beach company ran a full fleet of beach boats and virtually all of its work was salvage and services to shipping. (From an old postcard supplied by John Harrop)

below The waterfront at Gorleston, pictured in June 1969. The RNLI's double boathouse (far left) is next to three private boathouses, with the five 'sheds' on the Quayside all housing lifeboats at one time. The beach companies that used the houses were, from left to right, the Ranger Company (house built 1855); the Volunteer lifeboat house (formerly Storm Company, built 1863 and rebuilt 1881); and, on the right, the Young Company (1864). The Ranger Company house, in which the lifeboat Friend of All Nations was kept, was demolished in 1992 to make way for a new berth for the all-weather lifeboat. The lifeboat berth built in the 1960s can be seen to the far right. (Grahame Farr)

As well as the various independent lifeboat organisations, sea rescue was also undertaken by the beachmen of Norfolk and Suffolk. From the eighteenth century, groups of beachmen kept tall wooden lookouts on the beach, and manned fast rowing and sailing yawls, which they would use to salvage vessels on the sandbanks, which would catch out mariners but often leave their vessel intact. From Sheringham to Southwold, storms, fog, tidal currents, badly maintained vessels and ill-informed navigators brought wrecks aplenty. And in order to make the most of the opportunities presented to the coastal inhabitants of East Anglia, beach companies proliferated, with the salvage rewards being an important source of income for the local inhabitants.

The beach companies were most numerous during the mid-nineteenth century. At Yarmouth beach no fewer than seven companies were operating; one was at nearby Caister, two were based at Winterton to the north, with another at Corton and three at Lowestoft to the south. An average of almost one company per mile, some with one life-saving boat, others with two or three, worked the coast between Mundesley and Aldeburgh. They all had their own boats, but the men also provided the backbone of the lifeboat crews, although RNLI work purely involved saving lives, and salvage claims were frowned upon by the Institution.

When successful, salvage could be very lucrative. The Ranger Company of Gorleston earned £233 from the brig *Martin Luther* in March 1860. Although this was a considerable amount, it had to be shared out between the crews, plus one share (a fortieth) for the boat and another between former members.

The companies were formed by groups of fishermen – beachmen were primarily fishermen – who realised that cooperating with each other made their tasks, such as launching the boats, easier and safer. But although fishing was the main source of income, when the opportunity arose for other work, such as piloting and salvage, the men were quick to take these openings as a way of earning extra money.

As well as operating their salvage yawls, several private lifeboats were

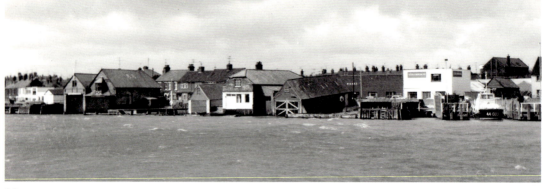

The East Anglian beachmen

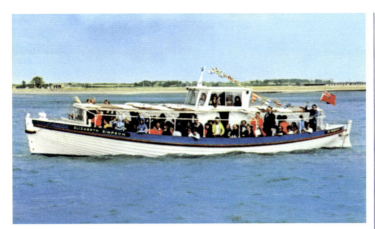

left The volunteer lifeboat Elizabeth Simpson in her latter days when used as a trip boat and after being fitted, in 1926, with twin 30hp Kelvin engines, which enabled the boat to achieve a respectable nine knots. The 47ft 8in Norfolk & Suffolk type boat was built in 1889 and had a long and eventful career operating out of Gorleston. The crew were mainly members of the Rangers Company based at Brush Quay. She remained 'on service' until 1939 although by the latter stages of her career was almost never called upon.

below The name badge of Elizabeth Simpson which is on display at the Great Yarmouth Maritime Museum.

below A postcard showing the beach at Caister in about 1910, by when the influence of the beach companies was waning. The two lifeboats, Nancy Lucy (ON.506) and the third Covent Garden (ON.431, nearest), were both Norfolk & Suffolk type boats, launched over the beach. The yawl Eclat shows how close in design the lifeboats were to the beach yawls of the region.

also manned and managed by the beachmen, the most significant of which were those operated at Yarmouth and Gorleston. They were owned by a number of organisations, which were based around the beachmen's companies. Four such lifeboats were operated by the beach companies at Gorleston during the 1850s and 1860s. The earliest of these was *Rescuer*, built in 1855 by Beeching Bros at Great Yarmouth, which was partly funded by a grant of £50 from the RNLI. She was operated by the Ranger Company between 1855 and 1867, after which she was sold to the beachmen at Winterton, where she served for thirteen years.

Some of the beachmen's companies were in existence before the RNIPLS was founded. Both the Ranger and Storm companies at Gorleston were in operation well before 1800. The Ranger Company of Boatmen, officially formed in 1820, owned the lifeboats *Rescuer* and *Ranger*, as well as a yawl, named *Breeze*, and some pilot gigs. The Storm Company was formed around the same time while a third company, the Young Flies, was later formed, and owned the lifeboat *Friend of All Nations* (1863).

The companies that operated the lifeboats were financially insecure. As a result their level of efficiency is questionable and their operation somewhat precarious, with the RNLI being approached on several occasions to take over their lifeboats. In March 1875 the Storm Company wanted to place their large salvage lifeboat, *Refuge*, which had been repaired recently at considerable expense, under the control of the RNLI, but the national body declined.

Gradually, during the latter half of the nineteenth century, lifeboats took over from the yawls. Around the start of the twentieth century, the Rangers changed their name to The Gorleston Salvage Company Ltd, the assets of which were divided into share. They retained their organisation, but worked with gigs and not yawls, and, by the 1920s, with motor lifeboats beginning to take over, the golden era of salvage and the beachmen were almost over.

15

The RNLI takes over

right The first self-righting type lifeboat, which was built in 1851 by James Beeching and, named Northumberland, served at Ramsgate until 1865. She was the product of the winning designs submitted for the Northumberland prize and measured 36ft in length, pulled twelve oars and is credited with saving 400 lives.

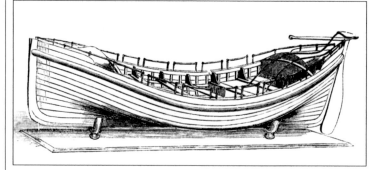

Northumberland Report

The Northumberland Report, which was published in 1851, included a survey of lifeboat provision around the country, with regional surveys of lifeboat stations as well as descriptions of the lifeboat models submitted to compete for the prize offered by the Duke of Northumberland for a new lifeboat design. The report described the situation on England's east coast thus: 'In England and Wales, with a seaboard of 2,000 miles, there are seventy-five lifeboats; of these forty-five are stationed on the east coast ... on the coasts of Norfolk and Suffolk, from Cromer to Southwold, there are ten boats, or one for every five miles; a fact highly creditable to the County associations. There are lifeboats also at Aldborough [sic], Harwich, and Broadstairs.' So the situation in East Anglia was better than on many coasts, but the report highlighted the need for improvements everywhere.

below The lifeboat house at Aldeburgh built in 1864 by the RNLI, thirteen years after it had taken over the station. The lifeboat in the doorway, the 32ft self-righter Pasco which was built in 1853, was one of very few boats of this type to serve in East Anglia, despite it being the RNLI's standard lifeboat design of the nineteenth century.

Despite the number and variety of independent lifeboats built and used during the nineteenth century, their efficiency was somewhat questionable. Many carried out some fine rescues, particularly the Lowestoft boats, but finding sufficient funding and crews were continual problems, and maintaining a lifeboat was an expensive business. So when the RNLI took over during the second half of the nineteenth century, improvements were needed at many stations to improve their operational effectiveness.

In the two decades after its founding in 1824 the RNIPLS opened many lifeboat stations, but it was not a truly national organisation as the local lifeboat societies continued their work independently. The situation started to change in the 1840s when, because few public appeals had been made, the Institution's fortunes were at a low point. A disaster at the mouth of the River Tyne in 1849, when one of the local Society's lifeboats capsized with the loss of twenty out of twenty-four on board in sight of land, highlighted the need for better lifeboats, and in the 1850s the RNIPLS was reformed, reorganised and renamed, becoming the Royal National Lifeboat Institution (RNLI) in 1854.

With a new secretary at its head and a new managing committee providing greater dynamism, the RNLI raised funds on a far greater scale than previously and considerably expanded its operations. The national economy prospered in the latter half of the century, and causes such as life-saving at sea gained a greater prominence.

A new design of lifeboat, the self-righter, was developed. This was primarily a rowing boat, 34ft or 35ft in length, with high end-boxes and a narrow beam that enabled it to come upright in the event of a capsize. Self-righters were used exclusively along the Kent coast, where the RNLI expanded its operations during the 1850s and 1860s with new stations established at Walmer, Margate, Broadstairs, Kingsgate, North Deal and Kingsdowne, primarily to cover the entrance to the busy Thames Estuary and the treacherous Goodwin Sands.

Further south, stations were established at Dungeness in 1854 and New Romney in 1861, while the Dover lifeboat was taken over in 1855. In

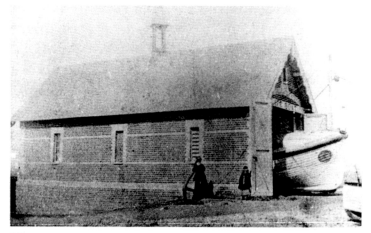

The RNLI takes over

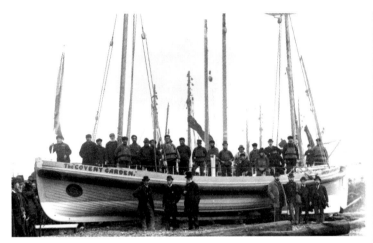

left Caister lifeboat Covent Garden (ON.17), a 42ft Norfolk & Suffolk type on station from 1883 to 1899, pictured on the day of her inauguration ceremony, 3 November 1883. The Norfolk & Suffolk type boats, similar to the area's native yawls, were designed primarily for sailing and covering relatively long distances.

Essex, stations at Harwich, Clacton-on-Sea and Southend-on-Sea were established within three years of each other in the 1870s, and soon became among the busiest around the coast. All the stations operated self-righters, although larger versions, over 40ft long and built primarily for sailing, were placed on service at some places.

While the RNLI expanded lifeboat provision around the Thames Estuary, the situation in East Anglia was rather different as many places already had a lifeboat. So the RNLI became involved in a series of takeovers, most of which were accomplished during the 1850s. However, when taking over the stations in Norfolk and Suffolk, the RNLI was forced to consider local preferences for a larger sailing type, and so far fewer self-righters saw service in East Anglia.

The design of lifeboat used in the East Anglian region, the Norfolk & Suffolk, was a large sturdy type of boat primarily designed for sailing rather than pulling. *Frances Ann* at Lowestoft is considered to be the first of this type, and the many boats subsequently built were similar to her design, being broad, non-self-righting craft, often more than 40ft in length and thus the largest lifeboats of this era. They performed much good service off the coast of East Anglia and were well liked by crews.

An unusual development came in the 1880s at Cromer. The crews requested a lifeboat similar to that which they had used prior to 1859, so a boat 35ft by 10ft 6in and pulling fourteen oars was designed and built for the station. Named *Benjamin Bond Cabbell*, she had a high bow, a raking stem and was not self-righting, but was manoeuvrable. Only two other boats of this design were built, both of which served in North Norfolk, being stationed at Wells and Blakeney.

By 1900, as the new century started, the RNLI was operating thirteen lifeboats in Norfolk at eleven stations, thirteen in Suffolk at eight stations, five in Essex, and thirteen in Kent, making a total of forty-four in the South East.

The RNLI takes over

During the 1850s a series of acquisitions of individual stations and takeovers of organised groups by the RNLI occurred. In East Anglia independent organisations flourished before 1850, and the more significant of these, with the dates when they came into connection with the RNLI, are listed below.

1851 • Suffolk Association for Saving the Lives of Shipwrecked Seamen – Aldeburgh

1854 • Southwold Lifeboat Society – Southwold

1855 • Suffolk Humane Society – Lowestoft, Thorpeness and Pakefield
Dover Humane Society – Dover

1857 • Norfolk Association for Saving the Lives of Shipwrecked Mariners – Cromer, Mundesley, Bacton, Palling, Winterton, Caister, Yarmouth

below The 35ft 3in Cromer type lifeboat Baltic (ON.375) at Wells, inside the boathouse on her carriage. She was one of only three Cromer type boats; the others served at Cromer and Blakeney. (From an old postcard supplied by John Harrop)

17

Nineteenth-century lifeboat work

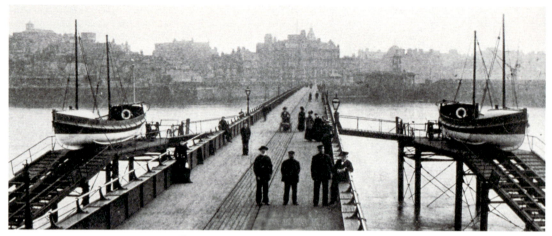

above At Margate, as at many other stations in East Anglia, Essex and Kent, two lifeboats were operated. The Margate boats were kept on slipways either side of the pier, and, when a call came, the one deemed most suitable, depending on the direction of wind and tide, was launched. Two 40ft self-righters were operated through this arrangement, with Civil Service No.1 (ON.415, on left) and Eliza Harriet (ON.411) both arriving in 1898.

below The Norfolk & Suffolk type lifeboat James Leath (ON.607) being brought back to her boathouse at Pakefield. To recover the large 42ft boat involved considerable effort from the shore crew, but launching across skids laid on the flat sandy beaches of Norfolk and Suffolk was usually the only way of getting a lifeboat afloat. (From an old postcard supplied by John Harrop)

The volunteer lifeboat crews of East Anglia, Essex and Kent performed many courageous and outstanding rescues during the nineteenth century, with the region's volunteer lifeboat crews among the busiest of any in the country as many stations gained fine records of gallantry. Along the bustling east coast shipping lanes, with their ever-shifting sandbanks ready to catch out the unwary mariner, many vessels were caught out and some very fine rescues by the area's lifeboats resulted.

The hazards of lifeboat work were considerable at this time, with the open boats offering little protection for their crews, whose skill with the sails and strength at the oars were crucial factors in determining the successful outcome of a rescue. Crews were often called upon to undertake long journeys to reach a casualty, testing not only their strength and stamina to the limit but also their courage and determination.

The service in January 1881 by the Ramsgate lifeboat *Bradford*, a 44ft self-righter, to the barque *Indian Chief* was one such, and has become famous in the history of the RNLI thanks to the efforts of the Ramsgate crew led by Coxswain Charles Fish, and the subsequent publicity the incident received in the national press. The vessel struck the Long Sands in an easterly gale during the early hours of 5 January 1881 and began to break up. The crew took to the rigging but of the twenty-nine on board eighteen were drowned.

Somehow the remaining eleven survived the night despite the freezing gale-force winds, and at first light were amazed to see, approaching through the breaking water across the sands, the Ramsgate lifeboat. *Bradford* had left Ramsgate just after midday the previous day following reports that a vessel was in difficulty, and was towed to the scene by the harbour paddle steamer *Vulcan*. The crew had thirty miles to endure in the open lifeboat through the biting gale and very heavy seas. Arriving on the scene in the dark

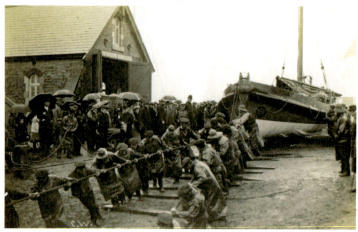

Nineteenth-century lifeboat work

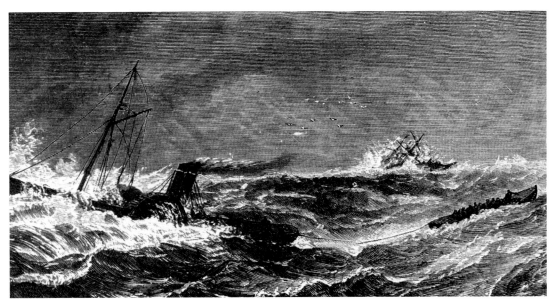

it was impossible to find the wreck, so the lifeboat stood by until daybreak. The steamer and lifeboat cruised between the sands with the lifeboat crew exposed to the whole force of the storm and the steamer sustaining damage.

In the morning, under her own sail, the lifeboat negotiated the seas around that wreck, went alongside, took off the remaining survivors, sailed back across the sands to *Vulcan* and was then towed back to Ramsgate after twenty-six hours at sea. The Gold medal was awarded to Coxswain Fish and the Silver medal to the lifeboat crew as well as the Master and crew of *Vulcan* for what had been a truly extraordinary rescue that tested the rescuers to the extreme, and which was successfully executed thanks to the crew's skill and the Coxswain's masterful seamanship.

The use of a steamer to tow the lifeboat had become fairly common practice at stations where steam tugs were available. Their usage around the major ports and harbours during the second half of the century had become widespread, and many were employed to tow lifeboats out to casualties. At Harwich, Gorleston and Ramsgate many rescues were accomplished with the aid of a steam tug.

The *Indian Chief* rescue was also not unusual in the distance travelled by the lifeboat to reach a casualty. Despite the pulling lifeboats having a relatively limited range, the sailing boats often went further, and crews at the Essex stations of Harwich, Walton and Clacton frequently took their boats many miles offshore to help ships wrecked on the sandbanks, and were often at sea for days at a time. The Clacton-on-Sea lifeboat *Albert Edward* (ON.32), a 39ft self-righter, undertook

above The Ramsgate lifeboat Bradford, the second of that name, being towed to the wreck of the Indian Chief by the Ramsgate Harbour tug Vulcan on 5 January 1881, during what became one of the epic rescues in the history of the RNLI, with Coxswain Charles Fish receiving the Gold medal for his exploits.

below Great Yarmouth lifeboat John Burch (ON.329) was one of the smaller Norfolk & Suffolk type lifeboats, measuring 32ft by 9ft 6in, and was thus suitable for carriage launching. Her non-self-righting design was similar to the much larger sailing boats of the same type used throughout East Anglia.

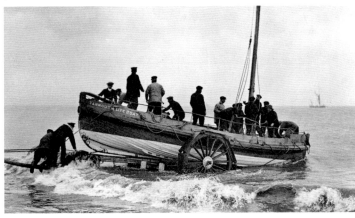

Nineteenth-century lifeboat work

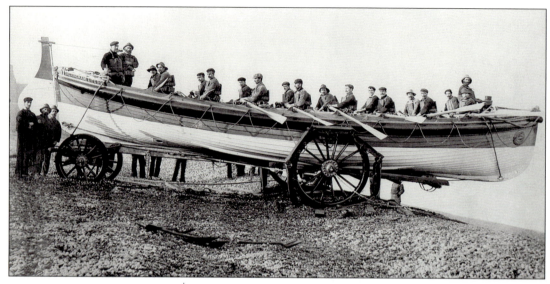

below The Sheringham lifeboat J.C. Madge (ON.536) is a good example of the Liverpool class sailing lifeboats that were designed during the late nineteenth century, a number of which served at stations in Norfolk and Suffolk.

below The 44ft self-righter Thomas Simcox (ON.312) at Dungeness, on the hard standing which was laid for her in 1905. Launching across the shingle beach at Dungeness was always a challenge, and the station has occupied various sites on the ever-shifting shingle beach. Thomas Simcox was on station from 1892 to 1915 and saved thirty-three lives. (From an old postcard supplied by John Harrop)

two very long rescues in the space of five days in November 1885. The first, to the barque *Garland* in gale-force winds, involved the lifeboat being away from her station for almost two days. The second, only four days later, involved assisting the schooner *Dorothea*, and the lifeboat did not return to station until 7.45 p.m. the following day, forty hours after setting out, by when the crew were totally exhausted and suffering from the cold.

The publicity generated by the *Indian Chief* rescue made Charles Fish into one of the most famous coxswains in the country at a time when the work of the lifeboat service was becoming more widely known thanks to publicity campaigns led by Charles Macara. Macara, a Lancashire-based businessman, organised the first lifeboat day, which was held in Manchester in October 1891, and raised both awareness and funds for the RNLI.

The street collections raised much needed finance for the RNLI, and with lifeboats being paraded through towns during lifeboat days, the public gained greater awareness of the work of the Institution and its volunteer crews. Although the first lifeboat days were held in the industrial cities of the north, they soon became more widespread, and street collections in London and its boroughs were introduced before the end of the nineteenth century.

Macara had been driven to act after witnessing, from his home overlooking the Ribble, a disaster in December 1886 when the self-righting lifeboats from Lytham, St Annes and Southport, on the Lancashire coast, put out to the aid of the German barque *Mexico*, which had been wrecked in the Ribble estuary in a severe gale. The Southport lifeboat capsized after having reached *Mexico*

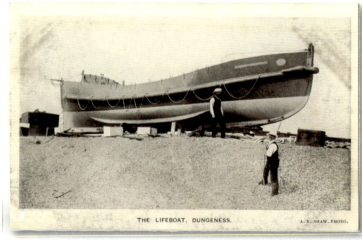

THE LIFEBOAT, DUNGENESS. A. E. SHAW, PHOTO.

20

Nineteenth-century lifeboat work

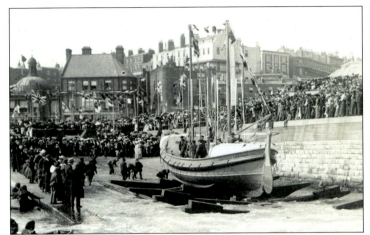

and failed to right, with the loss of fourteen of her sixteen crew. The St Annes lifeboat capsized some distance from the wreck and her entire crew of thirteen were lost. The Lytham lifeboat, however, despite the huge seas she encountered, successfully got alongside *Mexico* and took off her entire crew.

As well as showing that greater money was required for lifeboat work, particularly to compensate families who had suffered bereavement, the disaster also highlighted the inadequacies of the self-righting design. So, to improve matters, in the 1880s a new design was introduced, which became known as the Watson type after the RNLI's naval architect George Lennox Watson. This new craft was larger, steadier and far less likely to capsize than the self-righting type, although was itself not self-righting. Watson sailing lifeboats served at Clacton and Harwich, while the Liverpool sailing type, which was also designed by Watson and was similar in many respects to his original design, served at several stations in East Anglia, including Sheringham.

However, the self-righter continued to dominate at stations south of the Thames, with large examples of the type – 40ft and more in length – in widespread use. The stations of Walmer, Deal and Kingsdowne, whose

lifeboat crews went to the many ships wrecked on the notorious Goodwin Sands, as well as at stations just up the coast at Broadstairs and Ramsgate, all had large self-righters. Most were launched across the beach, but the Ramsgate boat was kept afloat and a slipway was built at Broadstairs.

The exploits of the lifeboat crews who provided assistance to the many ships wrecked on the Goodwins became well known during the nineteenth century. This was thanks in large part to their featuring in many publications; one author justified writing about their work by saying: 'What the lifeboatmen braved out on the Goodwins when … vessels were in distress is sufficient to stir our pulses.'

above A late nineteenth-century postcard entitled 'Ramsgate – The Call for the Lifeboat' using a posed image of a lifeboatman calling out the crew. (From an old postcard supplied by John Harrop)

above left Ramsgate's last sailing lifeboat, Charles and Susanna Stephens (ON.537), being named on 25 May 1905. The 43ft self-righter, one of the largest boats of this type to be built, served the station for twenty years, during which time she saved almost 300 lives; Ramsgate, at the entrance to the Thames Estuary, was one of the RNLI's busiest stations. (From an old postcard supplied by John Harrop)

below A self-righting lifeboat is pulled through the streets of Croydon during the local lifeboat day, with crowds of supporters in attendance. (From an old postcard supplied by John Harrop)

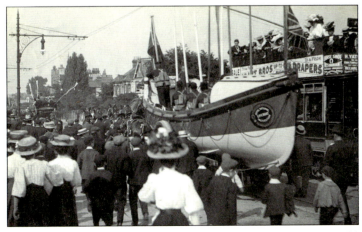

Nineteenth-century disasters

above The memorial on Wells Quay to the eleven who were lost in the lifeboat disaster of October 1880. The memorial was restored in 2004, with the brickwork being replaced for the 125th anniversary.

below Wells volunteer lifeboat crew mark the 125th aniversary of the loss of the lifeboat Eliza Avins, in which eleven men were lost, during a service of remembrance in October 2005.

Although the volunteer lifeboat crews performed many courageous and outstanding rescues, lifeboat work during this era was both difficult and dangerous. The physical effort required just to launch a lifeboat off an open beach was considerable, and in the face of gale-force winds the craft were largely at the mercy of the elements. That so many fine rescues were performed is tribute to the skill and bravery of the lifeboatmen. However, a significant number of lifeboats met with disaster during the latter half of the nineteenth century, and lifeboatmen lost their lives not infrequently during the latter half of the nineteenth century as their relatively small and unmanoeuvrable pulling and sailing lifeboats were unable to deal with the severe weather into which they had launched, and accidents were reasonably commonplace.

In Suffolk, where the RNLI took over in the mid-1850s, both Southwold and Aldeburgh lifeboats suffered capsizes before the end of the decade, the former on exercise on 27 February 1858 and the latter on service on 21 December 1859. On both occasions, three crew members lost their lives.

At Hunstanton, in Norfolk, the lifeboat *Licensed Victualler*, a small 32ft self-righter which had only been sent to the station the previous year, capsized in heavy seas on 8 April 1868 going out on service to a barge. Fortunately no lives were lost because the boat righted, as she was designed to do, and all twelve crew managed to regain the boat.

Although they saved many lives, the volunteer lifeboats were also involved in a number of accidents in which both rescued and rescuers lost their lives. On 13 January 1866 the Gorleston lifeboat *Rescuer* launched in response to a passing vessel's request for stores. As she went over the bar, she caught the ground and capsized. Not being self-righting, she remained bottom up and, of sixteen on board, twelve were drowned under the boat. The four who survived were saved by *Friend of All Nations*, another private lifeboat.

Rescuer capsized again on 3 December 1867 after being run down by the fishing lugger *James and Ellen*. Although other boats helped, more than

Nineteenth-century disasters

twenty of the thirty-five on board were lost, including eleven survivors who had been from the steamship.

On 15 July 1875 the Kessingland No.1 lifeboat *Bolton* (ON.25) was capsized in breaking surf as she was being launched, and of two men who got trapped by the upturned hull, one was dead by the time he was freed. On board when the boat capsized were fifteen men, but most were thrown clear as the boat turned over.

Five years later significant loss of life occurred off the Norfolk coast when, on 29 October 1880, the Wells lifeboat *Eliza Adams* was capsized. She was returning to shore after launching to the brig *Ocean Queen* and eleven of her crew of thirteen were drowned; they left behind ten widows and twenty-seven children. In *The Lifeboat* journal for 1 February 1881, it was reported that: 'The Wells disaster was by far the most fatal accident that had ever befallen a Lifeboat belonging to the National Life-boat Institution, the largest number of lives ever before lost, on any one occasion, having been six.'

Somewhat surprisingly, this state of affairs seems to have been accepted, and no measures to combat these losses were put into place. Just a few months later, on 18 January 1881, the Great Yarmouth No.2 lifeboat *Abraham Thomas* capsized on service and six crew were lost, together with one other.

In Kent, during a particularly bad storm on 11 November 1891, Dungeness and Hythe lifeboats both capsized on service to different casualties. The Dungeness boat, *R.A.O.B.* (ON.130), turned over when at anchor and five men were washed out, of whom three were hauled back aboard but the other two were swept away and drowned. When the Hythe lifeboat capsized during the same storm, one of her crew was lost.

The RNLI's Annual Report for 1891 contained the following statement:

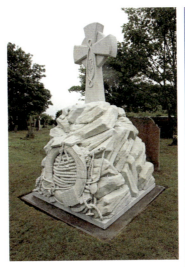

left The memorial in the Aldeburgh churchyard to the seven men lost in the lifeboat Aldeburgh (ON.304) in 1899.

above In the church itself is another memorial to these seven men (above).

'It is with the deepest regret that the Committee have to report that, of the 17,000 men who were afloat in the Life-boats during the year, six men lost their lives when making gallant attempts to rescue shipwrecked crews ... The widows, orphans, and dependent relatives of the unfortunate men were in every case well provided for by the Institution, and by funds raised locally.' Although accidents were fairly common, at least the RNLI recognised the hardship that they caused to the local communities in which the bereaved had lived and worked, and the Institution gave to local funds set up to help the dependants of lifeboatmen.

Not only did RNLI lifeboats get into difficulty, but so did the independently operated boats. The private lifeboat at Margate, *Friend to All Nations*, capsized on service on 2 December 1897 with the loss of nine crew. This was the third time the town's independent lifeboat had capsized, although the incidents in January 1866 and November 1877 had not seen any loss of life.

One of the more significant tragedies occurred on 7 December 1899 when the Aldeburgh lifeboat capsized. The boat, a 46ft Norfolk & Suffolk type named *Aldeburgh* (ON.304), which

East coast lifeboat accidents 1850 to 1890

SOUTHWOLD • 27.2.1858 • Three lives were lost when the lifeboat capsized returning from exercise: G. Ellis, Revd R. Hodges and J. Ord.

ALDEBURGH • 21.12.1859 • Three lives were lost when the lifeboat capsized: Thomas Cable, Philip Frances Green and John Pearce.

GORLESTON • 13.1.1866 • Thirteen lifeboatmen were lost: W. Dawkins, J. Fleming, B. Harris, W. Manthorpe, A. Newson, C. Parker, R. Spillings, E. Welton, C. Whiley, C. Woods, E. Woods Snr, J. Woods Jnr.

GORLESTON • 3.12.1867 • The private lifeboat capsized with the loss of six of nineteen lifeboatmen on board: C. Hannent, J. Leggett, T. Morley, W. Moss, J. Sheen and N. Spurgeon.

KESSINGLAND • 15.7.1875 • Thomas Tripp died after being trapped beneath the lifeboat.

BACTON • 1880 • J. Haylett and J. Stageman.

WELLS • 29.10.1880 • The lifeboat capsized with the loss of eleven lifeboatmen: Francis Abel, John Elsdon, Robert William Elsdon, William Field, William Green, Charles Hines, George Jay, C. Smith, Samuel Smith, John Stacey, William Wordingham.

GREAT YARMOUTH • 18.1.1881 • The lifeboat capsized and six of her crew were drowned: C. Beckett, J. Ditcham, W. Green, H. Masterson, J. Sherwood and R. Symonds.

HARWICH • 18.1.1881 • William Wink was washed away after the lifeboat capsized.

CLACTON-ON-SEA • 23.1.1884 • Thomas Cattermole and James Cross were drowned when the lifeboat capsized on service.

GORLESTON • 10.11.1888 • Private lifeboat Refuge capsized with the loss of four: A. George, S. George, W. Whiley and A. Woods.

23

Nineteenth-century disasters

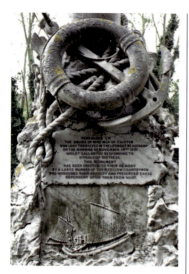

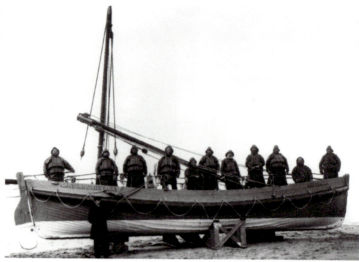

above The inscription on the memorial statue erected in Caister cemetery after the disaster of 1901. Made from Sicilian marble, it is in the form of a broken mast around which are the graves of the eight men whose bodies were recovered.

above right The Caister No.2 lifeboat Beauchamp (ON.327), which capsized on service in November 1901, on the beach at Caister.

East coast lifeboat accidents 1891 to 1914

DUNGENESS • 11.11.1891 • Daniel Nicolls and Henry Reeves were washed overboard and swept away after the lifeboat capsized.

HYTHE • 11.11.1891 • Lifeboatman C. Fagg was lost when the lifeboat capsized.

MARGATE • 2.12.1897 • Nine lives lost when the private lifeboat capsized: Coxswain William Philpott Cook (snr), Henry Brockman, Robert Cook, William Philpott Cook (jnr), Edward Robert Crunden, John Dyke, William Gill, George Ladd and Charles Troughton.

ALDEBURGH • 7.12.1899 • Six of eighteen crew were drowned: John Butcher, Charles Crisp, Herbert Downing, Alan Easter, Thomas Morris, James Miller Ward and Walter Ward.

CAISTER • 13.11.1901 • The lifeboat capsized and nine of the crew were drowned: Coxswain Aaron Walter Haylett, James Henry Haylett (jnr), William Brown, Charles John Brown, William Wilson, John William Smith, George King, Charles George (whose body was never found), and Harry Knights.

had been built specially to the design requirements of the crew in 1890, had launched into a raging gale but, when returning to the beach, she was caught by heavy seas and capsized.

Of the eighteen crew, six were drowned and another died three months later from the effects of the accident. Efforts to right the boat on the beach failed and the six trapped beneath the non-self-righting vessel all drowned. A hole was cut in the boat's side during the frantic attempts to release the six trapped men, and one of the crew who had been washed ashore, Charles Ward, repeatedly went back into the surf to try to help the trapped men, but to no avail. For his courage and determination, Ward was awarded the Silver medal by the RNLI.

The enquiry into the accident concluded that the boat was suitable for the work she had to do, was properly equipped and in good condition. She was in the hands of a competent Coxswain and crew and the accident was nobody's fault. That she was overwhelmed by and unable to deal with the heavy seas seems to have just been accepted, a common realisation during this period when loss of life was almost taken for granted.

Less than two years later a similar accident befell the Caister lifeboat, and it has since become famous in the annals of lifeboat folklore. On 13 November 1901 the Caister No.2 lifeboat *Beauchamp* was launched into a gale and very heavy seas after flares from a vessel on the Barber Sands had been seen. Once afloat, the boat proceeded towards the sands. As the mizenmast was not properly set, the Coxswain, Aaron Haylett, tacked just outside the surf. He then attempted to get the boat away from the shore but the boat was driven onto the beach and struck by several heavy seas. While the Coxswain was taking emergency action, the boat was caught by a particularly heavy sea which capsized her, trapping the crew. When the lifeboat was found, she was lying upside down with both masts gone and waves breaking over her, and it proved impossible to right her.

In the heavy surf and breaking seas, and regardless of their own safety, two men waded through the breakers and managed to help free and save some of the crew. Subsequently eight bodies were recovered as they were washed from under the boat. But of the twelve crew who had gone out that night, only three survived the capsize.

Past and present WELLS

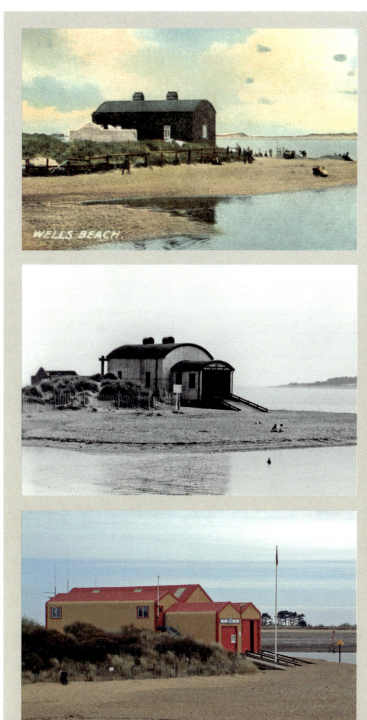

top The lifeboat house at the end of Beach Road, about a mile north of the Wells Quay, was built in 1894–5 for the second Baltic (ON.375) lifeboat, a 35ft 3in Cromer type pulling lifeboat. The previous boathouse was situated on the Quay and the decision to move the station to the new location was made in December 1893. In April 1894 the RNLI acquired the lease of the site for the new house and a month later drawings and specifications were prepared 'for an inexpensive house to accommodate the new lifeboat'. During 1894 and 1895, the house, complete with pile foundations and a slipway onto the beach, was constructed by local builder J. Platten at a cost of £551 10s 0d. The house took longer than anticipated to be built and not until October 1895 – almost a year after it should have been finished – was it ready, with the builder having failed to complete his contract and an extra £53 10s 3d incurred for additional work.

middle The lifeboat house has served the station for more than a century, although it has been altered and extended considerably during this time. This view, from the 1950s, shows the building after the extension to accommodate a launching tractor.

bottom The boathouse was almost completely rebuilt in the early 1990s to accommodate a 12m Mersey class lifeboat, Doris M. Mann of Ampthill (ON.1161), and the Talus MB-H launching tractor. It was extended at the side so that the D class inflatable could be housed, and a large crew room was incorporated to provide greatly improved accommodation for boat, tractor, inshore lifeboat and crew. Following the completion of the structural and internal rebuilding, the outside was stripped and reclad with plastic-coated moulded aluminium, leaving it bearing little resemblance to the original house. More improvements were implemented in the mid-1990s, when work on the timber revetment and groynes was undertaken to prevent erosion of the sandy headland on which the boathouse is sited.

Early motor lifeboats

right The steam lifeboat James Stevens No.3 (ON.420) at Gorleston, where she was stationed for just over five years, saving thirty lives in that time. She also served at Dover during a career that took her to six different stations. The RNLI built six steam lifeboats in total, and in the South East they served at Harwich (between 1890 and 1917) and Dover (1919 to 1922), as well as Gorleston. (By courtesy of Jeff Morris)

below The first motor lifeboat, J. McConnel Hussey (ON.343), originally stationed at Folkestone, pictured during her self-righting trials after being fitted with an engine in 1904. The box housing the motor can be seen amidships. (From an old photo loaned by Jeff Morris)

below The first motor lifeboat in the South East, James Stevens No.14 (ON.432), was stationed at Walton and Frinton. Built in 1900, she was converted to motor in 1906 when fitted with a single 32hp Blake four-cylinder petrol engine.

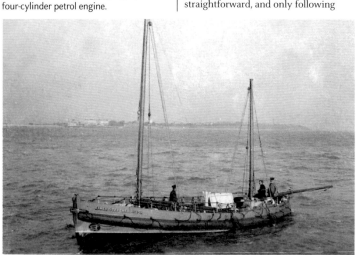

During the nineteenth century lifeboatmen using the pulling and sailing lifeboats often performed remarkable and extraordinary feats of life-saving. However, as technical advances in motive power developed during the nineteenth century, first in the form of steam and then the internal combustion engine, applying this to lifeboats was a logical step.

The first powered lifeboats were steam driven, and this offered distinct advantages over a lifeboat relying on sails, oars or a combination of the two. But designing and building a steam-powered lifeboat was far from straightforward, and only following advances in engineering techniques during the 1880s did building a steam-powered lifeboat become a possibility. In 1890 the first steam-powered lifeboat, Duke of Northumberland (ON.231), was launched from her builder's yard on the Thames and made her first trial trip. During the next decade the RNLI had a further five steam lifeboats built for service around the British Isles, and Gorleston, Harwich and Dover were among the stations they served.

But despite the steam lifeboats undertaking much fine rescue work, steam was poorly suited as a means to power lifeboats for a variety of reasons, and by the early years of the twentieth century the internal combustion engine offered far greater potential. In 1904 a lifeboat was fitted with an engine for the first time and, although many problems had to be overcome to operate an engine on board a lifeboat, once numerous setbacks and technical difficulties had been solved, lifeboats powered by the internal combustion engine pointed the way ahead.

The first lifeboats to be motorised were conversions. Pulling lifeboats already in service were fitted with an engine, and these boats were then used for trials to assess the suitability of motor power. The first boat to be so

Early motor lifeboats

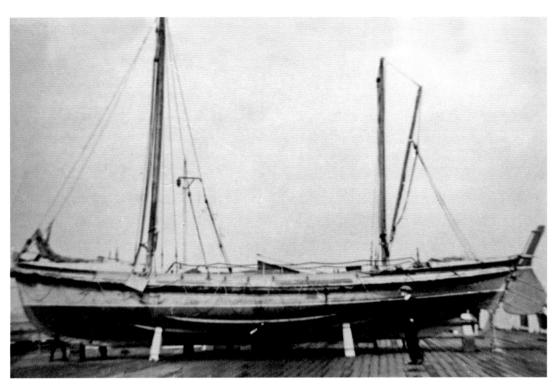

converted was the Folkestone lifeboat *J. McConnel Hussey* (ON.343), a 38ft self-righting type built in 1893 and pulled by twelve oars, which was fitted with an 11hp Fay & Bowen motor in 1904. The Ramsgate lifeboat *Bradford* (ON.350) was the next to be converted, in 1906.

The boats from Walton & Frinton and Clacton-on-Sea were also converted to motor, in 1906 and 1912 respectively. They were large sailing craft intended for work on the outlying sandbanks and were thus often called upon to travel considerable distances to reach casualties. Fitting them with an engine was a logical step as it improved their range and enabled the volunteer crews to operate more safely further afield.

During the First World War, the Clacton boat *Albert Edward* (ON.463) performed a number of fine services and saved twenty-nine lives in 1914 alone, quickly proving her worth as a motor lifeboat. She was also involved in medal-winning services during the war years, the first of which took place on 2 December 1914, when she launched to the P&O steamer *Harlington*, which was aground on the Gunfleet Sands in very heavy seas. Over several days the lifeboat was on scene continually and eventually saved the crew. Less than a year later, on 28 September 1915, *Albert Edward* went to the barquentine *Leading Chief*, which had run aground on the Sunk Sands in heavy seas. The rescue also proved to be an extremely challenging one, and the lifeboat had to be driven onto the deck of the sinking vessel to rescue the nine crew.

The other medal-winning service by *Albert Edward* took place on 27 December 1917, when she went to the Swedish steamer *Iris*, which was aground on the Long Sand in heavy seas and an easterly gale. Coxswain George Grigson took the lifeboat towards the vessel and, with great skill and teamwork, the shipwrecked crew jumped to safety one at a time.

above The 45ft Watson lifeboat Albert Edward (ON.463) on Clacton Pier after she had been converted to motor, with the propeller clearly visible. She carried twelve oars as well as a full sailing rig, even after the engine had been fitted. She served the Essex station from 1901 to 1929 and saved 277 lives during that time.

Essex medal winners

CLACTON-ON-SEA • 2 December 1914 • Silver medal to Coxswain George Grigson for the rescue of fifteen from the steamer Harlington in gale-force winds and very heavy seas.

CLACTON-ON-SEA • 28–29 September 1915 • Silver medals to Coxswain George Grigson and Second Coxswain Jesse Salmon for the rescue of the barque Leading Chief, of Guernsey.

CLACTON-ON-SEA • 27 December 1917 • Silver medal to Coxswain George Grigson and Bronze medal to Second Coxswain Jesse Salmon for the rescue of twenty-three from the steamer Iris in very rough seas.

WALTON AND FRINTON • 30 December 1917 • Silver medal awarded to Coxswain William Hammond and a Bronze medal to Second Coxswain John Byford for rescuing ninety-two people from the wrecked steamship Peregrine.

Motor lifeboats take over

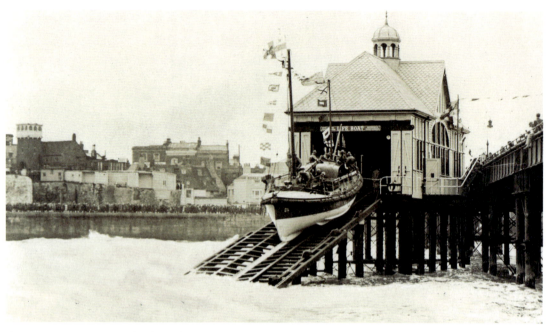

above Inauguration ceremony of Lord Southborough (Civil Service No.1) (ON.688) at Margate on 5 September 1925, seen outside the lifeboat house on Margate Pier; the boat, funded by the Civil Service Lifeboat Fund, was the station's first motor lifeboat and was one of ten 45ft Watsons built in the mid-1920s. (By courtesy of the RNLI)

below The 46ft 6in Norfolk & Suffolk type John and Mary Meiklam of Gladswood (ON.670) leaving the harbour at Gorleston. She was one of the first motor lifeboats in East Anglia.

Following the end of the First World War, the RNLI embarked upon a programme of lifeboat construction, developing new motor lifeboats and phasing the old pulling boats out of service. It was a long and expensive process, and while considerable progress was made in the 1920s and 1930s, by the time the world went to war again the fleet had not been completely motorised.

But before the motor lifeboat became commonplace around the coasts,

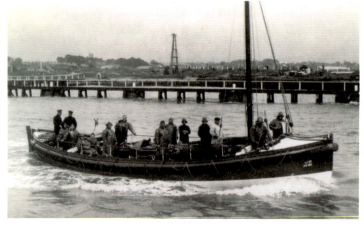

the skills, courage and strength of lifeboatmen using pulling and sailing lifeboats continued, as exemplified by an extraordinary rescue at Cromer in 1917. Led by Coxswain Henry Blogg, the lifeboat crew went out in the pulling and sailing lifeboat *Louisa Heartwell* to the Swedish steamer *Fernebo* in a north-easterly gale on 9 January 1917.

The assistance of hundreds of servicemen was needed to get the boat afloat, many of whom went up to their necks in the water trying to get the heavy lifeboat past the breaking surf. She was driven back onto the beach several times, until just before midnight when she was successfully got away and able to rescue eleven survivors. Due to wartime demands, lifeboat crews were almost all over military age, and more than one in this lifeboat crew was approaching seventy, but the rescue was achieved with stamina and courage.

By the end of the war, the converted motor lifeboats described above were in service at key stations where range was a factor – with the outlying sandbanks of the Thames Estuary to be reached –

Motor lifeboats take over

while steam lifeboats were also in situ at strategic points, so the first purpose-built motor lifeboats did not come to East Anglia and Kent until the 1920s.

The early 1920s saw Lowestoft, Ramsgate, Cromer and Gorleston receiving motor lifeboats, followed soon afterwards by Southwold, Margate and Southend. These stations were all supplied with large non-self-righting craft, all specially adapted for local conditions. Cromer, Lowestoft and Southwold received 46ft 6in Norfolk & Suffolk type boats fitted with single engines, with the Cromer boat being transferred to Gorleston in May 1924.

The motor lifeboat at Lowestoft proved her worth just over three years after coming on station when another Gold medal rescue was performed off the East Anglian coast, five years after the heroics by Coxswain Blogg and his crew at Cromer. Between 19 and 21 October 1924, attempts by the Gorleston lifeboat *Kentwell* (ON.543) to save the steamer *Hopelyn*, ashore on the North Scroby Sands in gales and heavy seas, proved unsuccessful. But in the early hours of 21 October *Agnes Cross* put out from Lowestoft and, with the Gorleston Coxswain aboard, veered down onto the steamer and managed to take off twenty-four men and a black kitten, despite great difficulties and dangers.

RNLI engineers developed further new types of motor lifeboat during the 1920s, designing boats for specific areas. The Norfolk & Suffolk design was one, while another was a special class, known as the Ramsgate type after the first station from which it operated, which was developed for service in the shallow waters of the Thames Estuary. This 48ft 6in class, of which only three were built, had moderate draft, a flat floor, low end-boxes, and a drop keel.

Meanwhile, for Dover the RNLI experimented by introducing a 64ft fast

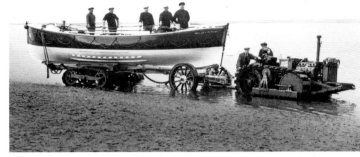

above The 32ft Surf motor lifeboat Royal Silver Jubilee 1910–1935 on her launching carriage at Wells, with the Case L launching tractor T32. As well as motorising the fleet during the interwar years, launching tractors were also developed to make the beach launch and recovery process quicker and easier.

Medal winners

CROMER • 9 January 1917 • Gold medal to Coxswain Henry Blogg, Silver medals to William Davies and Private Stewart Holmes, and Bronze medals to crew members George Allen, James Allen, Edward Allen, William Allen, Henry Balls, Charles Cox, George Cox, Leslie Harrison, Tom Kirby, Gilbert Mayers, Walter Rix and William Rix for the service to the Swedish steamer Fernebo. This was the first time Bronze medals had been awarded.

LOWESTOFT AND GORLESTON • 19/21 October 1922 • Gold medal to Lowestoft Coxswain John Swan, Silver medal to Motor Mechanic Ralph Scott, Bronze Second-Service clasp to George Ayers, and Bronze medals John Rose, H. Allerton, J. Ayers, W. Butcher, C. Mewse, Albert Spurgeon and F. Swan for rescuing twenty-four men and a black kitten from the steamer Hopelyn wrecked on North Scroby Sands. From the Gorleston lifeboat, the Gold medal was awarded to Coxswain William Fleming, and Bronze medals to his crew of fifteen. Commander Edward Carver, Divisional Inspector, received a Silver medal.

left The 46ft Watson motor type Michael Stephens (ON.838) served at Lowestoft from 1939, and had a shallow draft specially for working over the bar. (By courtesy of the RNLI)

Motor lifeboats take over

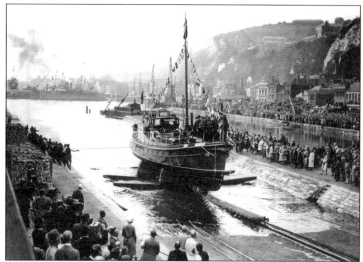

above The Ramsgate type lifeboat Greater London (Civil Service No.3) (ON.704) at Southend. She was one of three boats of this type developed for working in the Thames Estuary. (By courtesy of the RNLI)

above right The special 64ft fast lifeboat Sir William Hillary (ON.725) at Dover during her naming ceremony on 10 July 1930. (By courtesy of the RNLI)

Medal winners

LOWESTOFT • 21 November 1927 • Silver medal to Coxswain Albert Spurgeon for saving three men from the smack Lily of Devon, during which the lifeboat Agnes Cross struck the bottom and was thrown against the wreck.

CROMER • 22 November 1927 • For the epic service to the Dutch tanker Georgia, stranded on the Haisborough Sands, the Gold medal went to Coxswain Henry Blogg, with Bronze medals to the rest of the crew.

HYTHE and DUNGENESS • 11 November 1929 • Bronze medal to Coxswain Douglas Oiller of Dungeness and Silver medal to Coxswain Henry Griggs of Hythe for a service to the Rochester barge Marie May; both boats were pulling and sailing, and reaching the casualty in the gale-force winds was difficult.

ALDEBURGH • 23 November 1938 • Bronze medal to Coxswain George Chatten for a service to two barges, Grecian and Astrid, from which four men were saved.

right The 35ft 6in self-righting motor lifeboat City of Nottingham (ON.726), funded by the City of Nottingham Lifeboat Fund, being recovered on the beach at Hythe. (By courtesy of the RNLI)

lifeboat design. Completed in 1930, this twin-screw boat, named *Sir William Hillary*, was 64ft in length and her twin engines gave her a speed of over seventeen knots. She served at Dover to cover the Straits and 'attend promptly to any air disasters that occur in that part of the Channel', according to RNLI Naval Architect James Barnett.

Smaller, lighter types of lifeboat were also required for launching from a carriage, and so two 35ft 6in classes were developed: a Liverpool non-self-righter and motor self-righter. The Cromer No.2 and Sheringham stations operated carriage-launched 35ft 6in Liverpools, and the first 35ft 6in self-righter was sent to Hythe in January 1930. Meanwhile an even smaller type was designed, the 32ft Surf class, one of the first of which was sent to Wells.

For stations such as Aldeburgh, Walmer and Dungeness, where the lifeboat was launched across a shingle beach on skids, a Beach type was developed which had a strengthened hull to withstand the stresses of being dragged over a beach. The first 41ft Beach lifeboat, *Abdy Beauclerk*, was sent to Aldeburgh in December 1931, followed by similar boats which went to Dungeness and Walmer in 1933. A fourth boat of this class, *The Viscountess Wakefield*, went to Hythe in 1936.

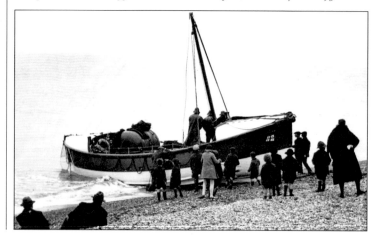

Past and present LOWESTOFT

above The lifeboats at Lowestoft have been moored afloat for more than a century at several locations around the harbour. Pictured is the 47ft Watson motor Frederick Edward Crick (ON.970) at moorings on the seaward side of Hamilton Dock, where the station was based between March 1955 and February 1969, at which point the jetty alongside which she was moored was demolished. After three years at temporary moorings, she was moved to a mooring in the Yacht Basin in 1972.

below Since 1998 the 47ft Tyne lifeboat Spirit of Lowestoft (ON.1132) has been moored alongside a purpose-built pontoon in the south-eastern corner of the Yacht Basin, adjacent to which is the crew facility and workshop built in 1998 on the site of the former Pier Pavilion. For the first ten years of her service, she was operated from the moorings taken up in 1972.

Wartime service

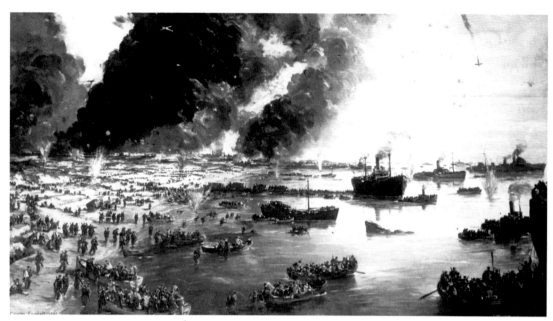

above A painting of the evacuation of Dunkirk in May 1940. Lifeboats were used to bring off many soldiers despite being continuously shelled. Coxswains Harold Knight of Ramsgate and Edward Parker of Margate were both awarded Distinguished Service Medals for their role in saving hundreds of men. (By courtesy of the RNLI)

below Margate lifeboat Lord Southborough (Civil Service No.1) (ON.688) landing twenty-three of the crew of the oil tanker San Calisto, of London, which was sunk by enemy action on 2 December 1939. (By courtesy of the RNLI)

During the Second World War the lifeboats of south-east England were in the firing line. When war broke out, the forecast that lifeboats would be in great demand soon proved to be the case. And the difficult conditions of war added to the dangers faced by the volunteers. Most aids to navigation, such as lighthouses, buoys and harbour lights, were switched off, and so launching lifeboats down slipways or across beaches at night had to be accomplished in total darkness.

When at sea, it was not unknown for lifeboats to come under enemy fire, while the crews also had to be wary of mines. Away from the coast, enemy air attacks disrupted the systems of communication on which the provision of spare parts and equipment for lifeboats depended. Shortly before the war broke out a new supply and repair depot had been completed at Boreham Wood and this became the RNLI's administrative HQ during the war.

The evacuation of Dunkirk in May 1940 was a severe test for all involved, with lifeboats playing a particularly significant role in Operation Dynamo, helping to bring soldiers from the beaches and in the process writing one of the more notable stories in the history of the RNLI. The operation began on 26 May 1940, and four days later the Ministry of Shipping contacted the RNLI requesting that as many lifeboats as possible be sent to Dover. This culminated in no fewer than nineteen lifeboats being sent, from Poole to Gorleston, with all going across the Channel to rescue the British Expeditionary Force soldiers.

Wartime service

The majority of the lifeboats which went to Dunkirk were manned by naval ratings, but the Ramsgate and Margate boats were taken across the Channel to France by their crews. The Ramsgate lifeboat towed eight small boats carrying evacuated soldiers, while the Margate boat was itself towed across by a Dutch barge on a hazardous fifty-mile trip that involved avoiding mines and dodging German bullets.

The Ramsgate lifeboat *Prudential*, under the command of Coxswain Howard Primrose Knight, spent thirty hours taking men off the beaches, using shallow-bottomed wherries to convey the men from beach to lifeboat, and thence to larger vessels lying further out. In all, the Ramsgate boat brought off about 2,800 men.

Although lifeboats proved invaluable at Dunkirk, not all came back unscathed. Indeed, the Hythe boat *The Viscountess Wakefield* (ON.783) was lost on the beaches. She was run onto the sands, and was too heavy to get off, so was left behind. The Hythe Coxswain had predicted this would happen, and, having failed to gain assurances from the naval authorities about pensions for the lifeboatmen's families should they not return, he was sent home. The Hythe station was subsequently closed and the Coxswain and Mechanic were dismissed from the lifeboat service.

In the aftermath of Dunkirk, the lifeboats returned to their stations in varying states of repair. The Walmer boat, *Charles Dibdin (Civil Service No.2)* (ON.762), had been badly damaged and so, as most of the town's population had been moved from their homes, the lifeboat station was closed, not to be reopened until the following spring. Operations elsewhere also proved difficult, and at Southwold a permanent loom of floats and chains was placed across the harbour in 1940; the lifeboat station had to be closed, and it did not reopen.

Other lifeboat stations were affected when gaps were blown in the middle

Medal winners

DOVER • Silver medal awarded to Coxswain Colin H. Bryant, and Bronze medal to three other members of the crew, for the rescue of sixteen men from HM trawler Blackburn Rovers on 26 November 1939 which was on an anti-submarine patrol off Dover, had dropped her anchor and had drifted into the minefield. It was a very gallant service carried out in the face of imminent peril, of which all were aware but against which nothing could be done. Lt Richard Walker RNR, Assistant King's Harbour Master, was also awarded the Bronze medal.

below Having been away from her Clacton station for more than three months, Edward Z. Dresden (ON.707) returns to the boathouse on 13 November 1940. She was moored at Brightlingsea after the lifeboat house had become unusable because a gap had been blown in the pier as an anti-invasion measure. (By courtesy of the RNLI)

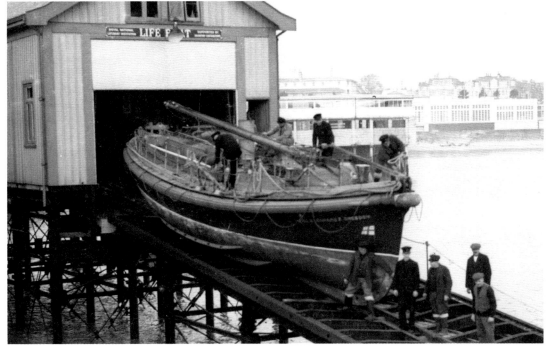

Wartime service

above right Three of the Margate lifeboatmen who took part in the Dunkirk evacuation: Coxswain Edward Drake Parker (centre), with his sons James on his right and Edward.

above left Ramsgate Coxswain Howard Primrose Knight, displaying his medals and official hat, commanded the Ramsgate lifeboat to Dunkirk in 1940. (By courtesy of the RNLI)

below The former Lowestoft lifeboat Agnes Cross (ON.663), built in 1921, served temporarily at Dover during the Second World War.

of piers to prevent enemy landings, cutting off crews from the boathouses. At Cromer a drawbridge was made across the gap. At Clacton the gap was blown in the pier without warning, with the lifeboat still in the boathouse. More damage was done than by a German mine which had exploded under the pier a few months earlier, and the lifeboat had to be moved to Brightlingsea harbour five miles away. Similar changes had to be made at Walton, where the lifeboat was moved to a creek after the pier was broken, preventing access to the station's boarding boat.

The situation at Margate was somewhat better, however, as the gap blown in the pier was to the seaward side of the boathouse so the lifeboat remained operational. And this was fortunate as Margate was one of the busiest lifeboats during the Battle of Britain. This lasted officially from 8 August to 31 October 1940, during which time there were 264 operational launches, of which 131 were concerned with aircraft. A Margate lifeboat also had the distinction of saving Richard Hillary, the pilot of a British craft, who was rescued on 3 September, notable by being a descendant of Sir W. Hillary, Founder of the RNLI.

During the summer of 1940, when invasion was imminent, lifeboat crews were instructed how to destroy their boats should the Germans land, and thus prevent them from falling into enemy hands. Fortunately these plans never had to be used and the defences that were built were never assaulted.

Part of the defences consisted of landmines, but because so many were laid their locations became uncertain. At Dungeness sappers found that mines were too dangerous and blew up fifty at once in an explosion which lifted the roof off the lifeboat house, shattered windows and broke the petrol tank.

On a number of occasions lifeboats came under enemy fire. The former Lowestoft lifeboat *Agnes Cross*, which had been transferred into the Reserve fleet, was stationed at Dover during the war and went over to Dunkirk where she rescued over fifty lives. She was also at Dover during the Battle of Britain and was damaged by splinters from bombs and shells. The day after the battle she left for Lowestoft to be repaired, but on passage through the Dover Straits she came under fire from the German guns at Calais. She was bombed off Broadstairs and spent the night at Margate. Heavy air raids while she was at Margate resulted in the pier

Wartime service

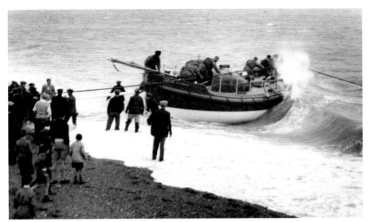

at which she was moored being sprayed with bullets by German aeroplanes. She sailed north that day behind a convoy which was bombed, but she survived and reached Lowestoft.

Despite the difficulties of war making the lifeboat crews' work more difficult, some outstanding rescues were carried out by the volunteers, with the exploits of the Cromer lifeboat crew under the command of Coxswain Henry Blogg being of particular note. The deeds of Coxswain Blogg and his extraordinary feats of life-saving made him one of the most famous lifeboatmen of all time.

One of the most outstanding of the wartime rescues by Coxswain Blogg and the crew of the Cromer lifeboat was undertaken on 5 August 1941 when the lifeboat *H.F. Bailey* (ON.777) was launched to Convoy 559, which was making its way down the east coast through a north-north-westerly gale. Six of the steamers in the convoy were driven onto the Haisborough Sands, and became stranded. They were in a desperate state when, in a series of daring rescues, Coxswain Blogg took his lifeboat alongside the wrecks and saved a total of thirty-one men.

In October 1941 Blogg undertook another incredible rescue using *H.F. Bailey*. She was launched to the steamship *English Trader*, which was wrecked on the Hammond's Knoll

sandbank. Several attempts to save the steamer's crew had already failed, and during one of these attempts the lifeboat had almost capsized. But a further attempt, on 27 October 1941, by Blogg and his Cromer crew saw the forty-four survivors on board the steamer being rescued and taken to Great Yarmouth. For this truly remarkable rescue Coxswain Blogg was awarded the Silver medal.

The exploits of the east coast lifeboat crews during the Second World War, and the Cromer boat in particular, were remarkable, and the RNLI sought to exploit Blogg's fame where possible for publicity purposes. He was involved in making six radio broadcasts during the war, undoubtedly helping the cause.

above left The Hythe lifeboat The Viscountess (ON.783), which never made it back from Dunkirk.

above Cromer lifeboat H.F. Bailey (ON.777) at Robinson's Yard, Oulton Broad, for repairs following the service to Convoy 559 in August 1941. During the service, she was severely damaged, having twice been driven over the sunken decks of the steamers, bumped severely on the sands, and at one point been run aground.

Medal winners

CROMER • 6 August 1941 • Convoy 559 and steamship Taara; Gold medal and British Empire Medal to Coxswain Henry Blogg; Silver medal to Second Coxswain J. J. Davies; Bronze medals to Mechanic Henry W. Davies; Thanks on Vellum to J. W. Davies, W. T. Davies snr, Henry T. 'Shrimp' Davies, J. R. Davies, Charles Cox, S. C. Harrison, Edward W. Allen, J. J. Davies jnr, W. H. 'Pimpo' Davies, R. C. Davies, George Cox, Charlie Brakenbury, Lewis B. Harrison. Bronze medals to No.2 Second Coxswain Leslie Harrison and Mechanic H. Linder.

CROMER • 26 October 1941 • Steamship English Trader, of London, saved forty-four. Silver medal to Coxswain Henry Blogg; Bronze medals to Second Coxswain John Davies, snr, Mechanic H. W. Davies, Second Mechanic James Davies, Bowman William Davies, John Davies, jnr, Sydney Harrison, Signalman Henry T. Davies, William Davies, Robert Davies, James Davies; Signalman Edward Allen was posthumously awarded Bronze medal.

left Coxswain Henry Blogg of Cromer was awarded the RNLI's Gold medal three times and the Silver medal four times in an extraordinary life-saving career.

35

Rebuilding after 1945

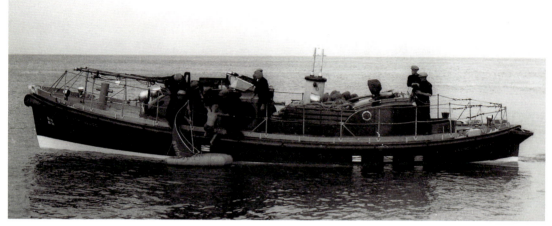

above The 46ft Watson cabin motor lifeboat Henry Blogg (ON.840) at Cromer. She was built in 1945 and was originally allocated to Douglas, coming to Cromer initially on a temporary basis only. This photo shows her crew pulling a boy from his dinghy in a flat clam sea. The 'rescue' was filmed on 9 August 1950, and shows David Tibble, nephew of Coxswain 'Shrimp' Davies, being taken on board the lifeboat. The footage was included in a film called Gale Warning which was shown at Cromer's Regal Cinema on 11 August 1952. (Port of Lowestoft Research Society)

below The RNLI's storeyard and depot at Boreham Wood, near Elstree, Hertfordshire was built in 1939–40. (From an old postcard supplied by John Harrop)

During the Second World War lifeboat construction and development more or less stopped. So after 1945 the need to build new lifeboats was considerable. Embarking upon a building programme for new boats, all of which had twin engines and twin propellers, the RNLI shared the optimism for a better and brighter future that swept the nation in the immediate post-war years. Many new boats were built, the pulling and sailing lifeboat was soon phased out, and a new chapter in the RNLI's history began.

The first new lifeboat in East Anglia was a 46ft Watson twin-screw type which was sent to Cromer initially on trials having been allocated to Douglas in the Isle of Man. Named *Millie Walton* (ON.840), the new boat arrived from on 20 December 1945 and, after a series of tests and practice runs, was hauled up the slipway and housed. She was the first lifeboat with a midship steering position and one of only two 46ft Watsons with two cockpits.

Although the boat had been named after her donor, when she got to Cromer to be tested the crew and Coxswain Blogg liked her so much that she was allocated to the station permanently. The RNLI then allocated general funds to pay for the boat so that she could be renamed *Henry Blogg* in honour of the town's most famous lifeboatmen.

At Wells the first of the new twin-engined 35ft 6in Liverpool class lifeboats was placed on station in July 1945, being one of only a handful of lifeboats to be built during the war years. Named *Cecil Paine* (ON.850), she was designed to be beach launched and was thus of relatively light construction, weighing just over seven tons. She was launched by a motor tractor, which had taken over from horses for launching lifeboats across beaches prior to 1939.

Elsewhere, during the summer of 1951 the Festival of Britain was held in London, organised by the government to give the country a feeling of recovery

Rebuilding after 1945

below Naming of the new 46ft 9in Watson lifeboat North Foreland (Civil Service No.11) (ON.888) at Margate on 17 May 1951 by HRH The Duchess of Kent. (By courtesy of the RNLI)

Medal winners

WALMER • 2–4 January 1948 • Silver medal awarded to Coxswain Frederick Upton and Bronze medal to Mechanic Cecil Cavell for rescuing thirty men, including two stowaways, and a dog from the steamer Silvia Onorato aground on the Goodwin Sands. The lifeboat spent forty-five hours at sea. The Maud Smith Award for the bravest act of lifesaving in 1948 was presented to Coxswain Upton.

WALMER • 13–14 January 1952 • Silver medal awarded to Coxswain Frederick Upton and Bronze medal to Mechanic Cecil Cavell for rescuing thirty-eight men from the wreck of the French steamer Agen that was aground on the South Goodwin bank, close to three other wrecks from which the Walmer lifeboat had rescued 115 people over the previous six years.

DOVER • 27 September 1951 • Bronze medal to Coxswain John Walker for the rescue of a man from the Dutch yacht Akeco that had dragged its anchor. In confused, violent and dangerous seas the lifeboat reached the yacht to find her little more than 100 yards from the cliffs, broadside on to wind and sea.

in the aftermath of war while also promoting British contributions to science, technology, industrial design, architecture and the arts. The RNLI played a prominent part by exhibiting the new Clacton lifeboat *Sir Godfrey Baring* (ON.887), a 46ft 9in Watson motor type and one of the new twin-screw designs being built as the lifeboat fleet was renewed. *Sir Godfrey Baring* reached her station in January 1952 and two months later a sister vessel, *North Foreland (Civil Service No.11)* (ON.888), was placed in service at Margate.

Meanwhile a lifeboat almost twenty years old, *Charles Dibdin (Civil Service No.2)* (ON.762), was involved in a dramatic rescue from the Goodwin Sands. Just after 11 p.m. on 13 January 1952 she was launched from her Walmer station under the command of Coxswain Frederick Upton to a ship aground on the South Goodwin Bank. The lifeboat and her crew, facing a south-westerly gale which brought stinging rain, spent more than two hours searching for the casualty, the French ship *Agen*, of La Rochelle, with a crew of thirty-eight.

She had gone aground and had already broken in two by the time the lifeboat arrived, with all the crew gathered on the forward part. Coxswain Upton decided to wait until conditions had improved, so the lifeboat stood by for several hours until just after 6 a.m., when she was taken between the two parts of the ship to rescue everyone but the master. Only one person was injured during the rescue, which was remarkable considering the state of the sea. The lifeboat landed the survivors and then returned to the ship so that Upton could persuade the captain to be taken off. Upton was awarded the Silver medal for this rescue and Percy Cavell, the mechanic, a Bronze.

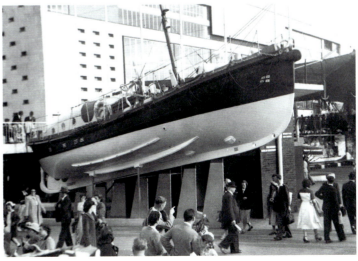

below The new 46ft 9in Watson class lifeboat Sir Godfrey Baring (ON.887) for Clacton-on-Sea on display at the South Bank Exhibition, Festival of Britain in 1951.

37

Rebuilding after 1945

right An unusual photograph showing two 46ft 9in Watson motor lifeboats together in Ramsgate harbour. In the foreground is the Margate boat North Foreland (Civil Service No.11), built in 1951, while at her moorings is Michael and Lily Davis (ON.901), which was built in 1953 and served at Ramsgate for twenty-three years, achieving a remarkable record of service by saving more than 300 lives.

Medal winners

DUNGENESS • 29–30 July 1956 • Bronze medal awarded to Coxswain George Tart for the rescue of the crew of nine of the motor vessel Teeswoo. When the lifeboat arrived at the scene the vessel had capsized and the men were rescued from the water in hurricane-force winds gusting to eighty knots.

SHERINGHAM • 31 October 1956 • Silver medal awarded to Coxswain Henry West and Bronze medal to Motor Mechanic Edward Craske for rescuing eighteen men from the steamer Wimbledon. Coxswain West was one of the first two members of a lifeboat crew to receive a gift from the James Michael Bower Endowment Fund, established in 1955.

below 37ft Oakley lifeboat The Manchester Unity of Oddfellows (ON.960) served at Sheringham from 1961 to 1990. Pictured leaving Gorleston on passage to station on 12 June 1962 with no operational number of her engine casing, she was the third of the Oakleys to enter service. They achieved their self-righting ability through a water ballast transfer system and righting tanks.

During the following summer the BBC broadcaster Richard Dimbleby went out with Upton on an exercise and a few months later spoke in favour of the RNLI in 'The Week's Good Cause'. This raised more than £3,300 with the appeal receiving donations from almost 4,000 different people, and significantly raised the profile of the RNLI.

In January 1953 the lifeboats all along the east coast were impacted by the disastrous floods which hit much of the east coast of England and Scotland. Over 300 people lost their lives either through these floods or in the accompanying storms, and fourteen lifeboat stations in England were damaged. In Essex the lifeboats at Southend and Clacton provided help to many marooned people, with the Southend lifeboat Greater London (Civil Service No.3) (ON.704) being called out seven times and spending more than twenty-six hours at sea.

Most of the stations in East Anglia, Essex and Kent continued to operate their pre-1939-built lifeboats well into the 1950s, and the number of new lifeboats built for service in the area at this time was relatively small. But one of the new 37ft Oakleys was sent to Sheringham in Norfolk in 1961 and this new type was significant because it represented a step forward in lifeboat design. The Oakley, named after its designer Richard Oakley, was the first lifeboat design to have a high degree of inherent stability and also to be self-righting in the event of a capsize.

Oakleys were stationed at Caister, Cromer No.2, Wells and Clacton, although the careers of the former two were short-lived. The Cromer No.2 station was closed in July 1967 and the Caister station in October 1969.

Past and present ALDEBURGH

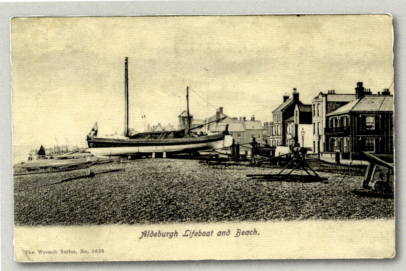

left The large 46ft Norfolk & Suffolk type sailing lifeboat City of Winchester (ON.482) on the shingle beach during the early years of the twentieth century. This site has been used for the lifeboats for more than a century. The residential buildings on the right can also be seen in the bottom photograph. (From an old postcard supplied by John Harrop)

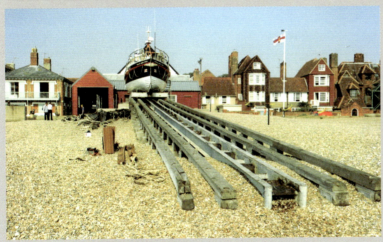

left A turntable and partial slipway across the beach were built for the motor lifeboats, the first of which came on station in 1930. The small wooden slipway was built in the early 1960s to improve launching. Between 1905 and 1959 two lifeboats were on station, kept at the head of the beach next to each other. The last lifeboat to be launched across the beach was the 37ft 6in Rother type James Cable (ON.1068), pictured here. (Nicholas Leach)

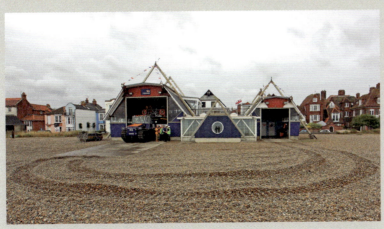

left When the station was changed to carriage launching in the early 1990s, a new lifeboat house was built on the same site as the cradle, turntable and slipway, all of which were removed. The new lifeboat station, consisting of two buildings, was completed in 1993 and featured external stainless steal A-frames from which the houses were hung. (Nicholas Leach)

Past and present CROMER

above The lifeboat house, built in 1923 at the end of Cromer's famous pier, was used until 1996; it was subsequently moved to Southwold, where it was used as a lifeboat museum with the former Southwold lifeboat Alfred Corry (ON.353) as its centrepiece. From this boathouse, the Watson motor lifeboat H.F. Bailey (ON.777) launched to undertake some of the most famous rescues in the annals of the RNLI under the command of the legendary Coxswain Henry Blogg.

below The 1923 lifeboat house was removed in 1996 and replaced on the same site by a new and larger structure, intended eventually for a new 16m Tamar lifeboat but built to accommodate the station's existing 47ft Tyne Ruby and Arthur Reed II (ON.1097). Construction work took place during 1997 and 1998 and proved to be a long and complicated process. The first slipway launch took place on 17 October 1998, using relief 47ft Tyne Sam and Joan Woods (ON.1075), and the boathouse was declared operational on 4 March 1999, which coincided with the 175th anniversary of the RNLI's founding.

Inshore lifeboats

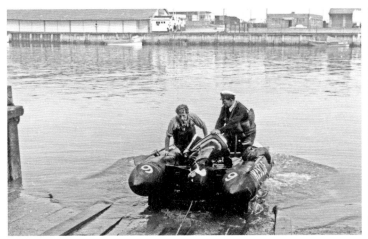

left Gorleston's first inshore rescue boat (IRB), No.9, launching on exercise down the slipway from one of the two boathouses built originally for the station's pulling and sailing lifeboats. Gorleston was one of the first ten places to operate an inflatable IRB in 1963. (Jeff Morris)

above The ILBs at Gorleston were kept in the boathouse and No.26 is pictured on the trolley used to launch them down the slipway into the river in June 1968. (Grahame Farr)

below The experimental Atlantic 17 ILB B-6 at Wells for three weeks of evaluation trials in June 1972 to enable the crew to assess the suitability of this type of boat for rescue work. The Atlantic 17, which was 16ft 6in in length and 6ft 10in in beam, was a new type of ILB with a fixed wooden hull with sponsons. It was only used on a trial basis as the larger Atlantic 21 proved to be more suitable and was adopted by the RNLI. Wells never received an Atlantic for operational service, but one was sent to the neighbouring Hunstanton station in the early 1980s. (EDP, supplied by Paul Russell)

One of the more significant developments in lifeboat provision came during the 1960s with the development of the inshore rescue boat (IRB), or, as it later became known, the inshore lifeboat (ILB). The first ILBs were introduced in England and Wales during the summer of 1963, when ten were sent to various stations. Such was their success that in each of the subsequent years more and more places began to operate the boats. By 1966 the number of ILBs had risen to seventy-two, of which thirty-two remained on station throughout the year, the rest operating only during the summer.

The early ILBs were rudimentary inflatable boats with outboard engines. They could be launched quickly and were ideally suited for work inshore helping people cut off by the tide, stranded on rocks or swimmers blown out to sea. But they were soon improved and more equipment was added, including VHF radio, flexible fuel tanks, flares, an anchor, a spare propeller and first aid kit. The ILB's advantage over the conventional lifeboat was its speed which, at twenty knots, was considerably faster than any lifeboat in service in the 1960s. Many existing stations received ILBs, while several new stations were opened to operate the new kind of rescue craft.

Stations in East Anglia and the south-east of England were among the first to receive ILBs. Wells, which already operated a carriage-launched Liverpool – top speed eight knots – was supplied with an early D class inflatable in 1963, and Southwold became the first former lifeboat station to be reopened with an ILB when it received one in 1963. At Whitstable in Kent a new station was established, also in 1963, with further ILBs going to West Mersea and Burnham-on-Crouch to cover the estuaries of Essex, where dinghy sailing was a popular pastime.

The Great Yarmouth & Gorleston station also received an ILB in 1963, to cover the busy holiday beaches along

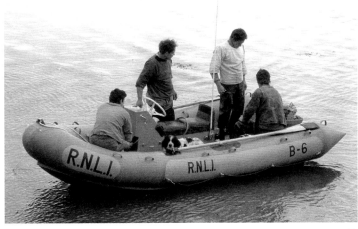

Inshore lifeboats

right One of the experimental inshore lifeboats, X2, developed during the early 1970s. This was an early type of Atlantic 21, built at Atlantic College, and was trialled at Gorleston among other places. (By courtesy of the RNLI)

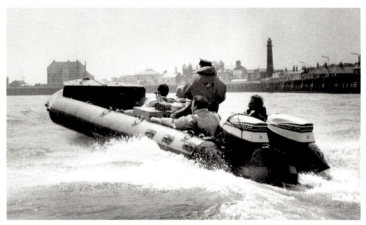

above 18ft 6in McLachlan class ILB A-510 at Ramsgate. The McLachlan was an unusual design of lifeboat of which only ten were built. A-510 served at Ramsgate from 1975 to 1984. (Ray Noble)

below The Atlantic 21 inshore lifeboat B-516 at Whitstable, which was funded by the Kensington and Whitstable branches and served the station for nine years. The volunteer crew used this boat to undertake hundreds of rescues, including two for the which the RNLI accorded the crews the Thanks Inscribed on Vellum. (By courtesy of the RNLI)

the Norfolk coast, and during the 1960s the station hosted several experimental inshore lifeboats. Other ILBs in Norfolk were stationed at Happisburgh, where a new station was opened, and Cromer, where the No.2 lifeboat was withdrawn.

The D class inflatables were, and still are, hugely successful and carry out many rescues every year. However, by the late 1960s a larger ILB was deemed necessary, capable of night operation and with a greater range. After various different designs had been tested, a rigid-inflatable developed at Atlantic College in South Wales was found to be the most suitable. The boat had a rigid wooden hull with inflatable sponsons, which gave great stability. The twin outboard engines enabled a speed of over thirty knots to be achieved.

Designated the Atlantic 21, the new design was developed and refined by the RNLI, and in 1972 the first of the class went on station. The first Atlantic 21 in the South East, B-506, was sent to West Mersea in 1972, and another went to Whitstable in 1974. At Southwold, where one of the first inflatable inshore rescue boats had been sent in 1963, the station was upgraded in 1973 with an

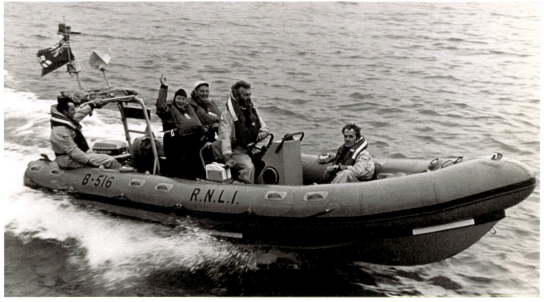

Inshore lifeboats

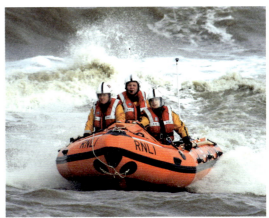

Atlantic 21, B-518 *Solebay*, as inshore rescue coverage continued to improve.

The Atlantic design has proved its worth on many occasions, and the volunteer crews have used skill and expertise to undertake rescues working at the limits of the boat's capabilities. On 25 February 1977 the Whitstable Atlantic saved three crew from the motor fishing vessel *RX216* which had run out of fuel and was dragging its anchor towards the Street Bank in a north-easterly gale and a rough sea. For his efforts, Helmsman David Victor was accorded the Thanks of the Institution on Vellum for this fine rescue.

Vellum services using the Atlantic 21 at West Mersea were also undertaken in the late 1970s. On 31 July 1978 Helmsman Graham Knott showed skill and seamanship to save four crew from the sloop *Blackbird*, which was aground at Sales Point in a north-easterly gale and rough seas. The following year, on 26 May 1979, at the same station the Thanks of the Institution on Vellum were accorded to Helmsman James Clarke and crew member Jonathan French for their assistance to ten small craft in difficulties in the River Blackwater estuary in a southerly storm and steep breaking seas. French jumped into the sea to search under one of the craft to see if anyone had been trapped.

An even more daring rescue was carried out in the Atlantic 21 at Southwold on 19 March 1981. In gale-force winds and confused seas the

above left The Avon EA16 type inshore lifeboat D-362 Kensington Rescuer on exercise off Sheerness. (Nicholas Leach)

above right One of the first of the IB1 type inflatable inshore lifeboats D-607 Spirit of Berkhamsted running down the surf line at Happisburgh during crew training off the Norfolk coast.

below The unusual sight of four inshore lifeboats together at Walmer in December 2006, as new Atlantic 85 and D class ILBs are sent to the station to replace older ILBs. Pictured, left to right, are D-663 Duggie Rodbard, D-514 Lord Kitchener, Atlantic 85 B-808 Donald Mcloughlan and Atlantic 21 B-589 James Burgess.

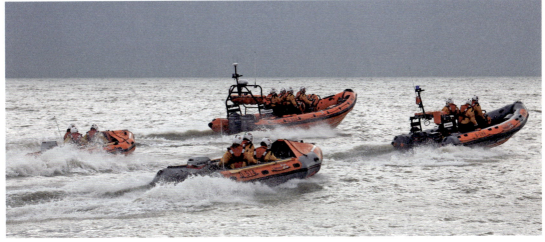

Inshore lifeboats

Inshore lifeboat stations

Opened	Station	D class	B class (Atlantic)
1963	Gorleston	1963–75	1975–
1963	Wells	1963–	
1963	Southwold	1963–73	1973–
1963	West Mersea	1963–72	1972–
1963	Whitstable	1963–74	1974–
1964	Walmer	1964–	1990–
1965	Happisburgh	1965–	2009–
1965	Southend-on-Sea	1965–	1976–
1966	Clacton-on-Sea	1966–	1984–
1966	Burnham-on-Crouch	1966–	1996–
1966	Margate	1966–	

Opened	Station	D class	B class (Atlantic)
1966	Littlestone	1966–72	1972–
1967	Cromer	1967–	
1967	Harwich	1965–78	1978–
1969	Ramsgate*		1984–
1971	Varne Lightvessel	1971–72	
1971	Sheerness	1971–	
1977	Aldeburgh	1977–	
1979	Hunstanton	1979–81	1981–
1986	Sheringham	1986–86	1992–
2001	South Broads	2001–11	

*Operated A class rigid-hulled ILBs 1969–84

Medal winners

SOUTHWOLD • 6 February 1972 • Bronze medals to crew members Patrick Pile and Martin Helmer for rescuing three people from a capsized motor dinghy in strong winds and heavy seas using the D class inflatable ILB.

SOUTHWOLD • 16 January 1981 • Bronze medal to Helmsman Roger Trigg, the Thanks on Vellum accorded to crew member Jonathan Adnams and Anthony Chambers and medal service certificates to crew members Nicholas Westwood and Steven Taylor for the service to the fishing vessel Concord.

below Atlantic 75 Leslie Tranmer (B-750) and Atlantic 85 Annie Tranmer (B-868) leaving the harbour at Southwold as the latter took over from the former in May 2013. Both boats were funded by the Annie Tranmer Charitable Trust.

lifeboat pulled the grounded fishing vessel Concord clear, and then escorted the vessel as she was towed by another fishing vessel to Lowestoft. The Bronze medal was awarded to Helmsman Roger Trigg for this service, and the Thanks Inscribed on Vellum were accorded to crew Jonathan Adnams and to the skipper of the fishing vessel Broadside, Anthony Chambers.

The benefits of the Atlantic 21 were more than evident even before the services at Whitstable, West Mersea and Southwold, and the importance to the RNLI of the fast rigid-inflatable boats cannot be understated. This was further demonstrated during the 1990s when a slightly bigger version of the Atlantic was developed, known as the Atlantic 75, which had greater speed, as well as water ballast tanks fitted so it could tackle bigger seas.

The Atlantic 85 was developed during the early years of the twenty-first century, and one of the first boats of this type went to the important station at Walmer to cover the Goodwin Sands. The 85 was larger still – 8.3m in length – with seating for a fourth crew member as well as carrying more electronic equipment, including a radar and VHF direction finder. At a number of stations two inshore lifeboats are operated, with Southend-on-Sea having three ILBs to meet demand at what is one of the country's busiest stations.

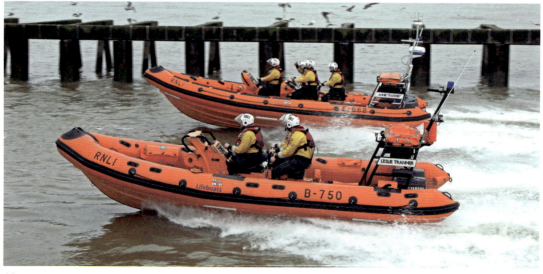

The modern era

right The 44ft Waveney Khami (ON.1002) was the second of the type to be built by the RNLI, and is pictured at the Lowestoft builder's yard of Brooke Marine where she was built. Brooke Marine built the first six of the steel-hulled 44ft boats, which were subsequently given the class name Waveney after the river which flows near Lowestoft. (Jeff Morris)

below The 35ft 6in Liverpool Cecil Paine (ON.850) outside the boathouse at Wells, the station she served for twenty years. The Liverpool and Watson types were the mainstay of the RNLI fleet in the immediate post-war years.

With the newly introduced **fast inflatable inshore lifeboats** proving their worth during the 1960s, the RNLI began to develop faster all-weather lifeboats. In developing the new designs, the RNLI built a number of interesting and unusual boats, many of which saw service at stations in the south-east of England, as the demands on the lifeboat service were increasing and every year more and more launches and rescues were being undertaken.

The RNLI recognised that the boats not only needed to be faster, but they also needed to be safer, as a series of capsizes during the 1950s and 1960s resulted in tragic loss of life of volunteer crewmen and led to questions being asked about whether the RNLI was providing the best possible lifeboats for its crews.

In 1963, the year the first inshore rescue boat became operational, there were fourteen offshore lifeboat stations in Norfolk, Suffolk, Kent and Essex and five inshore stations. The offshore stations were operating the following lifeboats: three 35ft 6in Liverpools, one 37ft Oakley, two 46ft Watsons, five 46ft 9in Watsons, one 47ft Watson, three 42ft Beach boats and one 51ft Barnett. Fine, well-built lifeboats they might have been, but all were based on nineteenth-century hull designs, none had a speed greater than nine knots and none was inherently self-righting.

To meet the changing demands being made on the service and lifeboat crews, new boats were needed and the first steps at modernising the lifeboat fleet came in the 1960s. In 1963 a 44ft steel-hulled lifeboat was purchased from the United States Coast Guard (USCG) for trials. This boat, self-righting by virtue of its watertight wheelhouse, was faster than and completely different from the conventional lifeboats then in service.

The USCG boat, designated 44-001 by the RNLI, was taken on a tour of stations throughout the United Kingdom and Ireland to assess its

below 37ft 6in Rother lifeboat Silver Jubilee (Civil Service No.38) (ON.1046) launching at Margate. The Rother was the last traditional lifeboat design to see service with the RNLI. In the South East, Rothers served at Aldeburgh and Dungeness as well as Margate. (By courtesy of the RNLI)

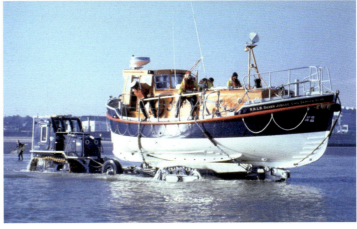

The modern era

above The 40ft Keith Nelson intermediate type lifeboat Ernest William and Elizabeth Ellen Hinde (ON.1017) pictured at Sheerness in 1969, where she spent several months on evaluation trials.

Medal winners

LOWESTOFT • 13 April 1974 • Bronze medal to Coxswain Mechanic Thomas Knott in recognition of his courage, seamanship and skill when the lifeboat saved the yacht Sarina and her crew of four. The yacht was dragging her anchor cable in a north-easterly gale and very rough seas. Bronze medal also to Second Coxswain Peter Gibbons in recognition of his courage and judgment in boarding the yacht.

GREAT YARMOUTH & GORLESTON • 22 December 1979 • Bronze medal to Coxswain Mechanic Richard Hawkins in recognition of his courage and seamanship when saving the crew of two of the fishing vessel St Margaret, which had stranded on Scroby Sands in a strong north-easterly wind and steep seas.

DOVER • 16 October 1987 • Silver medal to Acting Coxswain Roy Couzens and Bronze medals awarded to Acting Assistant Mechanic and Emergency Coxswain Michael Abbott, and crew members Geoffrey Buckland, Dominic McHugh, Christopher Ryan, Robert Bruce and Eric Tanner in recognition of their courage and determination in rescuing three people from the motor vessel Sumnia, which sunk in the western entrance to Dover Harbour in a south-south-westerly hurricane and massive seas.

left The 50ft Thames lifeboat Rotary Service (ON.1031) on service at Dover. She was one of only two Thames class lifeboats to be built for the RNLI. (Jeff Morris)

suitability for operations in British waters. The reaction of lifeboat crews was so positive that the RNLI ordered six of the new type to be built, with various modifications for service in UK water. It was given the class name Waveney and three of the initial batch of six went to the stations at Great Yarmouth & Gorleston, Harwich and Dover. At both Gorleston and Dover the boats were used to undertake a number of fine medal-winning services.

In total, the RNLI had twenty-two Waveneys built, and two more went to the Kent stations of Sheerness, where a new station had been established to cover the River Medway and the Thames Estuary, and the busy station at Ramsgate, where she operated alongside an Atlantic 21.

By the end of the 1960s, following the success of the Waveneys, the RNLI was investigating other designs of fast lifeboat and during the early 1970s two new types were developed: the Arun and Thames classes. The Arun, at 52ft, was larger than the Waveney and was also faster, being capable of speeds approaching twenty knots. It had a fully enclosed wheelhouse which provided an inherent self-righting capability, and carried a small Y class inflatable on its wheelhouse roof. In the South East, Aruns served only in a relief capacity, at Harwich and Dover.

The 50ft Thames class was developed at the same time, but only two were built. However, the first of these, Rotary Service (ON.1031), spent most of her career at Dover. She proved to be a fine lifeboat, was well liked by the crew there and undertook 454 services during her seventeen years on station.

In its quest for greater speed, the RNLI also examined a commercial hull developed by Keith Nelson. Moulded of glass reinforced plastic (GRP) by Halmatic Ltd, Havant, the 40ft boat was used to test whether a standard GRP hull could withstand the conditions often faced by lifeboats and enabled the RNLI to assess its possibilities for

The modern era

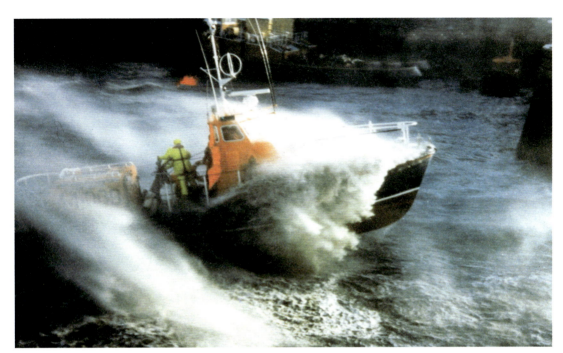

future lifeboat construction. The boat was the first RNLI lifeboat to be built of GRP and underwent operational evaluation at Sheerness. The intention was to find a lifeboat as seaworthy as conventional lifeboats but faster and, by using GRP in the construction, produced at substantially lower cost.

The relatively young Sheerness station has gone from strength to strength since its establishment in 1970 and the 44ft Waveney, *Helen Turnbull* (ON.1027), on duty from 1974 to 1996, was involved in some remarkable rescues during her time there. In March 1980 she went to the aid of the sinking radio ship *Mi Amigo* and was manoeuvred alongside by Coxswain Charles Bowry thirteen times in a north-easterly gale and very rough seas to save the four crew on the ship.

In October 1987 she was launched at the height of the infamous hurricane that swept southern England causing widespread damage, facing ninety-mile-an-hour winds and violent seas when searching for a small angling boat. The boat was found and its two occupants saved, at which point the lifeboat grounded on a sandbank and, undamaged, remained there for several hours before being refloated. On both services, the excellence of the Waveney's design proved itself to be a match for the worst of weathers and her volunteer crew demonstrated considerable courage and tenacity.

The development of the Waveney, Thames and Arun lifeboats represented

above In hurricane-force winds, the 44ft Waveney Helen Turnbull (ON.1027) sets out from Sheerness on service in October 1987 to help an angling boat. Coxswain Robin Castle was awarded the Bronze medal for the service to a small angling boat. (By courtesy of the RNLI)

below Into the modern era at Lowestoft: the then new 47ft Tyne Spirit of Lowestoft is named on 26 May 1988 by HRH The Duke of Kent, with Gorleston lifeboat Barham (ON.1068) in attendance. (By courtesy of the RNLI)

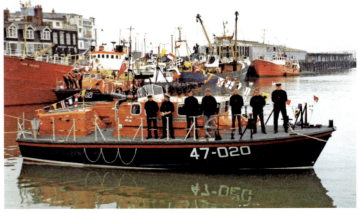

The modern era

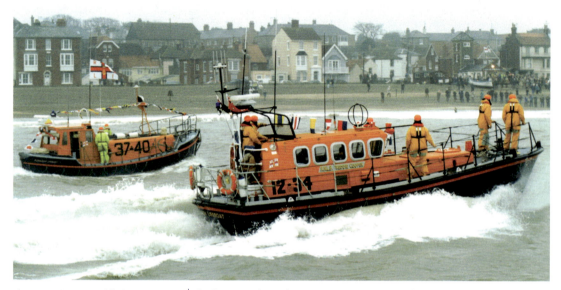

above 12m Mersey Freddie Cooper (ON.1193) arrives at Aldeburgh on 30 November 1993, escorted by 37ft 6in Rother James Cable (ON.1068), the last nine-knot lifeboat in RNLI service.

Medal winners

SHEERNESS • 19 March 1980 • Silver medal awarded to Coxswain/Mechanic Charles Bowry for the rescue of the crew of four from the radio ship Mi Amigo, which was sinking near the Long Sand bank. The Thanks of the Institution on Vellum was accorded to Second Coxswain Arthur Lukey, Assistant Mechanic Roderick Underhill and crew members Malcolm Keen, Ian McCourt and William Edwards.

SHEERNESS • 16 October 1987 • Bronze medal awarded to Coxswain Robin Castle for saving the two occupants of a 16ft day boat in south-westerly winds in excess of ninety knots and rough confused seas off the Yantlet Flats. Second Coxswain Dennis Bailey and Richard Rogers were accorded the Thanks inscribed on Vellum for their part in the service.

right 12m Mersey Doris M. Mann of Ampthill (ON.1161) on exercise at Wells; she was one of the first of the Mersey class lifeboats to enter service. At Wells she is often taken on her carriage a mile or more across the sands to reach a launch site, or when being recovered the dedicated shore crew have to travel similar distances to bring her back after a service.

the first part of a modernisation programme undertaken by the RNLI. It continued in the 1980s with the introduction of two new types: the 47ft Tyne and 12m Mersey types, intended for stations which practised slipway and carriage launching respectively. One of the first Tynes was stationed at the key station of Cromer, where it was launched down the slipway at the end of the pier, while further Tynes were built for Lowestoft and Ramsgate (later going to Walton & Frinton).

One of the first 12m Merseys to be built was stationed at Wells, with one of the last going to Aldeburgh. In fact, when the 12m Mersey *Freddie Cooper* arrived at Aldeburgh in December 1993, she replaced the last of the displacement-hulled nine-knot

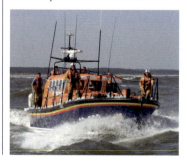

types, the 37ft 6in Rother *James Cable* (ON.1068), and thus represented the final piece in the jigsaw of fast lifeboats at every station.

Although the new designs of fast lifeboat, all capable of at least fifteen knots, were fine rescue craft, a new generation of even faster lifeboats was designed during the 1990s to further enhance lifeboat coverage in the shape of the 17m Severn and 14m Trent classes, which shared similar hull designs. Both were capable of twenty-five knots and were ideal replacements for the Aruns and Waveneys.

The Trent was introduced in 1994 and the first to enter service, *Esme Anderson* (ON.1197), went to Ramsgate in August 1995. The Trent was seen as the natural replacement for the Waveneys, and further examples of the type went to Gorleston and Sheerness during the 1990s.

In October 1996, the first operational Severn, *Albert Brown* (ON.1202), went to Harwich, a busy station with an expanding ferry port in its patch. And in 1997 another Severn came to the South East, *City of London II* (ON.1220), which was stationed at Dover and

The modern era

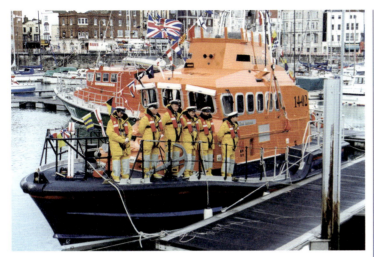

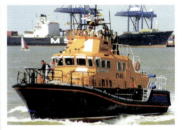

left 14m Trent Esme Anderson (ON.1197) at Ramsgate with her crew on board during her naming ceremony on 25 September 1994 when she was christened by HRH The Duke of Kent. The 14m Trent and 17m Severn classes, which entered service in 1992, could reach twenty-five knots, were built of fibre reinforced composite, a lightweight yet extremely strong material, and had twin propellers protected by extended bilge keels.

above 17m Severn Albert Brown (ON.1202) at Harwich on 25 May 1997 at the end of her naming ceremony.

below 16m Tamar Lester (ON.1267) launching down the slipway from the boathouse at the end of Cromer pier. The building of the new boathouse and slipway at Cromer was a major shoreworks project undertaken by the RNLI.

replaced the unique Thames class boat. The new £1.3-million lifeboat was funded from an appeal to mark the centenary of the RNLI City of London branch, receiving support from many companies, institutions and individuals within the square mile of the City.

Further advances were made during the early years of the twenty-first century with another twenty-five knot design, the 16m Tamar, being developed, primarily intended for slipway launching. A new boathouse and slipway built at Cromer meant the station became one of the first to operate the design, which was fitted with a systems computer to control the boat's vital functions and make it safer and easier for the crew. Another Tamar was placed at Walton & Frinton as the modernising of the area's lifeboat stations was almost completed.

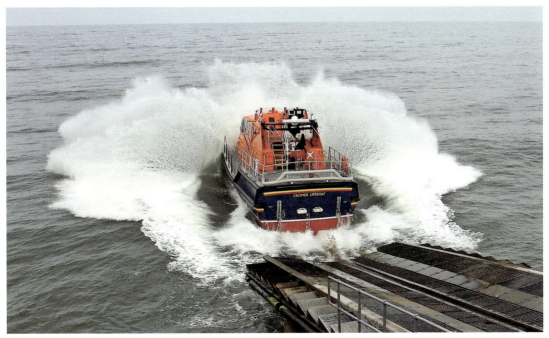

New stations, new methods

right The new London lifeboat service was officially launched on 2 January 2002 when three of the six new E class lifeboats were paraded on the river in front of the media and TV cameras, with the Tower of London providing a fine backdrop. Soon after their introduction, the boats proved to be busier than expected, demonstrating the value of the new lifeboat stations.

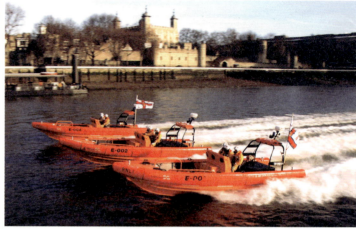

below The Legacy (E-005) on patrol near Waterloo Bridge. She was funded from the bequest of Lieutenant Philip Francis Spencer King and was named in recognition of the contributions legacies and bequests made to RNLI funding.

below right On patrol with the Chiswick lifeboat crew on board Joan and Ken Bellamy (E-006), passing beneath one of the capital's many bridges heading east. Two of the three-person crew on standby at Tower, Chiswick and Gravesend stations are full-time, with the third a volunteer. The full-time stations operate in a completely different way from the RNLI's other lifeboat stations, while Teddington operates as a traditional station. The three stations manned full-time have two crews: a day crew, and a night crew, each on a twelve-hour shift, with the boats often on the water for about six to eight hours during each shift.

During the early years of the twenty-first century the RNLI introduced new and innovative ways to save lives at sea, while also extending its scope of coverage by starting operations on inland waters. Not only were four new lifeboat stations founded on the Thames in 2002, but a new station at Oulton Broad was established to cover the Norfolk Broads, and hovercraft were brought into the service for the first time to work on mudflats and sands.

Thames lifeboats

The advent of the lifeboat stations in the Thames came about as a result of the findings of the Thames Safety Inquiries into the collision between the pleasure cruiser *Marchioness* and the dredger *Bowbelle*, which resulted in the loss of fifty-one lives in 1989, leading to a demand to step up search and rescue cover on the river. Planning for the service started in 2000 and on 2 January 2002 four new lifeboat stations became operational on the Thames. The new stations, to provide a round-the-clock rapid response service for the capital, were located at Tower, Chiswick, Gravesend and Teddington. The first three were manned continuously by a mix of full-time and volunteer crew to provide an immediate response, while Teddington was operated using volunteers in the same way as the RNLI operates its coastal lifeboat stations.

New stations, new methods

The Maritime and Coastguard Agency (MCA) co-ordinates the rescue operation from a Port of London Authority (PLA) operations room at the Thames Barrier, with the RNLI responsible for search and rescue on the river and committed to reach any point on the tidal reaches of the Thames within fifteen minutes of a call.

The new stations operated a new rescue craft based on a fast response craft which was 9m in length, jet-powered and capable of forty knots. The new design was designated the E class and in total six boats to this specification were built, ensuring a back-up is available for each of the three station boats. A speed of forty knots was needed to enable incidents to be reached within the agreed time. A standard D class inflatable was stationed at Teddington.

Almost as soon as they became operational, the stations were being called upon. Chiswick responded to twelve incidents in the first two weeks of its operation, ranging from bridge jumpers to overturned row boats, and in April 2002, a fifteen-month-old baby girl and a three-year-old boy were among five people rescued from floods by Chiswick and Teddington lifeboats.

Hovercraft

At the same time as the RNLI was setting up the Thames lifeboat stations, it was also investigating whether hovercraft could be used as effective and useful rescue tools. A decision was taken to trial a commercially available craft and a standard Griffon 450TD was selected, which was developed in

above E class lifeboats Public Servant (Civil Service No.44) (E-001) and Olive Laura Deare (E-002) on patrol in the Thames Estuary opposite Gravesend. E-001 was named in honour of the fund-raisers of the Communications and Public Service Lifeboat Fund ('The Lifeboat Fund').

below Naming ceremony of Brawn Challenge (E-09) at Chiswick on 27 September 2012. The boat was paid for by the Brawn Lifeboat Challenge, with the help of Ross Brawn, Team Principal of the Mercedes F1 Team, who is pictured on the boat with the station's crew and personnel.

51

New stations, new methods

above The hovercraft at Hunstanton, Hunstanton Flyer (Civil Service No.45) (H-003), was funded by the Civil Service, Royal Mail and BT, who combined to form The Lifeboat Fund. It is ideal for the tricky coastal terrains in and around the Wash, which had been difficult for the conventional ILB to negotiate.

right The hovercraft at Southend-on-Sea, Vera Ravine (H-004), at the head of the slipway, in the shadow of Southend's famous pier, down which she is launched.

below The RNLI lifeguard hut at Cromer. The RNLI has taken over lifeguard services throughout the UK, providing equipment and training. RNLI lifeguards patrol over 200 beaches around the UK and Channel Islands, and operate along beaches in Norfolk, Suffolk, Essex and Kent.

conjunction with the RNLI's technical department for search and rescue purposes. The 7.6m 470TD had two propeller-fans driven by twin 85hp 1.9-litre Volkswagen intercooled and turbocharged diesel engines.

The first inshore rescue hovercraft (IRH), H-002 The Hurley Flyer, went to Morecambe Bay in Lancashire in December 2002 and, in April 2003, the RNLI announced that Hunstanton lifeboat station was to become the second to have an IRH. The £100,000 craft was sent to the station for evaluation trials and, after final approval by the RNLI, H-003 became operational on 25 July 2003.

Another hovercraft was delivered to the South East in July 2004 when H-004 Vera Ravine was placed on station at Southend-on-Sea to supplement the three inshore lifeboats already there. The new craft was an ideal addition to the station to cover the extensive mudflats of the Thames Estuary on which the ILBs cannot operate.

The Shannon class

The most recent advance has seen the development of a new type of lifeboat, the Shannon class, as a replacement for the 12m Mersey class lifeboats at stations where carriage launching is employed. The new design was developed by the RNLI over several years, culminating in the first boat of the new type hitting the water in 2012.

Powered by Hamilton HJ364 waterjets, the Shannon class is the first modern all-weather lifeboat to use waterjets rather than propellers so the vessel can operate in shallow waters and can be intentionally beached. Waterjets also give the coxswain greater control when alongside other craft, in confined waters and in all sea conditions. A new launch and recovery rig with a four-track drive system will carry the boat across steep beaches and shingle. The first of the new type of lifeboat was sent to Dungeness in February 2014.

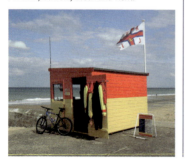

52

PART TWO

Norfolk, Suffolk, Kent and Essex Lifeboat Stations

Introduction to Part Two

At the end of 2013 the RNLI were operating twenty-three lifeboat stations in Norfolk, Suffolk, Essex and Kent, and another four on the River Thames. Most of the lifeboat stations in these counties have long and proud histories, while many of the most famous rescues in the history of the RNLI have been performed by lifeboat crews volunteering at these stations.

Details of all the stations, old and new, are included in this section, which is arranged geographically starting at Hunstanton on the north Norfolk coast and going east and then south down the coast to Suffolk, Essex, into London and then round the Kent coast, ending at Dungeness. The information in each entry includes key data and current lifeboats for each station, location information covering lifeboat houses, launch methods and operational changes, and the major events in each station's history. ON stands for Official Number, a sequential number given to all RNLI lifeboats.

Space does not permit all medal-winning services to be described, so the rescues included are representative of the many brave and courageous life-saving acts performed by the lifeboatmen and -women of south-east England. The operational information is up to date as of 1 March 2014.

above Aldeburgh lifeboat Freddie Cooper (ON.1193) has served her Suffolk station since December 1993.

below The 35ft self-righter James Stevens No.11 (ON.438) served at New Romney from 1900 to 1912, and was the station's penultimate lifeboat. She launched ten times on service and saved six lives. (By courtesy of Littlestone RNLI)

53

Hunstanton

Key dates
Opened	1824–43, 1867–1931 and 1979
RNLI	1867, reopened 1979
Closed	1931
Inshore lifeboat	1979
Hovercraft	2003

Current lifeboats
ILB Atlantic 85
B-848 Spirit of West Norfolk
Donor Readers of local paper The Lynn News, direct marketing appeal and the Hunstanton Guild.
On station 23.3.2011
Launch Tractor and do-do carriage

Hovercraft Griffon 470TD
H-003 Hunstanton Flyer (Civil Service No.45)
Donor The Lifeboat Fund (staff of the Civil Service, Royal Mail and BT)
On station 25.7.2003
Launch From boathouse

Station honours
Thanks Inscribed on Vellum	1
Bronze medals	2

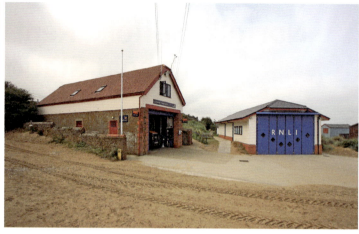

above right The site at Old Hunstanton with the 1900 lifeboat house and 2004 hovercraft house.

below Atlantic 85 Spirit of West Norfolk (B-848) with Senior Helmsman Michael Darby at the wheel. (The Lynn News)

1824 A lifeboat was provided at Hunstanton by the Norfolk Association for Saving the Lives of Shipwrecked Mariners, which also built a lifeboat house, measuring 30ft by 12ft and built of stone, next to the boathouse used by the Preventative service.

1851 The first lifeboat, which is unlikely ever to have been used for life-saving, was out of use by 1851, although the boathouse remained; it has since been demolished.

1867 The RNLI reopened the station and had a new lifeboat house built at Old Hunstanton, to the north of the main town, at a cost of £135; this building was used until 1900, when it was replaced, and it has since been converted into a beach shop. Three pulling lifeboats served the station between 1867 and 1931, all standard self-righters named *Licensed Victuallers* and funded by the Licensed Victuallers Lifeboat Fund.

1900 A new, larger lifeboat house was built at a cost of £647, on a site adjacent to the first house at Old Hunstanton; the house included a watch-room, something requested by the crew, and

Hunstanton

a concrete apron was laid in front of the main doors; the chalk roadway to the beach was widened and levelled to improve launching arrangements. This house was used until the station closed in 1931 and later became a café.

1902 The RNLI paid £70 compensation to the owner of a horse following its death during an exercise.

1912 The RNLI granted £30 as compensation for injuries sustained by a horse during an exercise.

1920 The RNLI's first trials with motor tractors were held at Hunstanton to assess the feasibility of using them to launch lifeboats across beaches. The trials began on 26 March with a 35hp Clayton & Shuttleworth agricultural tractor. The tractor had no difficulty in towing the lifeboat across the soft beach, and the trials were a success.

1921 Following further trials at a number of different stations, more tractors were ordered for service by the RNLI, with the first, tractor T2, being delivered to Hunstanton.

1931 The station was closed in July as motor lifeboats at neighbouring stations were deemed adequate to cover the seas off Hunstanton and the Wash.

1965 The RNLI planned to establish an ILB station, but did not proceed as the local authorities did not think an ILB was needed at the time.

1979 An inshore lifeboat station was established and D class inflatable D-181 was sent to the station on 24 May.

above Launch of Atlantic 85 Spirit of West Norfolk (B-848) at the end of her naming ceremony on 22 October 2011.

below The lifeboat house, built in 1900, was reacquired when the station was reopened in 1979 and has since been adapted for subsequent inshore lifeboats.

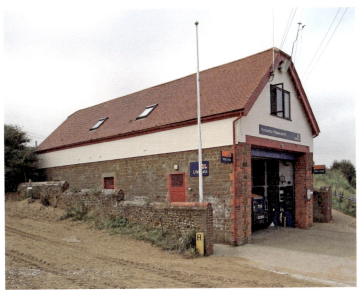

55

Hunstanton

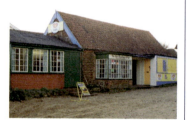

above The first RNLI boathouse, built in 1867, was used until 1900 and has been converted into a café and beach shop.

right The Griffon hovercraft Hunstanton Flyer (Civil Service No.45) (H-003) on exercise off the beach at Old Hunstanton.

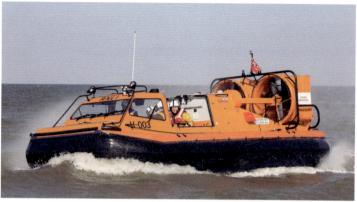

Following intensive training, the station was declared operational in June; the 1900 boathouse was reacquired, renovated and modified for the ILB.
1982 The D class ILB was withdrawn and replaced by an Atlantic 21, with the relief boat *Co-Operative No.1* (B-511) being placed on station on 25 March.
1996 A new fuel store was constructed adjacent to the lifeboat house.
2000 Further alterations to the lifeboat house were completed.
2003 An inshore rescue hovercraft, H-003, was sent to the station in May; it was initially kept in a temporary compound, which was constructed adjacent to the lifeboat house, with a Land Rover to tow it to the beach.
2004 A permanent building, on land adjacent to the existing boathouse at Old Hunstanton, was erected to house the hovercraft at a cost of £179,250.
2011 The lifeboat house was adapted and extended to accommodate the Atlantic 85 and its launch rig, with improved crew facilities and an enlarged boathall being provided.

below The house for the hovercraft built in 2004 at Old Hunstanton.

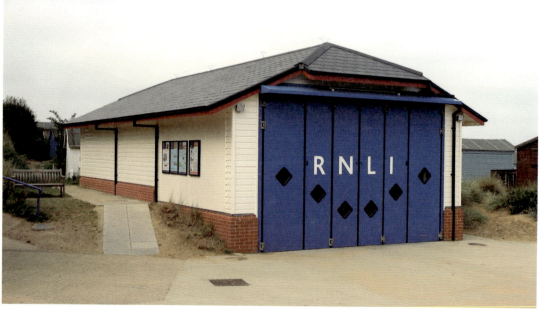

Brancaster

1823 A lifeboat at Burnham Overy, near Brancaster, was suggested by the Norfolk Shipwreck Association, and a boat was possibly in use between 1823 and circa 1843, but details are lacking.

1873 Following the two shipwrecks, the Rector of Burnham Deepdale and a local merchant and shipowner approached the RNLI about opening a lifeboat station at Brancaster.

1874 The RNLI established a station, and a lifeboat house, measuring 45ft by 22ft, was built by Messrs Becton Brothers about a mile north of the harbour at Brancaster Staithe, approximately fifty yards east of the Gap; the boathouse had large double doors at the front for the lifeboat and a small door at the south end.

1895 The rammed chalk road in front of the boathouse was extended a further twenty yards.

1916 A new lifeboat was built for the station, the 35ft self-righter *Winlaton* (ON.666), and the lifeboat house was altered to accommodate her, being lengthened and the fittings on the wall moved into an annexe. The annexe was built on the east side of the boathouse, and the horse harness, oilskins and lifejackets, were kept there; it was about 15ft in length and 3ft wide.

1923 A motor tractor was supplied to the station in October to improve launching arrangements as there were difficulties in obtaining horses.

1933 A storm surge effectively rendered the lifeboat house unusable, and as a result it was demolished; the lifeboat was therefore left in the open, on her carriage, in the gap between the golf links and the golf club house, covered with a tarpaulin. The tractor was kept in the golf club car park.

1935 The lifeboat was withdrawn and the station was closed; having no boathouse made the station inviable in the long run, and with motor lifeboats at the neighbouring stations a lifeboat was unnecessary; during almost sixty years of service, the lifeboats are credited with saving thirty-four lives.

Key dates
Opened	1823–43 and 1874
RNLI	1874
Closed	1935

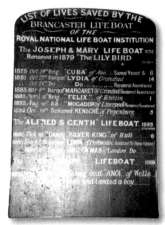

above No trace remains of the lifeboat station at Brancaster. The only item to show that a station once existed is the service board, which is displayed in the local parish church having been rescued from destruction in the late 1970s.

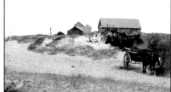

above The lifeboat house of 1874 pictured in around 1920 among the sand dunes.

left The lifeboat house built in 1874, pictured in 1933 after a storm surge had destroyed the chalk roadway from the house to the beach and undermined the building, making its use dangerous. The building was subsequently demolished by the RNLI after the lifeboat was withdrawn, leaving no trace of the station. (Brancaster photos by courtesy of Michael Softley)

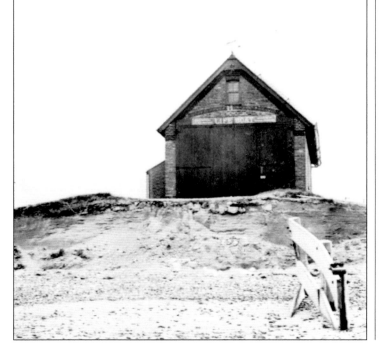

Wells

Key dates
Opened	1830–circa 1855 and 1869
RNLI	1869
Motor lifeboat	1936
Inshore lifeboat	1963

Current lifeboats
ALB 12m Mersey
ON.1161 (12-003) Doris M. Mann of Ampthill
Built 1990
Donor Legacy of Doris M. Mann, Ampthill, Bedfordshire
On station 3.7.1990
Launch Talus MB-H tractor and carriage

ILB D class inflatable
D-661 Jane Ann III
Donor Gift of Mrs Jan Branford, Sudbury
On station 9.1.2007
Launch Trolley

Station honours
Framed letter of thanks	1
Thanks Inscribed on Vellum	1
Bronze medal	2
Silver medal	1

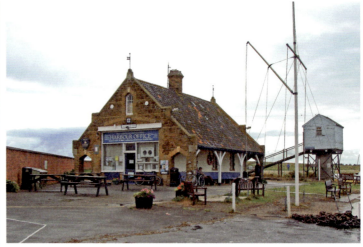

right The lifeboat house of 1869 was sold by the RNLI in 1896 to Wells Urban District Council for £75. One of the few examples of the RNLI's distinctive nineteenth-century lifeboat house design to survive without major alterations, it is now used as the Wells Harbour Office and has been restored and refurbished for the use of visiting sailors.

1830 The first lifeboat at Wells was funded and operated by the Norfolk Shipwreck Association; the 25ft North Country type boat was initially kept afloat in the harbour until a lifeboat house was built at the west side of the harbour entrance. The boat was in service until at least 1855 as in that year she claimed part salvage of a vessel.

1869 The RNLI reopened the station and built a new lifeboat house in the town, on The Quay, for the 33ft self-righting lifeboat Eliza Adams, at a cost of £300; this house was used until 1895, and was later converted into a café; it has since been used as the Harbour Office and a small Maritime Museum.

1880 On 29 October Eliza Adams capsized when returning to shore after a service launch. Eleven out of her crew of thirteen were drowned, leaving ten widows and twenty-seven children. The RNLI voted £1,000 towards a fund raised locally for the dependants and paid the funeral expenses of the men. A memorial was erected in 1906 to the memory of those lost in the tragedy.

1895 A new lifeboat house was built at the far end of Beach Road, close to the entrance to the harbour.

1936 Wells was the last lifeboat station to use horses to launch the lifeboat,

right The lifeboat house built in 1894–5 at the end of Beach Road, about a mile north of the quay; the building has been considerably altered and extended for new, larger lifeboats and is unrecognisable from the original building of 1895.

opposite inset 12m Mersey Doris M. Mann of Ampthill (ON.1161) and D class inflatable Jane Ann III (D-661) heading out of harbour on exercise.

opposite 12m Mersey Doris M. Mann of Ampthill returning to harbour, passing the lifeboat house to head up to The Quay.

Wells

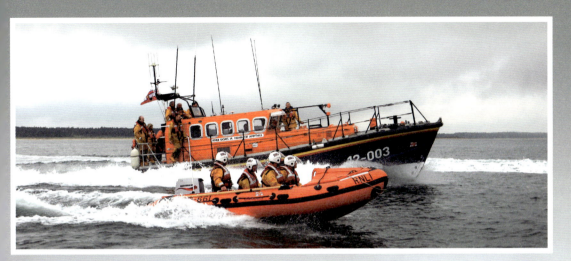

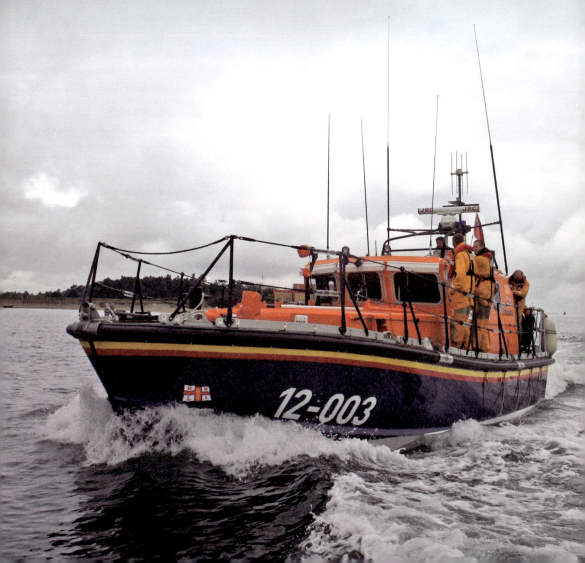

Wells

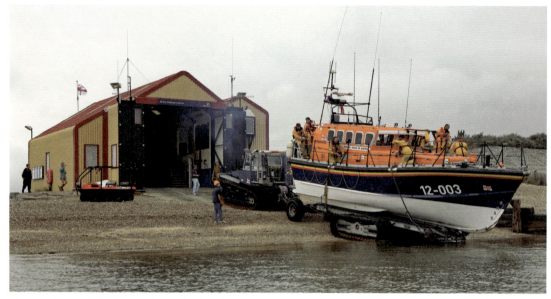

above 12m Mersey Doris M. Mann of Ampthill (ON.1161) leaving the lifeboat house ready to be launched by Talus MB-H tractor T96.

below The memorial situated at the west end of the quay to the eleven lifeboatmen who were lost in the tragedy of October 1880. Close to the lifeboat house of 1869, it is on the landward side of the road to the beach. It was unveiled on 12 September 1906 and was restored in 2004.

when the first tractor, T19, was supplied in February to launch the station's first motor lifeboat, the 32ft Surf class *Royal Silver Jubilee 1910–1935* (ON.780), which arrived at the same time.

1963 An inshore lifeboat station was established in June; the ILB was kept in a small house on the west side of the 1895 boathouse at the harbour entrance.

1965 The lifeboat house was altered for the new 37ft Oakley class lifeboat.

1978 The ILB house was destroyed by gales which hit the east coast in January; an extension to the main boathouse was built to house the ILB.

1983–4 The lifeboat house was modified to provide improved crew facilities and a boarding platform.

1986 A new tractor house for the Talus MB-H launching tractor was built alongside the 1895 lifeboat house.

1990 The lifeboat house was modified to accommodate the 12m Mersey lifeboat: a new main door was installed, and a workshop, store, souvenir outlet and concrete slipway were built.

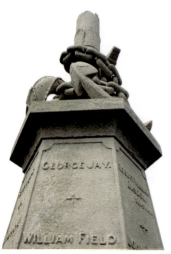

Wells

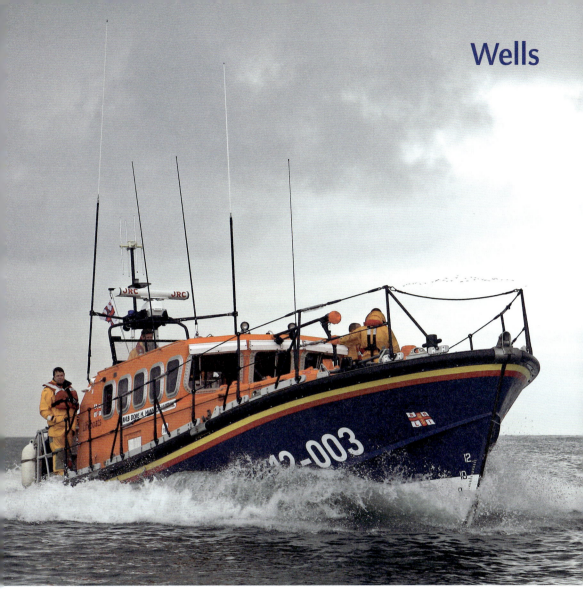

above 12m Mersey Doris M. Mann of Ampthill was one of ten aluminium-hulled Merseys to be built by the RNLI.

left D class inflatable Jane Ann III (D-661) is the third inshore lifeboat to serve at Wells that has been funded by Mrs Jan Branford, of Sudbury, Suffolk. The first ILB at Wells was sent in 1963, making the station one of the first to operate this type of lifeboat.

Blakeney

Key dates
Opened 1824–p.43 and 1862
RNLI 1862
Closed 1935

Station honours
Silver medals 1

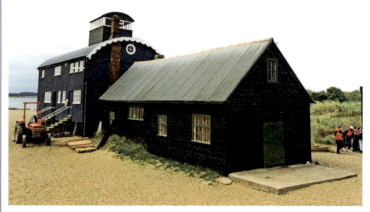

right The first lifeboat house, moved to its present site in 1867, is now used for accommodation purposes. It stands directly behind the later boathouse at Blakeney Point. Local boat trips to the Point run from Blakeney Quay and Morston, but are tide dependent.

above One of the station's three service boards, which can be seen on the wall of the west end of Blakeney parish church.

right The RNLI boathouse built in 1898 was used until the station closed in 1935. It is now used and maintained by the National Trust as an information centre and the warden's house, located on National Trust property at The Point, near the entrance to Blakeney harbour.

1824 The Norfolk Shipwreck Association opened a lifeboat station at Blakeney, one of several established by the Association, and also provided a mortar to Blakeney Hood, but by 1843 the boat was no longer in use, having fallen into decay.
1862 The RNLI reopened the station after several fishermen were drowned when going to a wreck on the bar the previous year; the lifeboat house built by the Norfolk Lifesaving Association before 1860 was taken over and the 30ft self-righter *Brightwell*, the first of two boats donated by Miss Brightwell of Norwich, was supplied in September, and was launched over skids.
1867 The boathouse was moved to a new location at Blakeney Point at a cost of £146 after seas had encroached on its original site making it dangerous.
1898 A new, larger lifeboat house was built, with a store and watchroom, at Blakeney Point; it was constructed on piles at a cost of £544 18s 8d, and stood directly in front of the previous boathouse, which remained standing.
1935 The lifeboat *Caroline* (ON.586), a 38ft Liverpool type which had been on station since November 1908, was withdrawn and the station was closed as motor lifeboats at the flanking stations of Wells and Sheringham could adequately cover the area. During seventy-four years of service, the Blakeney lifeboats saved 101 lives.

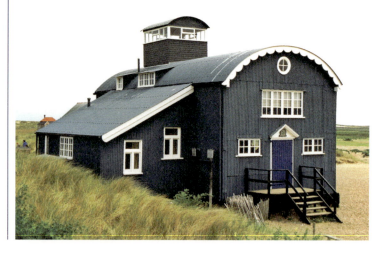

Sheringham

Key dates
Opened	1838
RNLI	1867
Motor lifeboat	1936–92
Inshore lifeboat	1992

Current lifeboats
ILB Atlantic 85
B-818 The Oddfellows
Built 2007
Donor Manchester Unity Independent Order of Oddfellows
On station 11.7.2007
Launch Tractor and do-do carriage

Station honours
Thanks Inscribed on Vellum	5
Bronze medals	2
Silver medals	1

1838 A lifeboat house was built about thirty yards from the high-water mark and fifty yards from the watch-house for the first lifeboat, which was a privately funded 33ft non-self-righter built locally and named *Augusta*; this boat was operated independently.

1867 The RNLI established a station and built a lifeboat house at the eastern end of the town, supplying the 36ft self-righting lifeboat *Duncan* in July.
1870 Heavy gales destroyed the slipway, which had to be rebuilt.
1877 The slipway was washed away in gales and heavy weather.

left The lifeboat house, built in 1867 and used until 1900; it has been much altered and largely rebuilt.

below Launching Atlantic 85 The Oddfellows (B-818) form the lifeboat house at the western end of the Promenade.

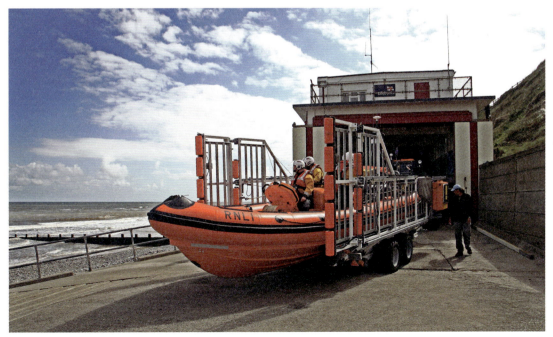

63

Sheringham

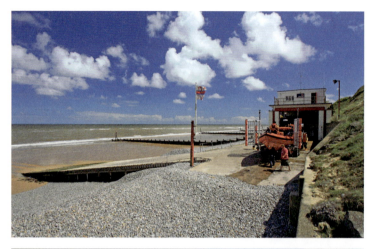

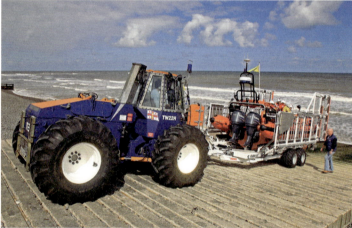

top Atlantic 85 B-818 The Oddfellows leaving the lifeboat house and being prepared for a routine exercise.

above Atlantic 85 B-818 The Oddfellows being launched on exercise.

below Plaque mounted on the wall of the first RNLI lifeboat house of 1867.

1894 The original private lifeboat *Augusta*, which was well liked by the local fishermen, was replaced by a new lifeboat built along the same lines and named *Henry Ramey Upcher*, being funded by Mrs Caroline Upcher.

1900 Following continued difficulties in launching from the 1866 boathouse, the lifeboat was moved to the East Gangway, and kept under tarpaulins on Beach Road, remaining in the open until 1903; the 1900 boathouse was subsequently sold and has since been converted into a craft centre, hardly recognisable as a former lifeboat house, but has a plaque mounted on the outside indicating its original use.

1902 Owing to difficulties in launching across the beach at Sheringham, the lifeboat was moved to Old Hythe, about a mile west of the town, where the beach was more suitable.

1904 A new corrugated lifeboat house and timber slipway was constructed at Old Hythe for the 41ft Liverpool sailing lifeboat *J. C. Madge* (ON.536). The lifeboat was operated from this site until 1936; the boathouse has since been demolished, and all that remain are a few concrete slabs.

1936 A new lifeboat house was built for the station's first motor lifeboat, the 35ft 6in Liverpool motor *Foresters' Centenary* (ON.786), at the western end of the Promenade at a cost of £7,616, funded from the legacy of Miss Edith Carless Attwood of Shirenewton.

1949 The first launching tractor, T15, was sent to the station.

1961 The lifeboat house was adapted to accommodate a 37ft Oakley lifeboat.

1962 A new tractor house was built to the west of the lifeboat house.

1983 Turning space for ambulances was provided to the east of boathouse.

1986 A D class inflatable was placed on station as a temporary measure when the 37ft Oakley *Manchester Unity of Oddfellows* (ON.961) went for overhaul and there was no suitable replacement.

1991–2 The launching slipway was dismantled and rebuilt over the winter.

1992 The all-weather lifeboat, *Lloyds II* (ON.986), was withdrawn as cover was provided by new faster lifeboats at Cromer and Wells; an Atlantic 21 B-536 was sent to the station in April, and was launched by tractor and carriage.

1994 The lifeboat house was upgraded to provide facilities for Atlantic 75 *Manchester Unity of Oddfellows* (B-702), which went on station on 29 January, and its launching tractor; the improved crew facilities included a crew room, kitchen, office, toilet and watchroom.

2003 An extension was constructed to provide better crew facilities and storage space.

Sheringham

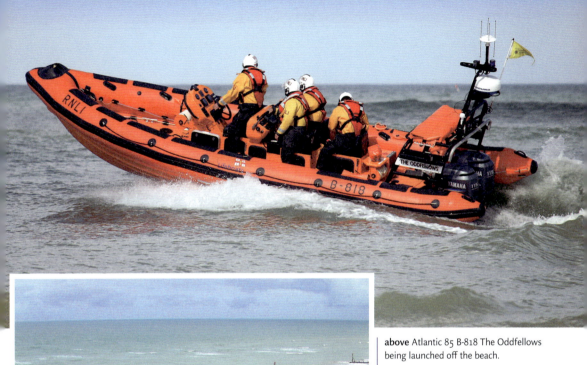

above Atlantic 85 B-818 The Oddfellows being launched off the beach.

left The lifeboat house and launchway at the western end of the Promenade built in 1936 for the station's first motor lifeboat, and subsequnelty modified and adapted. The original cost of the boathouse was defrayed by a legacy left to the RNLI by Miss Edith Carless Attwood, of Shirenewton, near Chepstow. In 2003 an extension was built on top of the boathouse to provide an enlarged crew room, complete with toilet, shower and storage facilities.

below Some of the station's service boards on display at the Mo Museum, which also houses three of Sheringham's former lifeboats and other exhibits relating to the local lifeboat station.

65

Cromer

Key dates
Opened	1805
RNLI	1857
Motor lifeboat	1923
No.2 station	1923–67
No.2 motor lifeboat	1934–67
Inshore lifeboat	1967

Current lifeboats
ALB 16m Tamar
ON.1287 (16-07) Lester
Built 2007
Donor Bequest of Mr Derek Clifton Lethern, of Southfields, London
On station 6.1.2008
Launch Slipway

ILB D class inflatable
D-734 George and Muriel
Donor Legacy of George and Muriel Lancashire, Middleton, Manchester
On station 17.7.2010
Launch Trolley and tractor

Station honours
Framed Letter of thanks	2
Thanks Inscribed on Vellum	58
Bronze medals	45
Silver medals	8
Gold medals	3

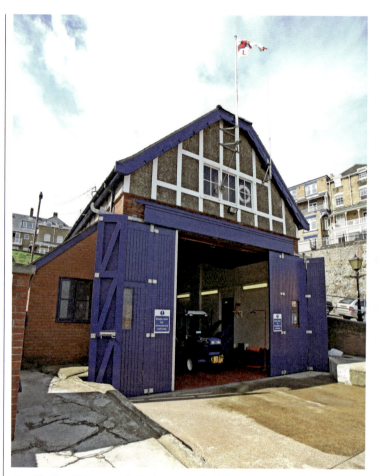

right The lifeboat house of 1902 was used for the No.2 lifeboat until 1967, and was then converted into a lifeboat museum, with the former No.1 lifeboat H.F. Bailey (ON.777) on display inside. When the purpose-built lifeboat museum was completed in 2005, H.F. Bailey was moved there and the boathouse was adapted to accommodate the D class ILB and its launching vehicle.

opposite 16m Tamar lifeboat Lester (ON.1287) on exercise off Cromer pier.

below Y class inflatable Y-207 is kept in stern of the Tamar and can be deployed and recovered while at sea from a stern door which is operated hydraulically.

1805 The first lifeboat, a 25ft North Country type built by Henry Greathead, was funded by local subscriptions. It was managed by a Local Committee, which was formed at a meeting held on 31 October 1804, and probably kept on the beach. The first lifeboat house, built sometime after the station was founded, was situated near the Coastguard cottages.

1823 The station was taken over by the Norfolk Shipwreck Association, which took on the responsibility for all the lifeboats in Norfolk.

1830 A new 31ft North Country type lifeboat was built for the station.

1857 The RNLI took over the Norfolk Shipwreck Association's stations, including Cromer, in December.

1858 The RNLI renovated the station and provided a new 34ft self-righter, which remained unnamed during her ten years at the station.

1868 A new lifeboat house was built at a cost of £298 at the foot of the East Gangway; the East Gangway was a steep hill which was paved with granite blocks arranged with their corners sticking up so that horses' hooves could grip as they pulled cargo up from the beach; this house was used until 1902. A new lifeboat, the 34ft self-righter *Benjamin Bond Cabbell*, was also provided, funded by and named after the donor, of Cromer Hall, who, in November 1867, provided for 'the whole expense of renovating the station'.

1902 A new lifeboat house was built at

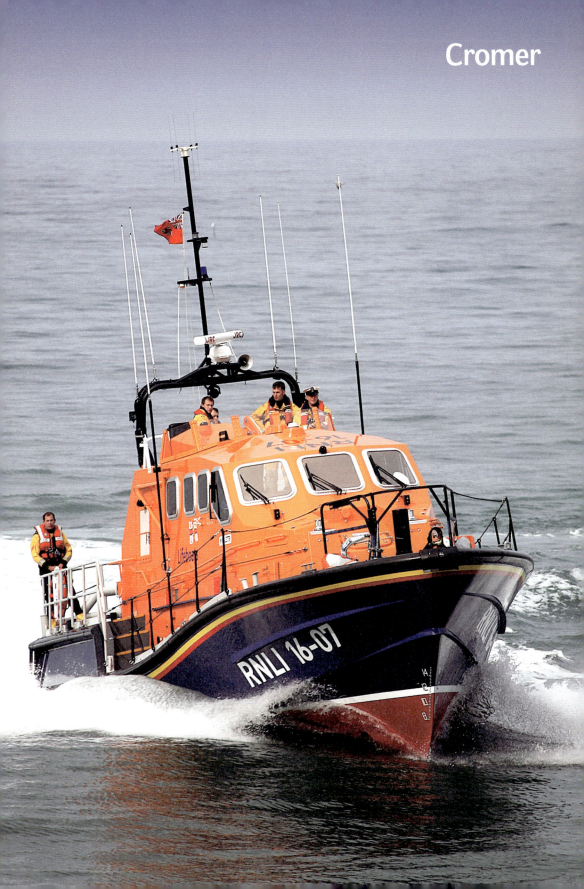
Cromer

Cromer

right The lifeboat house built at the end of the pier between 1996 and 1998, seen with the 47ft Tyne Ruby and Arthur Reed II (ON.1097) being recovered.

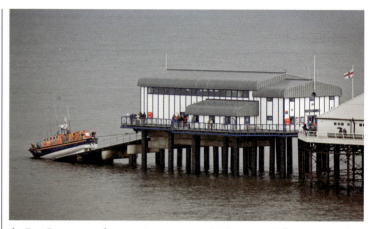

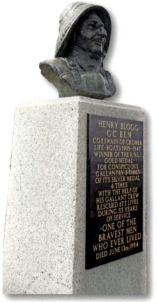

above A replica of the bronze bust of Henry Blogg on the East Cliff. The original bust is displayed in the pier lifeboat house.

below The 1902 lifeboat house at the East Gangway, looking over the East Beach and the Henry Blogg Lifeboat Museum.

the East Gangway on the same site as the house of 1868, which was too small and was demolished; the new house was built for the carriage-launched 38ft Liverpool *Louisa Heartwell* (ON.495).

1923 A new lifeboat house, with a slipway of 165ft in length, was constructed at the end of the pier for the station's first motor lifeboat, the 46ft 6in Norfolk & Suffolk motor *H. F. Bailey* (ON.670); this house was used until 1996, and was then dismantled and removed. The beach-launched boat was retained as a No.2 lifeboat as in certain states of weather it was not possible to rehouse the motor lifeboat up the slipway at the end of the pier.

1928 A Centenary Vellum was awarded.
1934 The 35ft 6in Liverpool motor *Harriot Dixon* was sent to the No.2 station, replacing the pulling lifeboat.
1938 A Clayton tractor, T7, was supplied to launch the No.2 lifeboat across the beach; this was the first of five motor tractors used at Cromer.
1967 An inshore lifeboat station was established in March and the No.2 lifeboat, the 37ft Oakley *William Henry and Mary King* (ON.980), was withdrawn on 22 June; initially the D class inflatable ILB, number D-101, was kept in the 1902 boathouse, and launched across the beach.

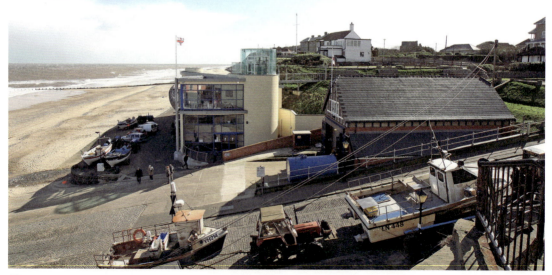

Cromer

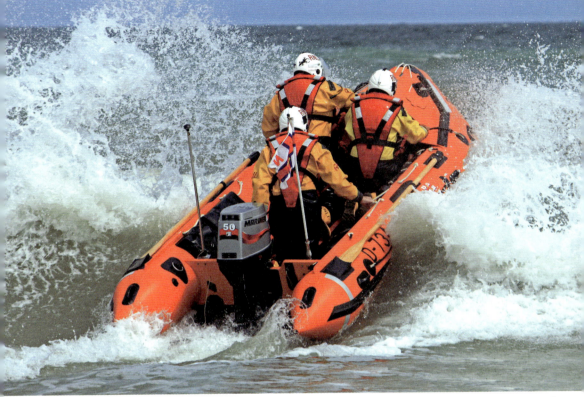

above D class inflatable George and Muriel (D-734) in surf off the East Beach.

1970 The ILB was moved in August to a new glass-fibre boathouse, situated to the west of the pier at the foot of the Melbourne slope, to overcome the problem of launching the ILB when the East Gangway was blocked by fishing boats drawn up in front of it.

1984 A new ILB house was built on the Promenade, to the east of the Gangway, and was used until 2004.

1996 The lifeboat house of 1923 at the end of the pier was removed; between 1996 and 1998, while the new house and slipway were being built, a carriage-launched lifeboat, the 12m Mersey *Her Majesty The Queen* (ON.1189), was operated from the beach close to the boathouse built in 1902.

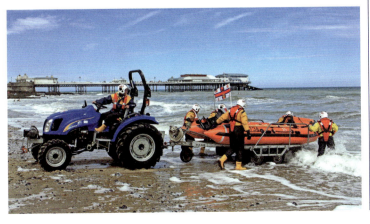

left Launching D class inflatable George and Muriel (D-734) from the East Beach using New Holland TC45DA tractor TA81.

69

Cromer

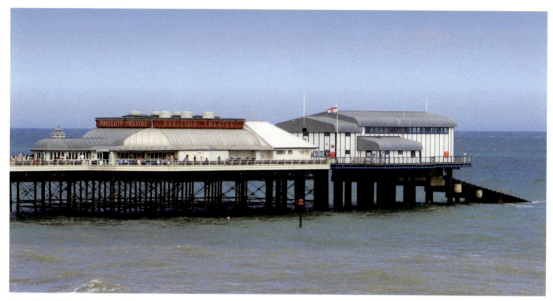

above The lifeboat house and slipway built at the end of the pier in 1997–98.

below Looking up the slipway at 16m Tamar Lester (ON.1287) resting on her hydraulic cradle, which tipped the lifeboat into position for launching.

below right Recovering 16m Tamar Lester (ON.1287) into the boathouse.

1998–9 A new larger house and slipway at the end of the pier was constructed; it became operational on 4 March 1999.
2004 The station was awarded a Vellum to commemorate its bicentenary.
2005–6 The lifeboat house of 1902 was adapted for the D class ILB and its launch tractor after the new Henry Blogg Museum was built on the adjacent site; this meant the lifeboat and artefacts displayed in the boathouse were removed, leaving the house free to be used for the ILB.
2007 The lifeboat house was adapted and the slipway was rebuilt for the 16m Tamar lifeboat Lester (ON.1287); the work was completed in November at a cost of £995,000; during rebuilding work, the relief 12m Mersey Royal Shipwright (ON.1162) was operated from the East Beach, and kept in the open outside ILB house, employing tractor and carriage launch.

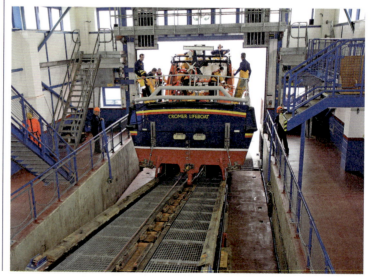

Mundesley

1811 A lifeboat station was opened following the loss of the brig *Anna* in November 1810. A local committee, led by Joseph Gurney of Norwich, obtained a subscription from Lloyd's and had a local fishing boat fitted up for use as a lifeboat as well as ordering a 26ft non-self-righter to be built. This first lifeboat was used until 1866, but was manned and operated by beachmen after 1858.
1823 The station was taken over by the Norfolk Shipwreck Association.
1857 The RNLI took over the station, the lifeboat and the boathouse, together with the other Norfolk Association's stations.
1858 The RNLI supplied a new 30ft Peake self-righter lifeboat in December, which was built by Forrestt, Limehouse.
1866 A new 33ft lifeboat, named *Grocers*, was sent to the station, and a new lifeboat house was erected on the beach to house her. The new house was built by T. Gaze at a cost of £141, and remained in use until 1895.
1891 The station was temporarily closed because obtaining a crew was proving problematic as the number of men fishing in the area, and able to form a crew, had declined considerably.
1895 The station was closed permanently as the crewing situation had not improved, and the lifeboat *J.H. Elliott* (ON.261), which had been on station since November 1882, was withdrawn. The boathouse, still standing at the end of Beach Road, has since been converted into a private residence and extensively converted.

Key dates
Opened	1811
RNLI	1857
Closed	1895

Station honours
Silver medals	1

below The lifeboat house built in 1866 overlooking the beach has been heavily converted into a private house.

Bacton

1822 A lifeboat station was established at Bacton by a local committee.
1823 The station was taken over by the Norfolk Shipwreck Association, which had a lifeboat house built at Rotherham's Gap for the 29ft 6in North Country type lifeboat.
1857 The RNLI took over the station, the lifeboat and the boathouse, with effect from 1 January 1858.
1858 The lifeboat house was moved to a new site provided by local landowner, Lord Wodehouse, at a cost of £123 3s 0d. A new 32ft self-righting lifeboat was provided, arriving in October, at which point the old lifeboat was given to the local fishermen.
1873 As a result of further erosion of the cliffs, the lifeboat house had to be moved again, at a cost of £55.
1880 The lifeboat *Recompense*, which had been on station since October 1865, capsized on service during a severe storm on 20 January and, of thirteen on board, two were drowned.
1882 During the previous few years obtaining a crew had become increasingly difficult as most men worked as farm labourers, and so in March the RNLI decided to close the station; the lifeboat was withdrawn on 25 May; nothing remains of the house.

Key dates
Opened	1822
RNLI	1857
Closed	1882

Station honours
Silver medals	2
Gold medals	1

Happisburgh

Key dates
Opened	1866 and 1965
RNLI	1866
Closed	1926
Inshore lifeboat	1965, 2nd ILB 2009

Current lifeboats
ILB Atlantic 75
B-742 Douglas Paley
Built 1997 (ex-Appledore)
Donor Gift from Mrs Evelyn Anne Paley, Sussex, in memory of her late husband Air Commodore Douglas Paley
On station 17.10.2012
Launch Tractor and do-do trolley

ILB D class inflatable
D-607 Spirit of Berkhamsted
Donor Gift from Berkhamsted branch
On station 21.10.2003
Launch Tractor and trolley

Station honours
Thanks Inscribed on Vellum	1
Silver medal	1

top The ILB house built in 1987 in the village, and used until 2003; it was demolished in September 2012 after continued cliff erosion made it unstable.

below The long-term temporary ILB house at Cart Gap completed in June 2010 at a cost of £150,000 for Atlantic and D class ILB and their launching tractors.

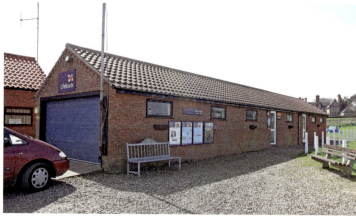

1866 The RNLI established a lifeboat station and a lifeboat house was built at a cost of £188 15s on the cliffs at Old Cart Gap, above the gap onto the beach; this house was used throughout the life of the station, and has since been demolished; the foundation bricks could be seen near the front of the first ILB house before further cliff erosion.
1884 The lifeboat *Huddersfield*, which had been on station since 1866, capsized on service to the schooner *Edith*, of Padstow, on 23 January. The lifeboat was swept across the wreck, and of thirteen on board all were saved.
1890 A £5 gratuity was granted to the widow of William Wilkins, who had been lender of the horses on the occasion of every service and exercise since the station had opened.
1926 With a motor lifeboat at Cromer able to cover the area, the station was closed and on 10 April the 34ft Rubie self-righting lifeboat *Jacob and Rachel Valentine* (ON.580) was removed. Between 1866 and 1926 the four pulling lifeboats gained a record of thirty-seven launches and saved sixty-nine lives.
1965 An inshore lifeboat station was established with the D class inflatable D-72 being placed on service in June; the ILB was kept in a small house at the top of the cliffs, above the gap onto the beach, and launched by tractor.
1987 A new ILB house was built on the same site as the first house; it provided

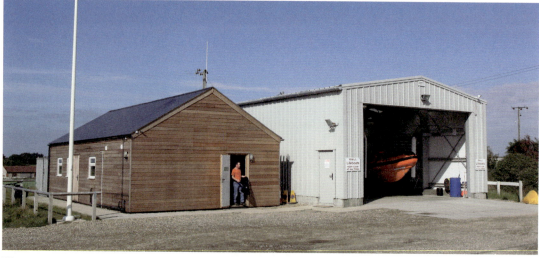

Happisburgh

a crew/instruction room, drying room, toilet and washing facilities.
1994 Following a visit in April 1994 by the Coast Review delegation, it was decided to place the D class ILB on all-year-round service; on 13 September the new D class inflatable *Colin Martin* (D-468) was placed on service.
1998 The ILB house was extended to provide improved crew facilities.
2003 The station was moved to temporary facilities at Cart Gap, to the south of the village, following cliff erosion which destroyed the existing launching ramp in the village; the new D class ILB *Spirit of Berkhamsted* (D-607) was placed on service on 22 October.
2009 The station was upgraded, with Atlantic 75 *Friendly Forester II* (B-710) being placed on service for evaluation trials on 9 April, working alongside the ILB. A new ramp was built for £350,000 down which the lifeboat was launched using Talus 4WH tractor TW29H.
2010 Following the successful completion of the trials with the Atlantic 75, long-term temporary facilities at Cart Gap were provided.

above Atlantic 75 Douglas Paley (B-742) and D class inflatable Spirit of Berkhamsted (D-607) off the beach.

below left Atlantic 75 Douglas Paley (B-742) on exercise off the beach.

below Douglas Paley (B-742) being brought down the purpose-built concrete ramp onto the beach for launching.

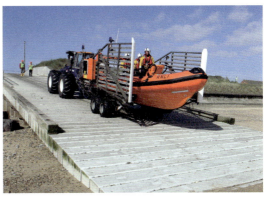

Palling

Key dates
Opened	1852
RNLI	1857
No.2 station	1870–1929
Closed	1930

Station honours
Silver medals	5

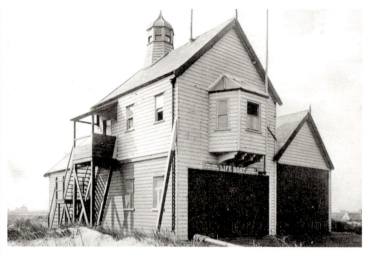

right The lifeboat house and lookout at Palling built in 1898 at a cost of £710, on the site of the previous No.2 boathouse. No trace of this station exists today.

above The station's service boards are preserved in St Margaret's church, Palling; these total eight from the RNLI era.

below The 40ft Norfolk & Suffolk lifeboat Hearts of Oak (ON.656) on the beach in front of the lifeboat house and lookout. This lifeboat was on station from 1919 to 1929, and was the last No.2 lifeboat.

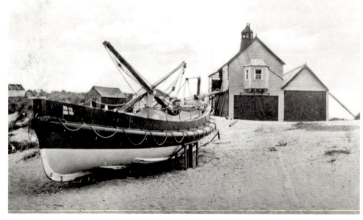

1852 The Norfolk Shipwreck Association established a station and supplied a 32ft non-self-righting lifeboat, which arrived in March; a boathouse was also built for her.
1858 The RNLI took over the station with effect from 7 January and a new 30ft Peake self-righting lifeboat was supplied, with the original boathouse being retained.
1870 A No.2 station was opened and a 40ft Norfolk & Suffolk lifeboat, named *British Workman*, arrived in September; a new wooden boathouse was built onto the south side of the boathouse to house the new lifeboat by J. B. Pestell at a cost of £158. This lifeboat was launched across the beach over skids, with a hauling-off warp laid offshore.

1884 A new lighter lifeboat, the 37ft self-righter *Good Hope*, was supplied to the No.1 station in August as the previous lifeboat, *Heyland*, was too heavy and was difficult to launch over the soft sand through the Gap.
1892 Alterations were made to the lifeboat house at a cost of £120.
1897 The watchtower was demolished during a severe gale on 29 November and the timber slipway was destroyed.
1898 A new boathouse was built on the site of the old No.2 house on the south side of the No.1 boathouse, at a cost of £710 18s 1d, for the larger No.2 lifeboat; the new house was built of wood, had a crew room above the lifeboat and, in the roof, a lookout turret from which the beachmen could keep watch for ships in distress.
1899 A new hauling-off warp was supplied for the No.2 lifeboat.
1929 The No.2 station was closed in July as motor lifeboats at Gorleston and Cromer could cover the area.
1930 The No.1 station was closed and the station's last lifeboat, the 34ft Rubie self-righter *Jacob and Rachel Vallentine* (ON.580), was withdrawn in October.
1974 The independent Palling Volunteer Rescue Service began operating an inshore lifeboat in August.

Winterton

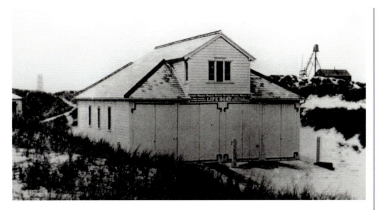

Key dates
Opened	1823
RNLI	1857
No.2 station	1879–1924
Closed	1924
Beachmen's Lifeboat	1868–78

Station honours
Silver medals	3
Gold medals	2

left The double lifeboat house built in 1884 on the beach and used until the station closed in 1925.

below The station's service boards on display in the parish church, Winterton.

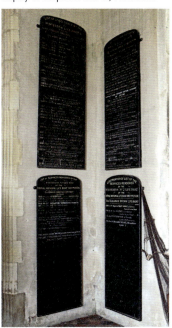

1823 The Norfolk Shipwreck Association established a station and supplied a 32ft North Country type lifeboat that had been built in 1822.
1843 A lifeboat house was built close to the beach.
1858 The RNLI took over the station with effect from 7 January and supplied a new 30ft Peake self-righting lifeboat, which arrived on 27 April; a new lifeboat house was built close to the beach at a cost of £121 16s 6d.
1868 The Winterton Beachmen had the lifeboat *Rescuer* from Gorleston purchased for them by B. Hume; the Beachmen wanted a larger sailing lifeboat and, as the RNLI would not provide one, took the initiative of obtaining one for themselves.
1879 The Corton lifeboat station was closed, and the Corton lifeboat, the 36ft Norfolk & Suffolk type boat *Husband*, was sent to Winterton as the No.2 lifeboat in place of the Beachmens' boat *Rescuer*, which was broken up; the No.2 lifeboat was kept in the open on the beach covered by a tarpaulin.
1884 A new double boathouse was built on the beach to accommodate both lifeboats; it was completed by local builder W. Hubbard at a cost of £487 13s 9d, and the smaller No.1 lifeboat was kept on her carriage with the No.2 boat launched over skids.
1924 The No.1 lifeboat *Edward Birkbeck* (ON.397) was withdrawn in October, and the following month the No.2 lifeboat was also withdrawn, being replaced by the 38ft Liverpool lifeboat *Charles Deere James* (ON.516).
1925 The crew refused to man the Liverpool type lifeboat so the station was closed, with the lifeboat being withdrawn on 5 January; in almost a century of service, the Winterton lifeboat crews saved at least 496 lives.

Scratby

1855 A 40ft Norfolk & Suffolk type lifeboat was acquired by the California Beachmen, who already operated two large sailing luggers for salvage work on the outlying sandbanks. The lugger-rigged lifeboat, which cost £200, was built by Beeching at Great Yarmouth and was named *Royal Albert*.
1865 The RNLI supplied a set of roller skids to help launch the boat over the beach; a haul-off warp was also used.
1875 This lifeboat was used by the beachmen until about 1875, with a reference in a Lowestoft newspaper of 9 March describing a rescue. No trace of the station at Scratby exists today.

Key dates
Opened	1855
Last reference	1875

Caister

Key dates
Opened	1845
RNLI	1857
Motor lifeboat	1941–69
No.2 lifeboat	1867–1929
Closed	1969

Station honours
Bronze medals	1
Silver medals	11
Gold medals	1

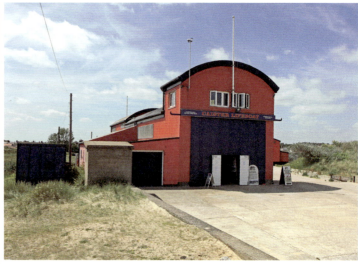

right The lifeboat house built in 1941 was used by the RNLI until 1969, when their lifeboat was withdrawn; it was subsequently taken over by the Caister Volunteer Rescue Service (CVRS) and was then enlarged and extended.

below The lifeboat house built by the RNLI in 1941 on the beach was enlarged by the Caister Volunteer Rescue Service, and, after ceasing to be the Service's operational boathouse, was converted into a Museum housing the former CVRS lifeboat Shirley Jean Adye (ON.906).

1845 The first lifeboat was funded and managed by the Norfolk Shipwreck Association. A wooden boathouse was constructed in which to keep the boat, a 42ft Norfolk & Suffolk type. The crew's gear was also stored in this house, although at this time the amount of gear was somewhat limited as life jackets were not in widespread use.

1858 The RNLI took over the station with effect from 7 January and retained the existing lifeboat, until October 1865.

1867 A No.2 station was established by the RNLI and a small 32ft 6in Norfolk & Suffolk lifeboat, named *The Boys* (ON.18), was supplied in September. The boathouse was used by the No.2 boat as it was too small for the larger No.1 lifeboat, but the lifeboats were subsequently kept in the open on the beach and launched over skids.

1885–6 A large crew store and waiting room was constructed, situated on the beach near the lifeboats, by W. J. Walker at a cost of £223 18s 0d.

1901 The No.2 lifeboat *Beauchamp* (ON.327) capsized on service on 14 November when approaching the

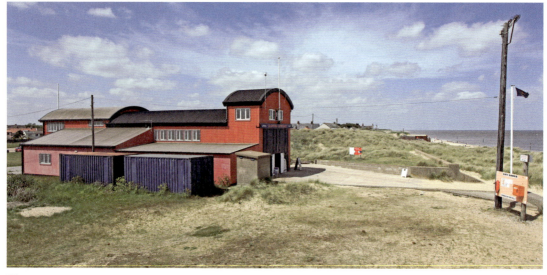

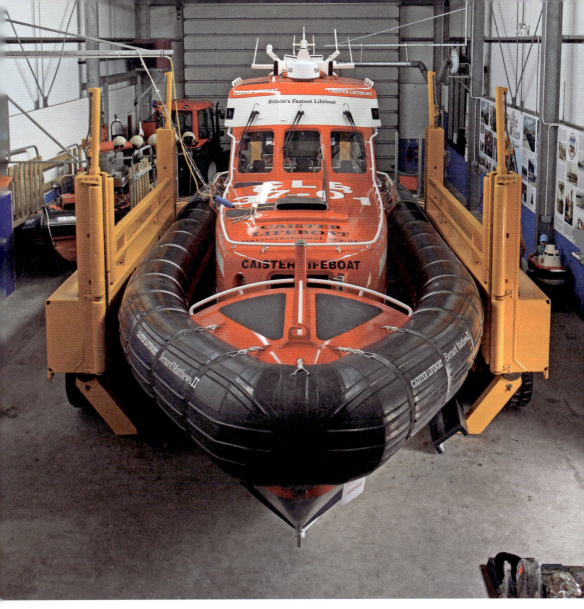

above The Caister Volunteer Lifeboat Service's rigid-inflatable Bernard Matthews II inside the lifeboat house on her specially designed launched rig.

left The two lifeboat houses at the end of Tan Lane, facing the beach, with the new, larger boathouse in the foreground.

Caister

above The lifeboat house built in 2003–4 for the Dutch-designed lifeboat Bernard Matthews II and her launching rig.

below The impressive memorial in Caister cemetery to the nine lifeboatmen who lost their lives in the Beauchamp tragedy of November 1901. Erected in 1903, it was restored in 2000 prior to the centenary of the tragedy, and on the same plot are the graves of the boat's crew.

beach as she returned from service in a north-easterly gale, with the loss of nine crew of the twelve on board. In the wake of this disaster the veteran lifeboatman James Haylett was awarded the Gold medal for rescuing three of the crew.

1929 The No.2 station was closed and the lifeboat *James Leath* (ON.607), a 42ft Norfolk & Suffolk type built in 1910, was withdrawn in November.

1941 A new lifeboat house was built on the beach at the seaward end of Tan Lane for the station's first motor lifeboat, the 35ft 6in Liverpool *Jose Neville* (ON.834), and a motor tractor, T21, and carriage were also supplied.

1963 The boathouse was altered to accommodate the 37ft Oakley lifeboat

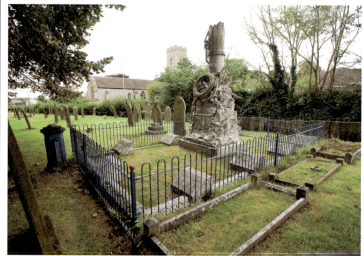

78

Caister

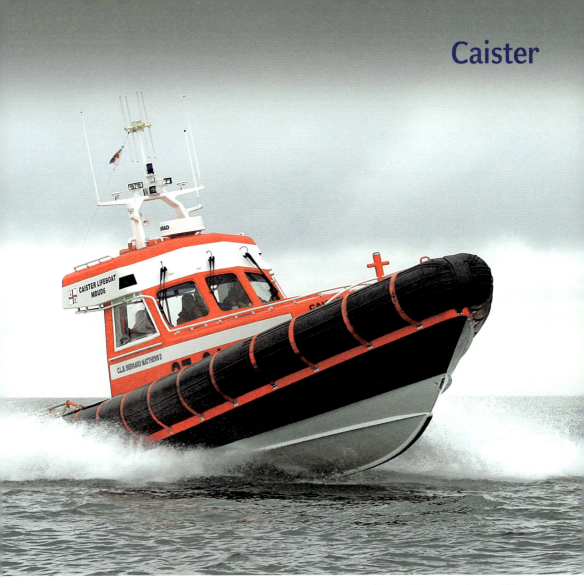

above The Caister Volunteer Lifeboat Service's 10.6m aluminium-hulled rigid-inflatable Bernard Matthews II was built in 2004 by Habbeké Shipyard, Volendam.

The Royal Thames (ON.978), which arrived on station in February 1964.
1969 The RNLI closed the station and the 37ft Oakley lifeboat was withdrawn on 31 October after the introduction of a fast 44ft Waveney lifeboat at Gorleston. To continue a rescue service, the Caister Volunteer Rescue Service was founded by a group of local people; a small IRB was operated from the old boathouse, rented from the local council.
1973 The former RNLI 35ft 6in Liverpool lifeboat ON.906, which was renamed *Shirley Jean Adye*, was purchased from a fisherman in Wells in 1973 for use as a lifeboat, being launched by tractor and carriage.

1991 A new, faster and more modern 38ft Lochin type lifeboat, *Bernard Matthews*, was built for the service.
1998–9 The lifeboat house was extended and refurbished for the new, larger Caterpillar launching tractor.
2001 The organisation was renamed Caister Volunteer Lifeboat Service.
2003–4 A new and larger lifeboat house was built on a site in part of the car park behind the 1941 boathouse to accommodate a new Dutch-built and -designed Valentijn type rigid-inflatable lifeboat, named *Bernard Matthews II*, which was launched using a special rig also built in the Netherlands.

Great Yarmouth

Key dates
Opened	1825
RNLI	1857
No.2 station	1833–83
Closed	1919

Station honours
Silver medals	3

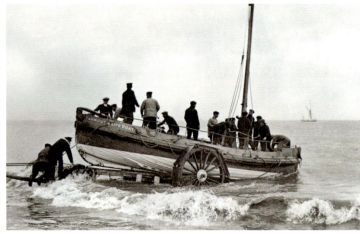

left Launching the small 32ft Norfolk & Suffolk type lifeboat John Burch (ON.329) from the beach at Great Yarmouth. She was on station from 1892 to 1912 during which time she launched 101 times on service and saved eighty-eight lives.

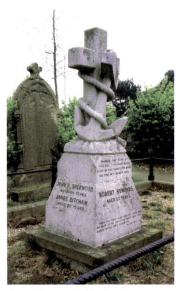

1825 A lifeboat, funded by the Norfolk Shipwreck Association, was built by local boatbuilder Beeching to the designs of Captain George Manby.
1833 A second lifeboat was supplied by the Norfolk Shipwreck Association.
1857 The station and both lifeboats were taken over by the RNLI.
1858 The RNLI supplied new lifeboats for both No.1 and No.2 stations.
1859 A new double lifeboat house was built, on the corner of Standard Road and the sea front, at a cost of £412 8s 7d.
1881 The No.2 lifeboat *Abraham Thomas* capsized on service to the schooner *Guiding Star* on 18 January, with the loss of six of her crew. A memorial to the six men can be found in Great Yarmouth cemetery.
1883 The original station was closed, while what had been the No.2 station remained operational.
1919 The station was closed, although the RNLI had decided to close the station some years before. The house was used to house *James Finlayson* (ON.541), which had been moved from Lossiemouth and served as the Gorleston No.3 lifeboat for a year from 1923 to 1924; she was moved to the Yarmouth boathouse after 1924 for exhibition purposes. The boathouse is still standing, at the southern corner of Standard Road and the Sea Front, and having been much altered is now used as an amusement attraction.

above The memorial in Great Yarmouth cemetery to the six lifeboatmen lost when the lifeboat Abraham Thomas capsized when returning from service to the schooner Guiding Star, of Padstow, on 18 January 1881.

right The double lifeboat house built in 1859 on the sea front and used until 1919, when the station was closed. It has since been converted into an amusement arcade with an elaborate frontage added.

80

Gorleston

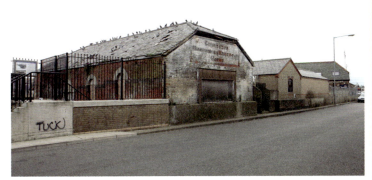

Key dates
Local committee	1802–07
Ranger Company	1853–67
Storm Company/Gorleston VLBA	1863–1939
RNLI	1866
No.2 station	1883–1924
No.3 station	1892–1904
Steam lifeboat	1897–98 and 1903–08
Motor lifeboat	1924
Inshore lifeboat	1963

Current lifeboats
ALB 14m Trent
ON.1208 (14-10) Samarbeta
Built 1995
Donor Volvo Cars UK Limited and legacies of Elizabeth Longman and Constance Rogers
On station 25.2.1996
Launch Afloat

ILB Atlantic 75
B-786 Seahorse IV
Donor The Surrey Seahorse Ball and the Bisley Clay Pigeon Shooting Challenge
On station 3.7.2002
Launch Davit

Station honours
Framed Letter of Thanks	6
Thanks Inscribed on Vellum	4
Bronze medals	24
Silver medals	21
Gold medals	1

1802 A lifeboat built by Henry Greathead was placed at Gorleston having been moved from Lowestoft, where it was disliked; it was kept on the beach and launched by carriage.

1807 The beachmen disliked the lifeboat and it was returned to Lowestoft having never been used.

1853 The Ranger Company of beachmen had a 42ft by 12ft Norfolk & Suffolk lifeboat, named *Rescuer*, built by Beeching for service from Gorleston; this was the first of several lifeboats operated by the beachmen, which were also used for salvage purposes. The boats were launched from boathouses built on the west bank of the River Yare, close to the harbour entrance, on a site to the north of the RNLI's lifeboat house of 1881. The boathouse built in 1855 was demolished in 1992.

1863 The Young Flies Beachmens' Company had the lifeboat *Friend of All Nations* built for their use; she was a 43ft by 12ft Norfolk & Suffolk type.

1866 The lifeboat *Rescuer* capsized on 13 January with the loss of thirteen of the seventeen crew on board. Following the accident, the beachmen approached the RNLI and requested a self-righting lifeboat be sent to the station; in July a 33ft self-righter was supplied and a lifeboat house was built, on the beach, at a cost of £244 3s 0d by J. J. Isaac.

1881 A new lifeboat house and slipway were built on the west bank of the river as the previous boathouse had become unusable following encroachment of the site by the sea; taking the lifeboat on her carriage along the beach was

top The riverfront site at Gorleston, on the west bank of the River Yare, where the Volunteer and RNLI lifeboats have been based since the nineteenth century. The boathouse nearest the camera was built in 1863 for the Storm Company.

left The 1863 Storm Company boathouse was one of three used by local beachmen and was built during the nineteenth century on this site on the river.

below All that remains of the boathouse, built in 1864 and used by the Young Company, is part of the slipway.

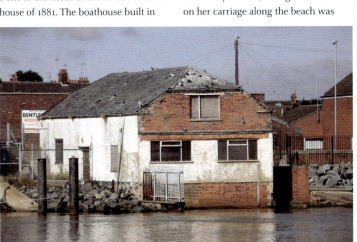

Gorleston

above 14m Trent Samarbeta (ON.1208) leaving Gorleston harbour on a routine training exercise.

right 14m Trent Samarbeta (ON.1208), which was placed on station in 1996, blasts her way out of the harbour.

opposite 14m Trent Samarbeta (ON.1208) in the mooring pen, which was constructed in 1992–93, close to the historic double lifeboat house.

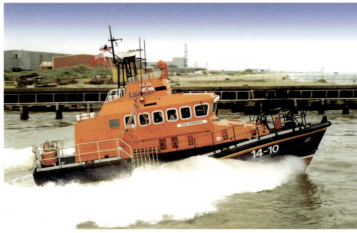

below View of the lifeboat mooring berth and the current lifeboat houses, now used for the Atlantic 75 ILB, and (on right) the Gorleston Volunteer lifeboat house, as seen from across the River Yare.

not possible due to the erosion, and the boathouse walls started to crack in 1879 making the building dangerous. The new boathouse, on the south side of the River Yare adjacent to the Ranger's boathouse, was built by J. M. Bray at a cost of £329 and enabled the lifeboat to be launched directly into the river.

1883 A boathouse was added to the north of the 1881 building to form a large double boathouse and accommodate a No.1 lifeboat; the lifeboats were launched by slipway from this second boathouse, which was built by J. M. Bray at a cost of £495.

1888 The private lifeboat *Refuge*, operated by the Gorleston boatmen, was being towed back to port by a tug after a service on the Hammond Knoll when the rope parted and the lifeboat capsized. Four of her crew of seven were drowned: A. George, S. George, W. Whiley and A. Woods.

1891 A corrugated iron boathouse and short slipway on piles were built at a cost of £508 17s 10d on the east bank of the river, just to the north of the entrance to the harbour, for a No.3 lifeboat, the 31ft Norfolk & Suffolk *Thora Zelma* (ON.326). The third lifeboat was deemed necessary to assist a vessel aground on the North Bank.

1897 A steam lifeboat, *City of Glasgow* (ON.362), was sent to the station, and was kept moored at a berth in the river. She served for just a year.

1903 Another steam lifeboat, *James Stevens No.3* (ON.420), was placed on

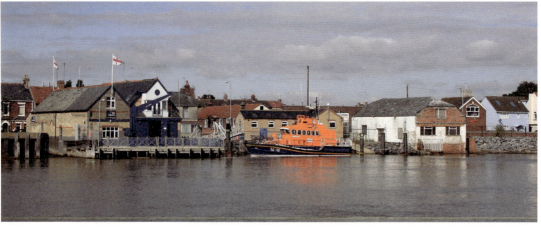

82

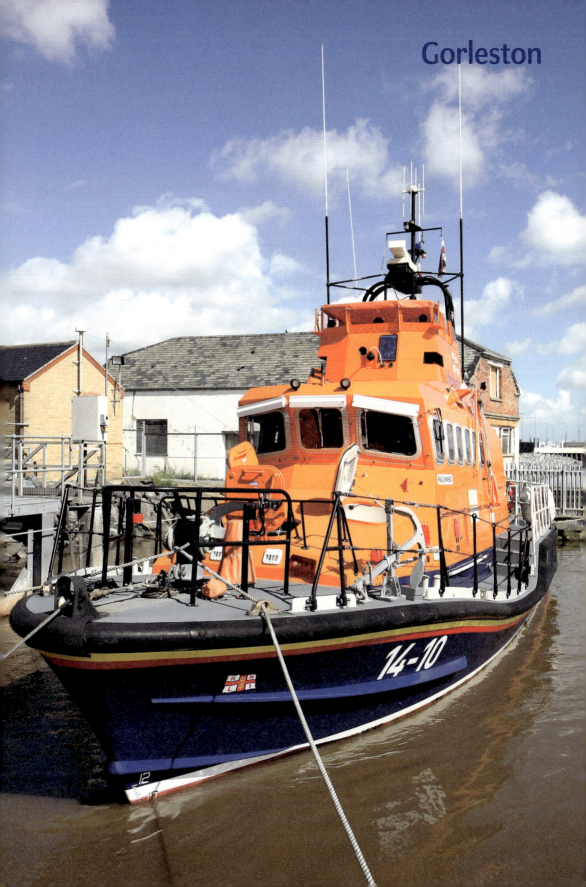
Gorleston

Gorleston

above Atlantic 75 Seahorse IV (B-786) leaving harbour on a training exercise. (Peter Edey)

below The historic double boathouse at Gorleston was built in the 1880s and has since been converted to house the Atlantic 75 ILB, which is launched by davit, and the historic motor lifeboat, John and Mary Meiklam of Gladswood (ON.663), which is the centrepiece of a small museum.

station in January, and was kept afloat in the river; she was withdrawn in 1908.
1904 The No.3 station was closed in January; the boathouse was dismantled, taken across the river and re-erected in Drudge Road, with the original wood-panelled ceiling retained.
1916 Gunfire broke all the windows in the lifeboat house.
1921 The station's first motor lifeboat, *John and Mary Meiklam of Gladswood* (ON.663), arrived in February, but was removed in March because of difficulties with the Beachmen refusing to crew the new boat.
1924 In May another motor lifeboat, the 46ft 6in Norfolk & Suffolk type *John and Mary Meiklam of Gladswood* (ON.670), was sent to the station. The No.2 station was closed, after being temporarily closed the previous year, and the lifeboat *James Finlayson* (ON.541), which had only been on station for just over a year, was withdrawn on 31 December.
1926 The station was renamed Great Yarmouth & Gorleston.
1936 Two crew members were washed out of the lifeboat, which was also damaged, while she was on service on 18 November; both were recovered.
1957 A Centenary Vellum was awarded to Great Yarmouth & Gorleston, taking into account service of Great Yarmouth station, taken over by the RNLI in 1857.
1963 An inshore lifeboat station was established in May, operating one of the RNLI's first D class inflatable lifeboats.
1967 A mooring pen was constructed upstream from the double boathouse for the fast afloat lifeboat, the 44ft Waveney *Khami* (ON.1002); this pen was used until 1993. The double boathouse was converted into a crew facility and to house the ILB.
1975 An Atlantic 21 ILB, B-531 *Waveney Forester*, was sent to the station in July, and was launched by davit.

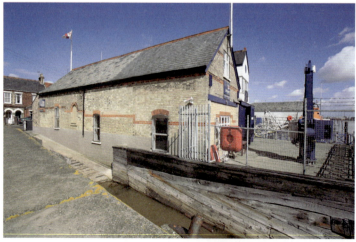

Gorleston

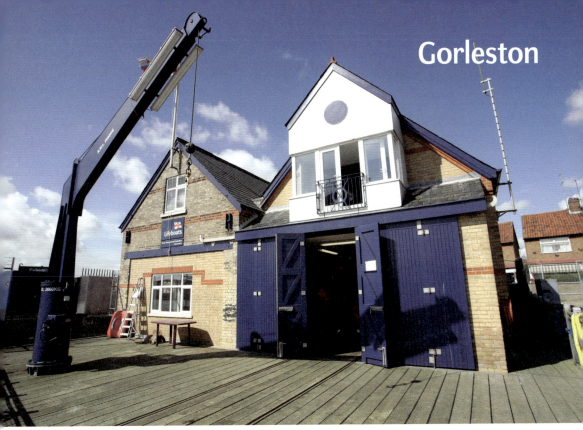

1978 The D class inflatable was withdrawn at the end of the year.
1992–3 A new mooring berth, 70ft in length, was built for the all-weather lifeboat adjacent to the double lifeboat house; the boathouses were renovated and modernised with one half accommodating the davit-launched Atlantic, crew room, drying room and changing facilities, and in the other space for a souvenir shop and the former No.1 lifeboat *John and Mary Meiklam of Gladswood* (ON.670), which is on display to visitors. The refurbishment cost nearly £350,000.
2011 The station took over the duties of the South Broads station, which was closed, and an Arancia IRB was allocated for use on the Broads; it was transported by Ford Ranger vehicle FR01, reallocated from South Broads, to various launch sites in the area.

above The historic double boathouse at Gorleston was built in the 1880s and was originally used for the pulling and sailing lifeboats, before housing the early motor lifeboats and, since the 1960s, the station's inshore lifeboats.

Corton

1869 A request was made to the RNLI to supply a lifeboat and establish a station at Corton, a fishing village three miles north of Lowestoft; the 36ft Norfolk & Suffolk lifeboat *Husband* (ON.16) was built at Great Yarmouth and arrived on 19 October. A brick boathouse measuring 40ft by 17ft was built by local builder J. Round at a cost of £226 18s 0d. The entire cost of the station was provided from a gift of £620 provided by Mrs Davis, of Clapham, London.
1879 At a meeting on 27 August, the local committee recommended that the station be closed because changes in the sandbanks meant the lifeboat's effectiveness was restricted. The lifeboat *Husband* was withdrawn and on 16 December was transferred to the Winterton station. No trace is left of the boathouse built at Corton.

Key dates
Opened	1869
RNLI	1869
Closed	1879

Lowestoft

Key dates
Opened	1801–05 and 1807
RNLI	1855
Motor lifeboat	1921
No.2 lifeboat	1870–1912
Lowestoft VLBA	1883–c.1893
Eastern Counties Railway Co.	1861–?

Current lifeboats
ALB 47ft Tyne
ON.1132 (47-020) Spirit of Lowestoft
Built 1987
Donor The Lowestoft Lifeboat Appeal, with the bequest of Albert Frederick Worboys and other gifts and legacies
On station 16.11.1987
Launch Afloat

Station honours
Framed Letter of Thanks	4
Thanks Inscribed on Vellum	2
Bronze medals	16
Silver medals	21
Gold medals	2

above right The crew facility built in 1998 at the south side of the harbour on the site of the former Pier Pavillion.

below 47ft Tyne Spirit of Lowestoft (ON.1132) at her moorings in the south-east corner of the Yacht Basin.

1801 The first lifeboat, built by Henry Greathead, was provided by a local committee in February.

1805 The lifeboat was removed as the local boatmen refused to man it.

1807 A second boat was built specially for the station. Named *Frances Ann*, she was a 40ft sailing lifeboat and was funded through the efforts of the Suffolk Humane Society. A boathouse was built near the low lighthouse, beneath the town, to house the boat.

The lifeboats were launched over the North Beach until the station was moved to the harbour.

1855 The RNLI took over the running of the station from 26 March, and moorings for the lifeboat were provided in the harbour during the winter, probably in the Outer Harbour, the Trawl Basin or the South Basin.

1858 With the RNLI operating the station, a new lifeboat house was built at a cost of £153 14s 6d.

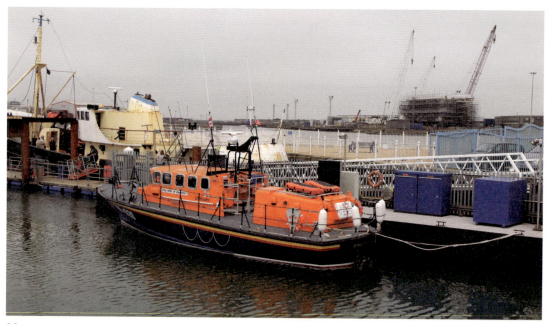

Lowestoft

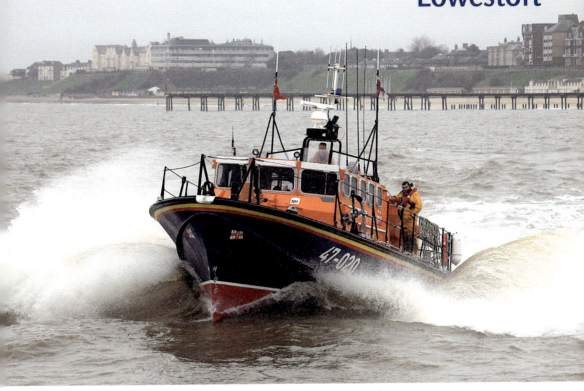

1870 A new boathouse was built alongside the 1858 boathouse. These two houses were used, with various alterations, until the lifeboats were moved to moorings in the harbour. They stood just to the north of the present Hamilton Dock, but were demolished in 1972.

1878 The No.2 lifeboat was placed on the beach during the fishing season when most of the men were away.

1883 The large No.1 lifeboat, the 44ft Norfolk & Suffolk type *Samuel Plimsoll* (ON.22), was afloat during the winter months after the owners of the dock, the Great Eastern Railway Co., granted a mooring in the fork of two jetties at the inner end of North Pier.

1886 The mooring was used all year round, after a second large lifeboat was sent for the No.2 station on the North Beach, and the lifeboats have been moored afloat ever since.

1892 A gear shed and store was built close to the moorings.

1897 The harbour tug was made available to tow lifeboat out on service if necessary at a cost of £1 10s 0d in summer and £2 5s 0d in winter.

1912 The No.2 station was closed and the 46ft Norfolk & Suffolk *Stock Exchange* (ON.356) was withdrawn.

1922 The first motor lifeboat, the 46ft Norfolk & Suffolk motor *Agnes Cross* (ON.663), arrived in March.

1955 A jetty to the seaward side of Hamilton Dock was used from March for the lifeboat's moorings;

above 47ft Tyne *Spirit of Lowestoft* (ON.1132) on exercise off the harbour.

left The statue of a lifeboatman on the south side of the River Waveney beside the bascule bridge. Unveiled on 24 June 2000, the 14ft-high statue is a memorial to the port's volunteer lifeboatmen past, present and future. The statue was created by sculptor Dominic Marshall out of cold-cast bronze. The plaque in front dedicates it to lifeboat crews 'for their sterling duty to seafarers of the world'.

Lowestoft

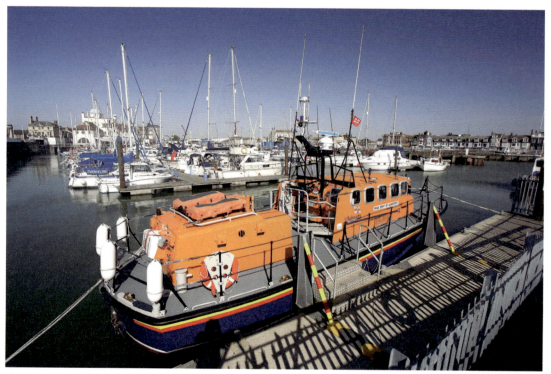

above 47ft Tyne Spirit of Lowestoft (ON.1132) at her moorings alongside the purpose-built boarding pontoon.

in February 1969 the moorings were moved, after which the jetty was demolished.

1969 A berth was provided on the north side of Hamilton Dock, and the lifeboat was moored here until 1972, with a gear store nearby.

1972 The lifeboat was moved to the Yacht Basin, with shore facilities provided on the adjacent Norfolk and Suffolk Yacht Club quay; these moorings were used until 1998.

1998 A new shore facility and workshop were built on the site of the former Pier Pavilion, and a new pontoon mooring in the south-east corner of the Yacht Basin was provided nearby as part of the development of a marina.

2001 Bicentenary Vellum awarded to commemorate 200 years of service.

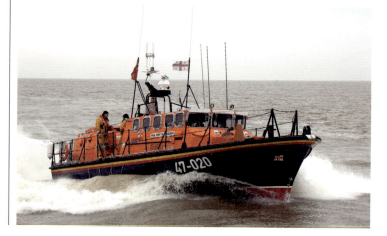

right Spirit of Lowestoft (ON.1132) on exercise off the harbour.

South Broads

Key dates	
Opened	2001
RNLI	2001
Inshore lifeboat	2001–11
Closed	2011

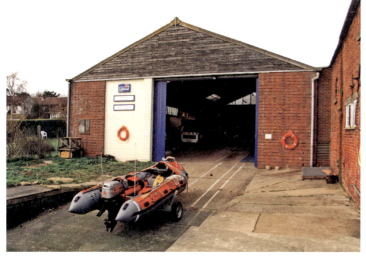

left The lifeboat station at A. D. Truman's boatyard, where temporary wooden walls were put in the boatyard for changing and stores, and the ILBs were launched down the slipway stern first. The station was also equipped with an XP boat that was transported by road on a 4x4 vehicle to enable them to travel to certain areas more quickly than by water.

2001 An inland lifeboat station was established to cover the South Broads, becoming operational from 12 July with a relief D class inflatable; it was based in an existing building at Oulton Broad leased from A. D. Truman's, located at the end of Caldecott Road.

2005 The station was relocated to Hampton Boats, where one portacabin was used as an office, with a second portacabin as a changing facility.

2011 The station was closed; the D class ILB was withdrawn, and the other equipment was relocated to Great Yarmouth & Gorleston, which could cover the Broads area more effectively.

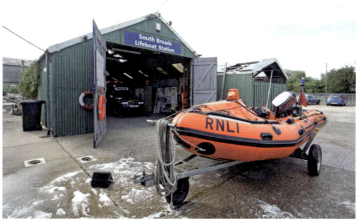

above D class inflatable Jean Ryall (D-714) on her launching trolley outside the boathouse in the north-east corner of Oulton Broad. Between 2001 and 2011 the station's ILBs and volunteer crews undertook 194 rescues and saved two lives on the Broads.

left D class inflatable Jean Ryall (D-714) was the only new ILB sent to South Broads, but served for just nineteen months before being withdrawn when the station closed. She is pictured on 21 August 2010 after being formally named by Heather Hampton.

Pakefield

Key dates
Opened	1840
RNLI	1855
No.2 station	1871–95
Closed	1922
Beachmen LB	1861–70

Station honours
Silver medals	3

above Launching the 42ft Norfolk & Suffolk sailing lifeboat James Leath (ON.607) across the beach at Pakefield, where she served for nine years.

below The large 46ft 3in Norfolk & Suffolk sailing lifeboat Two Sisters, Mary and Hannah (ON.23) being launched at Pakefield; she was on station as the No.1 lifeboat 1872–86 and 1890–1910.

1840 The first lifeboat was operated by the Suffolk Humane Society; the 45ft Norfolk & Suffolk type lifeboat was built in Great Yarmouth, and a lifeboat house was built on the beach at the southern end of Pakefield village.
1855 The station and lifeboat were taken over by the RNLI.
1861 A lifeboat was built at a cost of £200 by the Beachmen's Company for use as both a salvage boat and a lifeboat; it was used until 1870.
1870 The lifeboat house was moved after encroachment by the sea threatened the site and had begun to undermine the foundations.
1871 A No.2 station was opened by the RNLI after the Beachmen's Company lifeboat was removed; a 30ft 3in Norfolk & Suffolk type lifeboat and launching carriage were supplied, with the lifeboat arriving in January and being named *Henry Burford RN* (ON.24). To accommodate the No.2 lifeboat, a wooden boathouse measuring 30ft by 18ft was built on the beach at the northern end of Pakefield village.
1886 The No.1 lifeboat house was in need of moving again following further encroachment by the sea, but as the large lifeboat was by then deemed of limited use due to the Pakefield Gateway becoming blocked, which made it impossible to reach vessels wrecked on the Newcombe Sands, the RNLI decied to close the station. The lifeboat, *Two Sisters, Mary and Hannah*, was withdrawn on 15 May, leaving Pakefield with just one lifeboat.
1890 The No.1 station was reopened following the efforts of local people who were concerned over the withdrawal of the large lifeboat. In 1888 they presented a petition to the RNLI, and eventually in November 1889 the RNLI agreed to reopen the station. A new boathouse was built at a cost of £798 10s 9d close to the original site, and on 4 March, with the new house ready, *Two Sisters, Mary and Hannah*, returned from Lowestoft, where she had been serving since 1886.
1891 Much of the beach in front of the No.2 boathouse was washed away and the building's foundations were undermined; repairs were carried out by H. Reynolds at a cost of £180 10s 10d.
1893 Further storms made the No.2 boathouse unusable, so *Henry Burford RN* was moved into the No.1 boathouse, with the No.1 lifeboat *Two Sisters, Mary and Hannah* being kept in the open at the top of the beach under a tarpaulin.
1895 The No.2 station was closed and *Henry Burford RN* was withdrawn at the end of June; a concrete sea wall was built in front of the No.1 boathouse, at a cost of £12 5s 0d, to protect it.
1919 A smaller lifeboat, *Hugh Taylor* (ON.629), was placed on station as the larger lifeboat was moved to Caister.
1922 The station was closed as Lowestoft's new motor lifeboat could adequately cover the area; *Hugh Taylor* was withdrawn in May. There is nothing left of either of the boathouses. The sites are now some distance offshore as the original cliffs have been washed away and the coast eroded. The service boards were hung in Pakefield church, but were destroyed when the church was bombed in 1940.

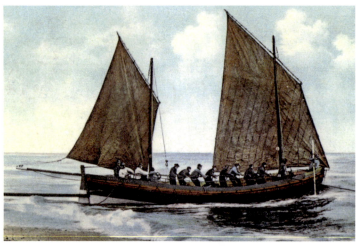

Kessingland

Key dates
Beachmen	1855–69
RNLI	1867
No.2 station (at Benacre)	1870–1918
No.3 station	1884–96
Closed	1936

Station honours
Bronze medals	14
Silver medals	5

left The lifeboat house of 1870 at Kessingland Beach pictured in 1936 after severe storms had caused the front section of the building to collapse.

below The rear and side walls of the boathouse at Kessingland Beach, dating from 1870, have been incorporated into the house in the foreground, but nothing else is left of the station.

below The last Kessingland lifeboat was the 34ft Norfolk & Suffolk type Hugh Taylor (ON.629), which served from May 1931 to November 1936, and is pictured returning to the beach.

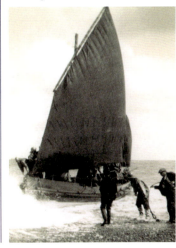

1855 A lifeboat was funded and operated by the local beachmen, who bought the former beachmen's lifeboat *Solebay*, a 40ft Norfolk & Suffolk, from Southwold in July at a cost of £55. The RNLI sent a grant of £10 towards the cost of the boat and also provided a set of cork life jackets.

1860 A lifeboat house was built for £40, with the RNLI contributing £10.

1867 The RNLI decided to establish their own station and a 32ft Norfolk & Suffolk type lifeboat, named *Grace and Lally of Broadoak* (ON.26), was supplied. A lifeboat house was built at Benacre Ness, almost a mile south of Kessingland Beach, by local builder Mr Rix at a cost of £164 2s 0d.

1870 The beachmen's lifeboat *Solebay* was found to be unfit for service and so was withdrawn. In her place, the RNLI provided another lifeboat, the 42ft Norfolk & Suffolk *Bolton* (ON.25) to operate from a station at Kessingland Beach, where a boathouse was built by Wigg & Co. at a cost of £266 7s 0d. The new boat, which was designated the No.1 lifeboat, arrived in November.

1882 The foreshore was eroded and so a platform was built in front of the No.1 boathouse at a cost of £56 10s 0d.

1884 A No.3 station was established, with the 38ft 6in Norfolk & Suffolk lifeboat *Charles Bury* (ON.27), which was operated from Kessingland Beach. To accommodate her, a new double boathouse was built by R. Chipperfield to accommodate both lifeboats at a cost of £337 6s 0d.

1897 The No.3 station was closed and *Charles Bury* (ON.27) was withdrawn having never launched on service.

1918 The No.1 station was closed in October when the *Bolton* lifeboat was transferred to the Southwold No.1 station, where she served until a new motor lifeboat arrived there in 1925.

1936 During severe storms in November, the foundations of the lifeboat house were undermined and the front section of the building collapsed; the lifeboat *Hugh Taylor* (ON.629), which had been on station since May 1931, was recovered from the house, slightly damaged, but the RNLI decided to close the station as a result of the damage to the boathouse, and *Hugh Taylor* was sold locally.

1937 A plaque was unveiled in the parish church commemorating the rescue work of the volunteer lifeboat crews of Kessingland.

Southwold

Key dates
Opened	1841–1940 and 1963
RNLI	1854–1940 and 1963
No.2 station	1866–1920
Motor lifeboat	1925–40
Closed	1940
Inshore lifeboat	1963

Current lifeboats
ILB Atlantic 85
B-868 Annie Tranmer
Donor Annie Tranmer Charitable Trust
On station 29.5.2013
Launch Davit

Station honours
Framed Letter of Thanks	2
Thanks Inscribed on Vellum	4
Bronze medals	5
Silver medals	10

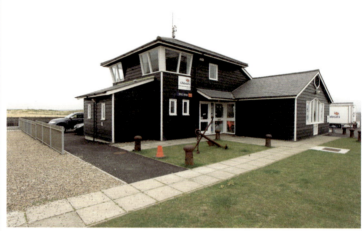

right The ILB house, built in 1993 on the Dock Wall, is close to the entrance to the harbour and located at the end of Ferry Road, about a mile to the south of Southwold town.

left The ILB house on the Dock Wall was built in 1993 and has housed Atlantic 21, 75 and 85 inshore lifeboats.

1840 A lifeboat station was established by the Southwold Lifeboat Society, an independent organisation formed following serious loss of life on the Barnard Sand in November. A meeting was held on 18 December at the Town Hall at which the Society was founded.
1841 The Society raised £385 7s 2d through local subscriptions during its first year, and this was used to fund a lifeboat house, built under the North Cliff, and a lifeboat. The first lifeboat, the 40ft Norfolk & Suffolk type *Solebay*, was built by Teasdel of Great Yarmouth.
1854 The RNLI took over the running of the station from the Southwold Lifeboat Society in October.
1858 The 40ft Norfolk & Suffolk sailing lifeboat *Harriett* (ON.29) capsized during an exercise in February with the loss of three crew out of eighteen.
1862 The lifeboat house was rebuilt in a more secure place on the South Denes after it had been undermined during a severe gale in which about a third of the house was destroyed.

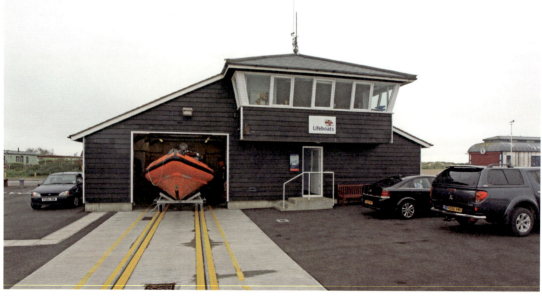

Southwold

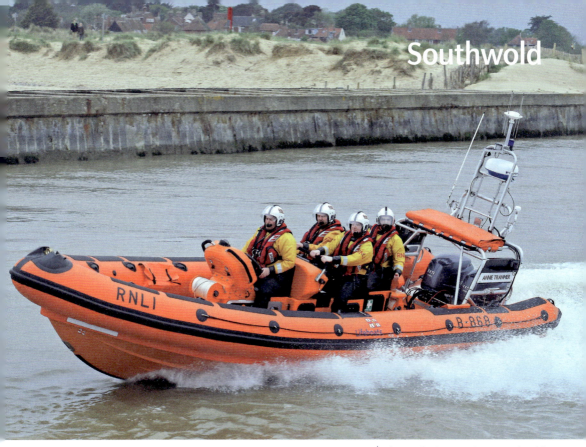

1866 A No.2 station was established, and a lifeboat house was built for the station's second lifeboat, the 33ft self-righter *Quiver No.2*, which was launched by carriage.

1880 Both lifeboat houses were repaired and the shingle floors were cemented at a cost of £72 1s 9d.

1893 The boathouse was enlarged to accommodate the new lifeboat, *Alfred Corry* (ON.353), at a cost of £143; the house was used until 1908.

1904 Following erosion of the beach, sheet piling was built around the front of lifeboat houses to protect them at a cost of £328 5s 8d.

1908 The No.1 lifeboat was moved to the harbour, where she was kept on a

above Atlantic 85 Annie Tranmer (B-868) leaves harbour on exercise. She is the fourth, and largest, Atlantic rigid-inflatable ILB to serve the station.

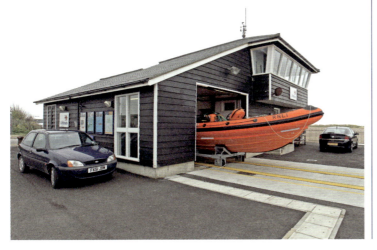

left The ILB house on the Dock Wall with Atlantic 85 Annie Tranmer (B-868) on the launching cradle. Designed by architects Mullins Dowse and Partners of Woodbridge, the building is an L-shape with the main ground floor comprising a changing room and the boathall. A crew room and lookout are on the first floor.

93

Southwold

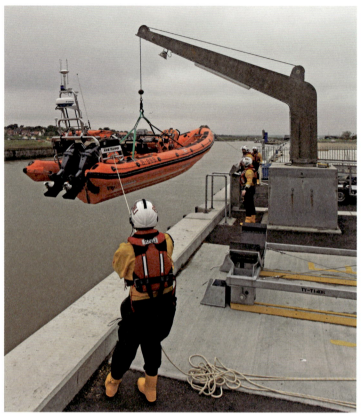

above Launch of Atlantic 85 Annie Tranmer (B-868) from the rebuilt Dock Wall using the davit installed in 1993. The cradle, to the right, was supplied in 2013 for the Atlantic 85.

platform built to seaward of the steam ferry and a storehouse was constructed.
1918 Some time after 1918, the lifeboat was placed at moorings in the river.
1920 The No.2 station was closed, and the two lifeboat houses on the South Denes were demolished, though the No.2 house stood until at least 1939.

1925 The motor lifeboat *Mary Scott* (ON.691) was placed on station and was kept afloat in the harbour.
1940 The station was closed because the boom placed across the harbour as an anti-invasion measure prevented the lifeboat putting to sea.
1963 An inshore lifeboat station was established in July; the D class ILB was kept in the store building of The Harbour Inn; Southwold became one of the first ten stations to have an ILB.
1966 A purpose-built wooden ILB house was constructed at Blackshore, 100 yards from the first location; a combined Harbour Master's Office was added later; from this house, the ILB was launched stern first down a short slipway into the river; this house was used until 1993, but remains standing.
1973 The station was upgraded with an Atlantic 21; *Solebay* (B-518) was placed on station in August.
1993 A new ILB house was built on the Dock Wall, near the harbour entrance, providing improved crew facilities; the ILB was launched using a marine davit.
2012 The station moved to a temporary site upriver from the boathouse and the Atlantic was launched by carriage and tractor while the sea wall was rebuilt.
2013 A new launching cradle, running on rails, was installed for the Atlantic 85, and the boathouse doors were raised to accommodate the new boat.

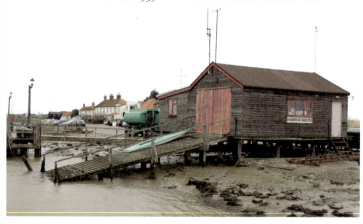

right The ILB house built in 1966 at Blackshore, on the south bank of the River Blyth, for the D class inflatable, and later used by the first Atlantic 21, has since become the Harbour Master's Office.

Dunwich

Key dates
Opened	1873
RNLI	1873
Closed	1903

left This lifeboat house, built in 1873, served throughout the life of the station, housing three lifeboats. The station was temporarily closed in 1901 due to crew shortages and permanently closed two years later. The small village of Dunwich suffered considerably from erosion by the sea and, at the time this photograph was taken, November 1911, the lifeboat house was at the edge of the beach. The continued undermining resulted in the collapse of the house, and no trace remains of the station. (From an old photo in the Jeff Morris Collection)

1873 A station was established by the RNLI, who supplied the 30ft self-righter *John Keble* and built a lifeboat house at a cost of £192 10s 0d. The lifeboat was launched by carriage across the beach.
1893 Tippings Plates were supplied to improve launching for the station's third and final lifeboat, *Lily Bird* (ON.370), a 34ft self-righter which arrived on station in September.
1903 The station was closed and the boathouse was sold for £25.

Sizewell/Thorpeness

1826 A 24ft lifeboat was stationed at Sizewell by the Suffolk Shipwreck Association in November, and a brick 27ft by 12ft boathouse was built for her.
1851 The station was taken over by the RNLI and the lifeboat was moved to Aldeburgh, about four miles south.
1853 A station was opened at Thorpeness and a boathouse was moved there from Aldeburgh at a cost of £30.
1863 A new lifeboat house was built at a cost of £170; lifeboat carriage launched.
1889 The lifeboat was moved to Sizewell Gap and the lifeboat house was sold for £100 in about 1890.
1892 Lifeboat removed back to the site of the old lifeboat house.
1900 The station was closed.

Key dates
Opened	Sizewell: 1826–51
	Thorpeness: 1853
RNLI	1855
No.2 station	1860–63
Closed	1900

left Between 1853 and 1900, a lifeboat was operated from the village of Thorpeness. The station was managed by the Aldeburgh committee, and it was from Aldeburgh that the station's first lifeboat was transferred. The boathouse pictured is that built in 1863 and inside is probably one of the three self-righting lifeboats named *Ipswich* that served the station between 1862 and 1892, most likely the latter of the three. This boat, a 37ft self-righter pulling twelve oars, served from 1873 to 1892 and is credited with saving nineteen lives. The station was closed in 1900 as the area was adequately covered by the two lifeboats at Aldeburgh where a crew could be obtained more readily, and the last lifeboat, the 39ft self-righter *Christopher North Graham*, was withdrawn in April 1900.

Aldeburgh

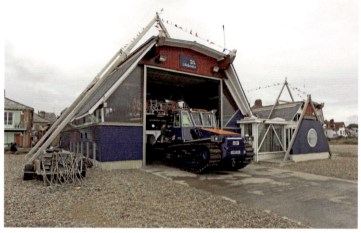

Key dates
Opened	1851
RNLI	1855
No.2 station	1905–1959
Motor lifeboat	1930
Inshore lifeboat	1977

Current lifeboats
ALB 12m Mersey
ON.1193 (12-34) Freddie Cooper
Built 1993
Donor Legacy of Mrs Winifred May Cooper, named in memory of former director of East Midland Allied Press Limited
On station 19.12.1993
Launch Talus MB-H tractor and carriage

ILB D class inflatable
D-673 Christine
Donor Legacy from Mrs Florence Kemp
On station 1.5.2007
Launch Trolley

Station honours
Framed Letter of Thanks	3
Thanks Inscribed on Vellum	1
Bronze medals	5
Silver medals	10

right The lifeboat house at Aldeburgh is one of eight 'Penza' lifeboat houses; it was built in 1993 for the Mersey lifeboat.

opposite 12m Mersey Freddie Cooper (ON.1193) on exercise off Orfordness.

below The lifeboat house built in 1993 consists of a boathall for the all-weather lifeboat and a separate house for the Talus MB-H launching tractor

1826 A 24ft by 8ft non-self-righting lifeboat was placed at Sizewell, as mentioned above, by the Suffolk Shipwreck Association and was manned from Aldeburgh; a boathouse measuring 27ft by 12ft was built to accommodate the boat.

1851 The RNLI took over the Suffolk Association's lifeboat operations and the Sizewell lifeboat was moved to Aldeburgh at the end of the year; a wooden boathouse, measuring 38ft by 15ft, was built at Slaughden Quay, at the southern end of Aldeburgh, at a cost of £58; this house was used until 1864.

1855 On 3 November, during severe weather, seven vessels were wrecked or driven ashore; while attempting to wade out with a line to the Swedish brig *Vesta*, Thomas Cable was killed after the line parted. Despite this setback, the other rescuers continued with their attempts and eventually saved seven of *Vesta*'s crew of nine.

1859 The lifeboat capsized on service on 21 December in very high surf, with the loss of three of her crew of fifteen; they were Thomas Cable, Philip Francis Green and John Pearce.

1864 The site of the lifeboat house was required for building purposes, so the house was demolished and a new brick replacement was built by J. T. Wright at a cost of £225 12s

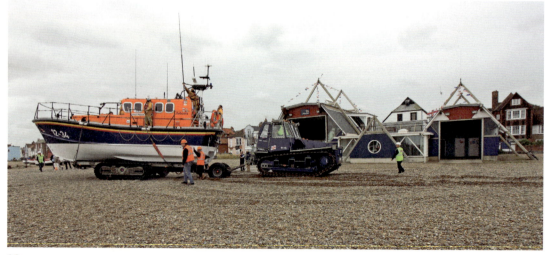

Aldeburgh

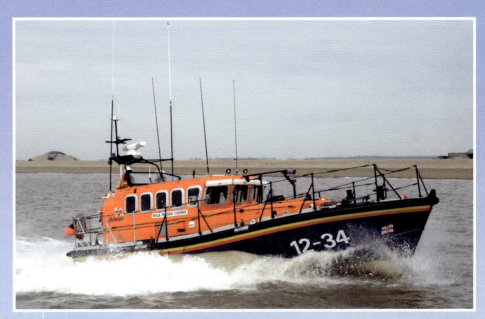

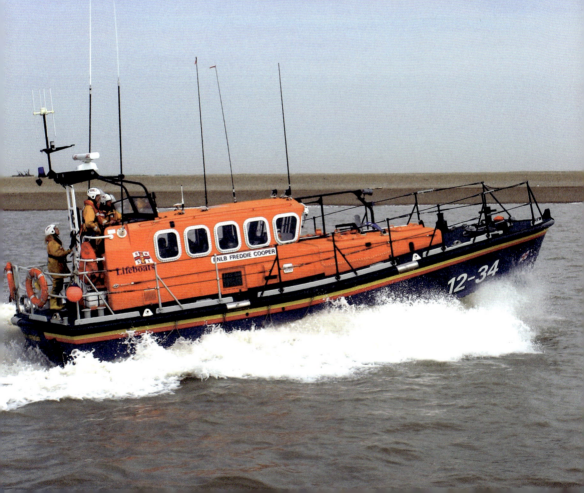

Aldeburgh

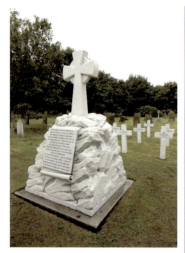

above The memorial in Aldeburgh parish churchyard to the seven lifeboatmen who lost their lives in the disaster of December 1899 when the lifeboat capsized. The graves of those who died are marked by plain crosses adjacent to the memorial.

below 12m Mersey Freddie Cooper (ON.1193) on exercise off Southwold.

od; this was used until 1879, and was demolished in 1884.

1879 Due to severe encroachment on the boathouse by the sea making the building dangerous, the boat was moved out of the house and kept in the open under canvas at a site three-quarters of a mile to the north, just to the south of the Moot Hall; from then on, as at many stations in East Anglia, the lifeboats were kept on the beach.

1883 A store house was rented to provide a gear store for the crew.

1892 A gas service was provided to the lifeboat house.

1899 During a south-easterly gale and extremely heavy seas on 7 December the lifeboat *Aldeburgh* (ON.304) went to the assistance of a vessel aground on Shipwash Sands. When crossing the Inner Shoal, the lifeboat was struck broadside on by two huge waves, and capsized, leaving six of her crew trapped. As soon as the lifeboat came ashore efforts were made to get the trapped men out of the upturned hull but to no avail. Seven of the crew of eighteen were lost: John Butcher, Thomas Morris, Herbert Downing, Charles Crisp, Walter Ward, James Millerward and Alan Easter.

1905 A 38ft Liverpool type lifeboat, *Edward Z. Dresden* (ON.545), was placed on station as a No.2 lifeboat following the closure of the stations at Dunwich and Thorpeness; like the No.1 lifeboats, she was also kept in the open and launched across the beach.

1930 A turntable was installed for the No.1 lifeboat to improve launching arrangements; a motor lifeboat, the 43ft Watson *William MacPherson* (ON.620), was sent to the station in February on a trial basis, staying until October to assess whether a motor lifeboat could be launched across the beach.

1931 Following the success of the trials, the station's own motor lifeboat, the 41ft Beach *Abdy Beauclerk* (ON.751) was

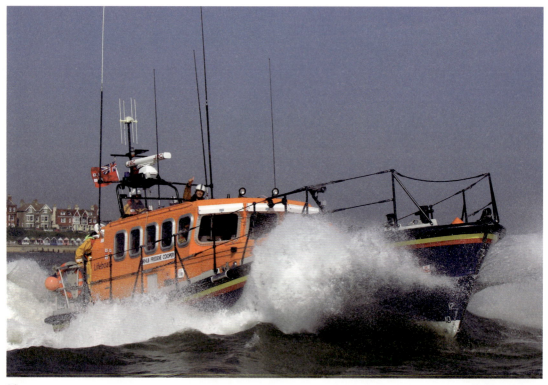

Aldeburgh

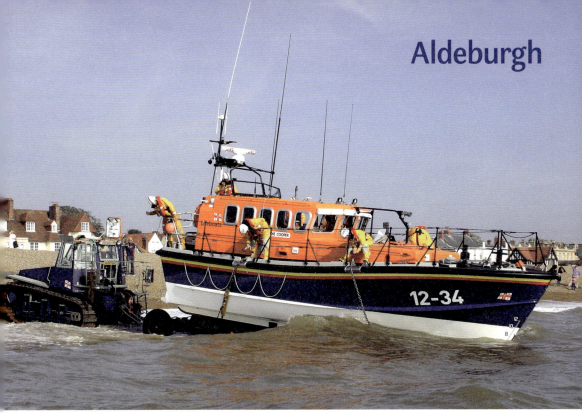

placed on station in December.

1939–45 During the war, the Aldeburgh lifeboats were launched on service fifty-eight times and rescued 107 lives.

1940 The 35ft 6in Liverpool motor *Lucy Lavers* (ON.832) became the first motor lifeboat at the No.2 station in May.

1959 The No.2 lifeboat *Lucy Lavers* (ON.832) was withdrawn in February when the new 42ft Beach motor *Alfred and Patience Gottwald* (ON.946) was placed on station. A new turntable was built higher up the beach, so as to give the lifeboat a better run down to the sea, and a new electric capstan for recovering the boat was installed.

1963 A new turntable and 62ft launchway were built across the shingle to improve launching arrangements.

1968 A new workshop and crew room were built on the beach close to the launching slipways.

1974 A 150th Anniversary Vellum awarded to the station.

1977 An inshore lifeboat station was established in July, and the D class inflatable D-111 was supplied.

1978 The Old North Lookout, situated on the beach to the north of the lifeboat cradle, once used by the Fishermen's Guild and originally by the pilots, was adapted to house the ILB.

1986 A tractor house and workshop were built; they were used until 1993.

1993 The station was adapted for a 12m Mersey class lifeboat, launched by tractor and carriage, to replace the beach launch used hitherto. A new lifeboat house was built on the beach, on the same site as the turntable and

above 12m Mersey *Freddie Cooper* (ON.1193) launching on exercise from the shingle beach at Aldeburgh.

below The North Lookout building, which was severely damaged by a storm in 1959 and repaired in 1960, has been used by the ILB since 1978. The extension at the front was added in 1997 and the roof was repaired and replaced in 2013. The historic building, which dates from the mid-nineteenth century and backs on to Crag Path, was one of two built on the beach for the use of competing pilot organisations.

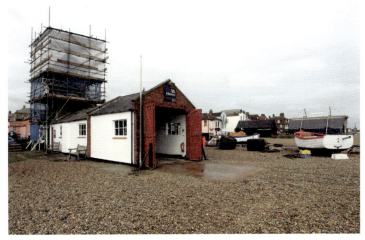

99

Aldeburgh

above left The Bobcat T250 multi-terrain loader, number BC06, used for flattening the shingle and launching the ILB.

above right D class inflatable Christine (D-673) inside the North Lookout lifeboat house on her launching trolley.

launchways, which were removed; this consisted of two buildings adjacent to each other, one for the lifeboat and the other the launching tractor, linked by a single-storey section providing crew facilities and a souvenir outlet.

1997 The ILB house was extended to accommodate the bladed tractor used for flattening the shingle.

2002 An extension to the boathouse was completed in September at a cost of £240,739.

Bawdsey/Orford/Woodbridge

Key dates

Bawdsey	1801–25
Woodbridge	1825–54
Orford	1826–34

The two lifeboats that were stationed between Orford and Woodbridge Haven operated from three different locations, with the stations known variously as Bawdsey, Hollesley Bay, Orford, Orfordness and Woodbridge. Their area of coverage was Hollesley Bay, between Orford and Bawdsey, and Woodbridge Haven, at the entrance to the River Deben. The precise locations from where the lifeboats operated is not known, and no trace remains of the boathouses that were built.

1801 A local committee, led by the Revd Richard Frank and P. B. Broke organised the purchase of a lifeboat for Bawdsey. The lifeboat, built by Henry Greathead, was funded by local subscriptions, and was kept in a wooden boathouse.

1806 The station was taken over by the Suffolk Humane Society, an organisation founded on 7 January.

1824 The lifeboat was taken over by the Suffolk Association for Saving the Lives of Shipwrecked Seamen, which was founded on 16 October; in December the new Association decided to acquire a new lifeboat for Orford.

1825 The 1801 lifeboat was moved to Woodbridge by the Suffolk Association and the boathouse from Bawdsey was also moved there, at a cost of £30.

1826 A new lifeboat was built by William Plenty for the Suffolk Association, and was stationed at Orford, to the north of Bawdsey, in March; it was named *Grafton*. A new boathouse was also built, which measured 29ft by 13ft in size, with the door 10ft by 8ft.

1835 The Plenty-built lifeboat *Grafton* was moved two miles south to the entrance to Woodbridge Haven, having never been used at Orford, and replaced the 1801-built Greathead lifeboat.

1843 The boathouse at Woodbridge was sited, according to the Report on Shipwreck, on the north side of the River Deben, and the lifeboat was under the charge of Joshua Rodwell, secretary to the Suffolk Association.

1851 The Woodbridge station was taken over by the RNIPLS. The boathouse was about 25 yards from the low-water mark and the boat was launched over rollers.

1854 At a Committee Meeting of the RNIPLS on 6 July it was reported that the local committee deemed their lifeboat was no longer required, so she was withdrawn and the station closed.

Harwich

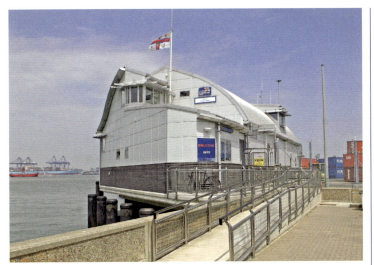

Key dates
Opened	c.1821–p.43, 1876–1917 and 1965
RNLI	1876–1917 and 1965
Motor lifeboat	1967
Inshore lifeboat	1965
Fast lifeboat	1967

Current lifeboats

ALB 17m Severn
ON.1202 (17-03) Albert Brown
Built 1996
Donor Bequest of Victoria Maisie Brown, London, in memory of her husband
On station 2.10.1996
Launch Afloat

ILB Atlantic 75
B-789 Sure and Steadfast
Donor The Boys' Brigade Appeal
On station 15.10.2002
Launch Davit

Station honours
Framed Letter of Thanks	4
Thanks Inscribed on Vellum	
Bronze medals	4
Silver medals	16

1821 The first lifeboat, *Braybrooke*, was built by George Graham and funded by the Essex Lifeboat Association, which first met on 7 December 1820; the boat was officially launched on 12 September, and was kept moored in the harbour near the guard vessel. Independently of this, another lifeboat was built for service at Landguard Fort, opposite Harwich, by Jabez Bayley, funded by a subscription in Ipswich, and known as the 'Ipswich Life Boat'.
1825 In October it was reported that the Landguard lifeboat was 'totally inefficient' and she was sold.
1829 *Braybrooke* was reported to be in a state of disrepair and was rotting.
1876 The RNLI established a station following the wreck, in December 1875, of the steamship *Deutschland*; a lifeboat house was built at a cost of £247 10s on the sea bank east of the town from which the lifeboat, a 35ft self-righter, was launched using a carriage; tugs were employed to tow the lifeboat when required at a cost of £5.
1881 The lifeboat *Springwell* capsized on service on 18 January with the loss

above left The crew facility and ILB house built in 2001–2 on The Quay.

below The lifeboat station, ILB launch davit and mooring pontoon for 17m Severn at Navyard Wharf.

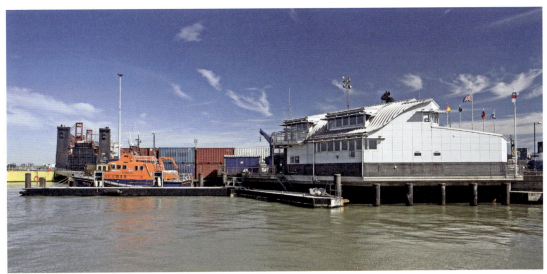

101

Harwich

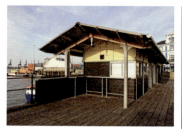

above The building which housed the Atlantic 21 from 1978 to 2002 on Ha'penny Pier; it has since been converted and extensively rebuilt for use as a café.

right The lifeboat house built in 1876 and used for the lifeboat until 1881; the original ornamental turret was removed but was replaced with a replica, and the building has been converted into a small lifeboat museum.

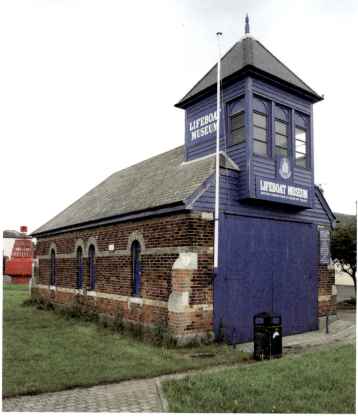

above The gravestone for William Wink in Dovercourt Cemetery, with the inscription reading 'who lost his life by the upsetting of the lifeboat'.

opposite 17m Severn Albert Brown (ON.1202) on exercise off the Essex coast.

of one crew member; as a result a larger lifeboat, measuring 45ft by 11ft, was sent to the station, also named *Springwell*, and was moored in the harbour, near the pier, as she was too large to be kept ashore; she was often towed to wrecks by steam tugs. The boathouse was retained until the station closed in 1917; in 1922 the boathouse was surrendered to the War Office. The building was bought by Essex County Council in the 1990s and passed to the Harwich Society in 1993. It has since been converted into a Museum and houses the former Clacton-on-Sea lifeboat *Valentine Wyndham-Quin*.

1890 In addition to the pulling lifeboat, a steam lifeboat was placed on station; the RNLI's first steam lifeboat, *Duke of Northumberland* (ON.231), arrived in September and was kept at moorings in the harbour near the pulling lifeboat.

1894 A new steam lifeboat, *City of Glasgow* (ON.362), was built for the station and served until 1901.

1897 Three members of the lifeboat crew were washed out on service on 2 December to an unknown vessel; fortunately they were recovered.

1912 The 43ft Watson sailing lifeboat *Ann Fawcett* (ON.517), which had been on station since March 1904, was withdrawn in October, as a sailing lifeboat was not considered necessary with the steam lifeboat in service.

1917 The station was closed when the steam lifeboat, the second *City of Glasgow* (ON.446), which had been on station since May 1901, was withdrawn from service in December; she was subsequently bought by the Admiralty.

1965 The station was reopened and an inshore lifeboat, D-71, was placed

Harwich

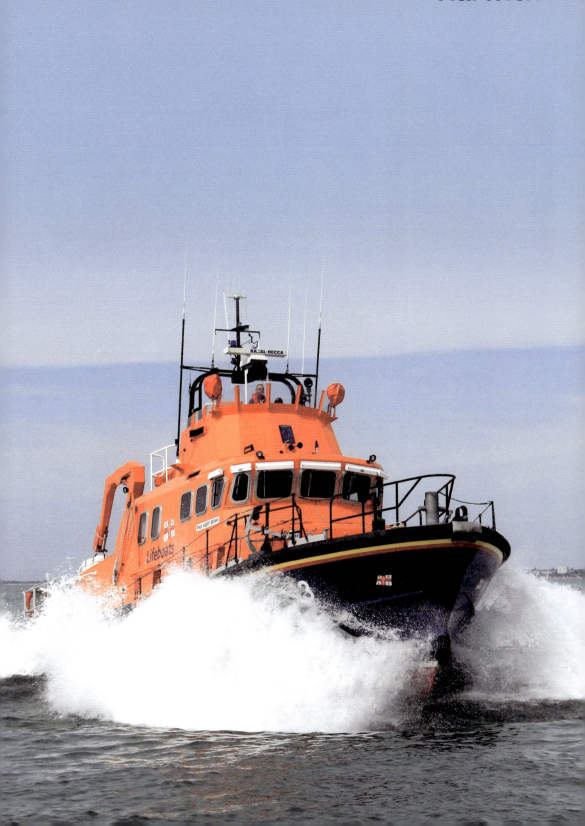

Harwich

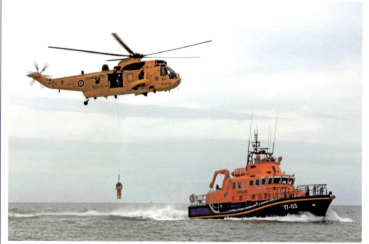

above Atlantic 75 Sure and Steadfast (B-789) on the cradle beneath the davit outside the lifeboat station, with Albert Brown (ON.1202) at moorings.

above right Albert Brown (ON.1202) on exercise with RAF Sea King helicopter.

below Atlantic 75 inshore lifeboat Sure and Steadfast (B-789) on exercise.

on station in May. A gift from the Graham Dunn Harbour Rescue Fund was used towards the cost of the boat. The D class ILBs on station from 1965 to 1978 were housed in a former army garage, since demolished, at Angelgate (now called Timberfields), close to the 1876 boathouse, which was occupied by a further education sailing club.

1966 The RNLI's Committee of Management decided to station a 44ft Waveney fast afloat lifeboat at Harwich, initially for a two-year trial period.
1967 The Waveney *Margaret Graham* (ON.1004) was placed on station in September and was kept afloat in The Pound, near Halfpenny Pier.
1970 The RNLI's Committee of Management confirmed the re-

Harwich

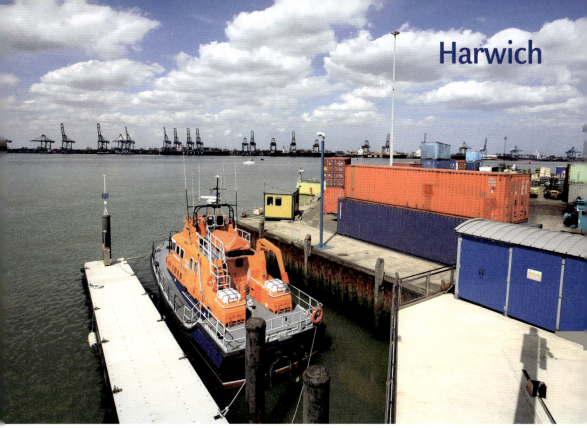

above Relief 17m Severn The Duke of Kent (ON.1278) alongside the pontoon, looking towards Felixstowe Container Terminal.

establishment of Harwich as an all-weather lifeboat station.
1977 A new ILB house was built on Halfpenny Pier, with a davit launching facility installed, for the Atlantic 21 B-526 which was sent to the station in December for trials.
1978 Atlantic 21 B-526 returned to the station in March and took over as the station's ILB in place of the D class ILB, which was withdrawn.
1990 A small extension was built at one end of the ILB house on Halfpenny Pier to provide a souvenir sales outlet.
1993 A larger crew room was provided to improve facilities at the ILB house.
1997 Harwich Haven Authority agreed in February to lengthen the piles and the lifeboat berth by two metres; during the 1990s a berth for the lifeboat had been found in the Harbour Master's Pound as the moorings in The Pound were unsuitable.
2000 Work began on construction of a new station building to house an Atlantic 75 at Navy Yard Wharf, together with improved crew facilities

and boarding arrangements; the building was completed in April 2002 at a cost of £1,450,000. The Atlantic was launched by davit from the quayside on a railed trolley; a mooring adjacent to the station was constructed for the all-weather lifeboat on a pontoon, which acts as a breakwater; the whole area of development was situated to the seaward of the present harbour wall.
2004 A new pontoon berth completed in November at a cost of £75,000.

below 17m Severn Albert Brown (ON.1202) and Atlantic 75 Sure and Steadfast (B-789) returning from exercise.

105

Walton and Frinton

Key dates
Opened	1884
RNLI	1884
Motor lifeboat	1906
Fast lifeboat	1993

Current lifeboats
ALB 16m Tamar
ON.1299 (16-19) Irene Muriel Rees
Built 2011
Donor Bequest of Irene Muriel Rees, Cliff Way, Frinton, plus RNLI funds
On station 9.5.2011
Launch Afloat

Station honours
Framed Letter of Thanks	16
Thanks Inscribed on Vellum	44
Bronze medal	11
Silver medal	4

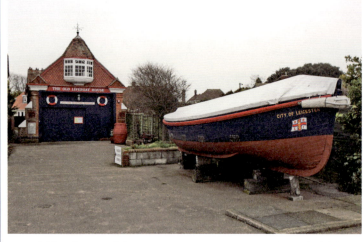

right The lifeboat house with the station's former boarding boat City of Leicester on display outside.

below The lifeboat house built in 1884, used until 1900 and now housing the Walton Maritime Museum.

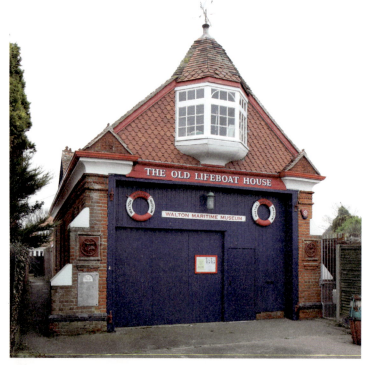

1884 A lifeboat house and slipway were built at a cost of £441 9s 6d close to the seafront on a site granted to the RNLI at a nominal rent by Robert Warner, Chairman of the newly formed local committee. The house was at the north end of the town, at East Terrace, close to the Coastguard station; a roadway was also constructed from the lifeboat house to the slipway down which the lifeboat was taken on its carriage; this house was used until 1900.

1890 The boathouse and slipway were improved, with the slipway widened and the roadway also improved.

1894 A lifeboat was acquired by some local boatmen and, named *True to the Core*, was kept moored off the pier.

1900 When a larger lifeboat, the 43ft Norfolk & Suffolk type *James Stevens No.14* (ON.432), was supplied to the station, she was kept afloat at moorings off the pier as she was too large to be launched by carriage, with the boarding boat *Ramon Cabrera* (ON.263), an old 33ft self-righter, nearby; various improvements to the boarding stage at the pier have been made, although boarding the lifeboat in severe weather was difficult as the moorings were very exposed. A wooden house built on piles on the south side of the pier was used as a rudimentary crew facility for the life jackets and other equipment.

1901 A private lifeboat, a 32ft 6in Norfolk & Suffolk type built for RNLI service at Caister, bought by Cook & Co., was stationed at Frinton-on-Sea and was used for salvage work; this boat was taken over by the Frinton Volunteer Lifeboat Society in 1904.

Walton and Frinton

16m Tamar Irene Muriel Rees (ON.1299) off Walton pier.

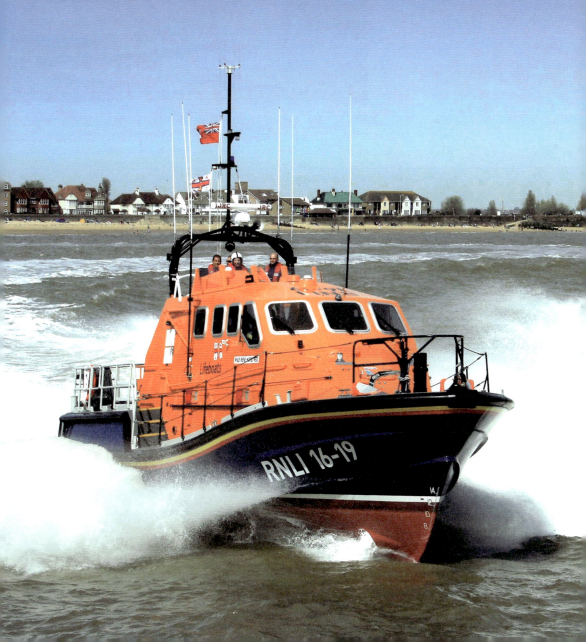

Walton and Frinton

right The shore facility, crew room and souvenir outlet situated in the centre of the town on the hill overlooking the pier. The building was constructed in 1938 and has since been adapted and extended. The station's service boards are mounted on the outside of this building.

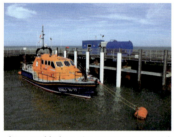

above and below 16m Tamar *Irene Muriel Rees* (ON.1299) in the purpose-built mooring pen, protected by the wavebreak, at the end of Walton Pier. (Peter Edey)

1906 The lifeboat *James Stevens No.14* (ON.432) was fitted with a 40hp four-cylinder Blake petrol engine, one of only five lifeboats to be motorised.

1917 The Frinton lifeboat *Sailor's Friend* ceased operations after she sank at her moorings opposite the old Beach Hotel, and was never used again.

1938 A new shore facility was built at Barnden's Corner at the end of New Pier Street, overlooking the pier, with work being completed in November.

1940 The lifeboat *E.M.E.D.* (ON.705) took part in the evacuation of the British Expeditionary Force from Dunkirk. During the Second World War the lifeboat launched fifty-seven times and saved twenty lives.

1984 The old lifeboat house was taken over by the Walton Maritime Museum.

1984 A Centenary Vellum was presented to the station.

1998 The crew facilities were improved and a fuel storage room was completed.

2004–5 A new mooring berth and wavebreak were constructed alongside the pier to improve boarding arrangements and make it unnecessary to use a boarding boat; it was operational from 20 January 2005.

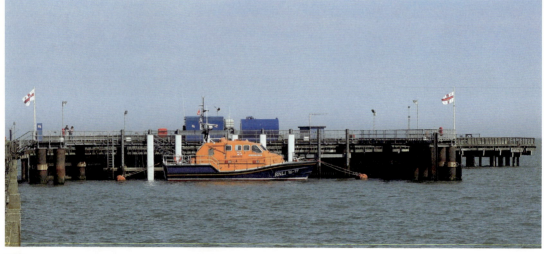

108

Clacton-on-Sea

Key dates
Opened	1878
RNLI	1878
Motor lifeboat	1912–84
Inshore lifeboat	1966, 2nd ILB 1984

Current lifeboats
ILB Atlantic 85
B-863 David Porter MPS
Built 2012
Donor Local fundraising
On station 8.8.2012
Launch Tractor and do-do carriage

ILB D class inflatable
D-723 Damarkand IV
Donor Gift from David and Marion Snell
On station 25.6.2009
Launch Tractor and trolley

Station honours
Framed Letter of Thanks	2
Thanks Inscribed on Vellum	5
Bronze medals	2
Silver medals	22

1878 A lifeboat station was established to cover the treacherous sandbanks off the Essex coast; a lifeboat house, with Masonic emblems to commemorate the donor, was built in Anglefield on the corner of Church Road and Carnarvon Road, at a cost of £510; soon after its building, a fence had to be placed around it to prevent cattle from causing damage. This house was used for the carriage-launched pulling lifeboats until 1901, and has since been converted into a public house called The Old Lifeboat House after being used as an Electrical Stores for some years.
1884 Two slipways were built on either side of the pier, at a cost of £690, to improve launching arrangements; the lifeboat was kept on the pier during the winter, and launched down the slipway.
1893 Repairs made to the slipways at a cost of £160.
1901 A large 45ft Watson sailing lifeboat, *Albert Edward* (ON.463),

left The first lifeboat house, built in 1878 at Anglefield, was used until the 1920s and has since been converted into a public house called the Old Lifeboat House.

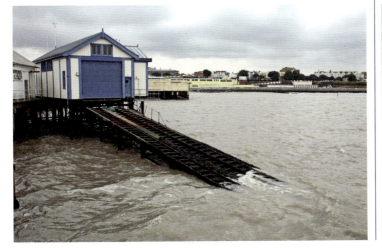

above The inshore lifeboat house built on the promenade in 1967 for the D class inflatable ILBs and launch vehicles with Seahorse II (D-559) outside being made ready for service after an exercise launch.

left The lifeboat house and slipway built in 1927–8 alongside the pier remain standing, but have been empty since 2006.

109

Clacton-on-Sea

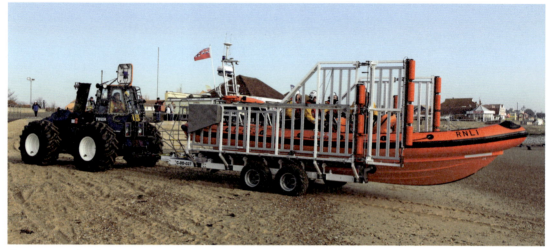

above Low-water launch of B-863 David Porter MPS across the beach using Talus 4WH tractor TW60H.

below Damarkand IV (D-723) being launched across the beach from the Martello Bay boathouse using New Holland TC45D tractor TA74.

below Atlantic 85 David Porter MPS (B-863) on exercise off the pier.

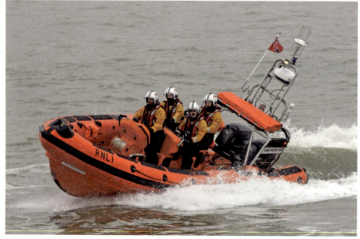

was sent to the station; she was too large to be carriage launched, so was kept at moorings off the pier during the summer, and launched from the slipways on the pier in the winter; a boarding boat was supplied to reach the lifeboat when it was on moorings; this arrangement lasted until 1927.
1912 The 45ft Watson *Albert Edward* (ON.463) was fitted with a 40bhp Tylor petrol engine; she was the largest pulling boat to be converted to motor.
1927 A new lifeboat house and roller slipway were built on the north side of the pier to improve launching arrangements, with a new 45ft 6in Watson motor lifeboat, *Edward Z.*

Dresden (ON.707), sent to the station; this boathouse was used until 2006 with alterations for subsequent lifeboats. A small memorial plaque to Second Coxswain Frank Castle, who lost his life on service in April 1943, was placed in the boathouse.
1940 *Edward Z. Dresden* was one of the nineteen lifeboats that took part in the evacuation of the BEF from Dunkirk. During the war, the lifeboat could not use the lifeboat house as the middle of the pier had been blown up to make it unusable to invading forces, so the lifeboat was moved to Brightlingsea in the River Colne, where she lay afloat.
1966 An inshore lifeboat station was established in July; the D class inflatable ILB was initially kept in a small container below the Pavilion.
1967 An ILB house was built on the lower promenade to the west of the pier and the ILB was launched over the beach; this house was used until 2006.
1978 A Centenary Vellum was awarded to the station.
1983 The relief 42ft Watson motor *The Duke of Montrose* (ON.934) was kept at moorings at Brightlingsea; silting at the foot of the slipway made launching the lifeboat difficult, and so the RNLI decided to change the status of the station and allocated an Atlantic 21.

Clacton-on-Sea

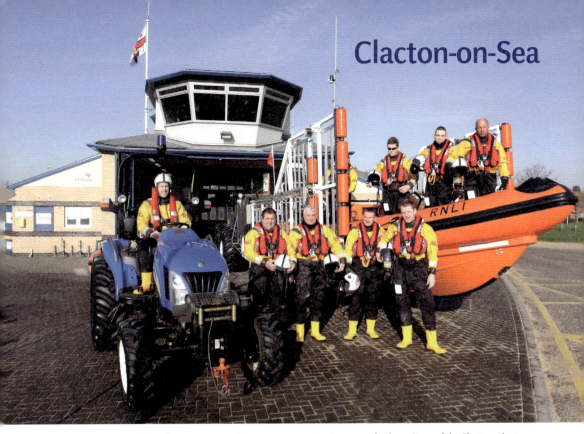

above Some of the Clacton volunteer lifeboat crew outside the lifeboat house with D class ILB Damarkand IV (D-723) and Atlantic 85 David Porter MPS (B-863).

1984 The lifeboat house was adapted to accommodate the Atlantic 21 on a launching cradle, which was installed and ran on rails down the slipway.

1998 The lifeboat house was modified and extended to accommodate an Atlantic 75, incorporating improved crew facilities; while the alterations were being undertaken the Atlantic 21 was launched by tractor and do-do carriage from a temporary site in Hastings Avenue, Martello Bay.

2005–6 A new lifeboat house, built at a cost of £645,125, was completed in September 2006; it was situated to the west of the pier and accommodated the Atlantic and D class ILBs, with greatly improved crew accommodation and modern facilities; the lifeboats were launched by tractor across the beach.

above The lifeboat house built in 2005–6, for housing both the B and D class inshore lifeboats, is situated about a mile west of the pier, close to the Martello Tower.

left D class inflatable Damarkand IV (D-723) on exercise off the pier.

West Mersea

Key dates
Opened	1963
RNLI	1963
Inshore lifeboat	1963

Current lifeboats
ILB Atlantic 75
B-761 Dignity
Donor Dignity Caring Funeral Services
On station 1.6.2001
Launch Tractor and do-do trolley

Station honours
Framed Letter of Thanks	3
Thanks Inscribed on Vellum	3

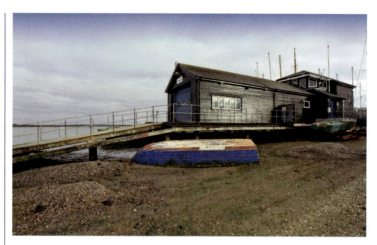

right The ILB house built in 1991–2 and altered in 2001 for the Atlantic 75.

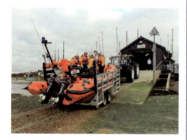

above Atlantic 75 B-761 Dignity being launched on exercise by tractor TW14.

right Atlantic 75 B-761 Dignity on exercise on the west side of Mersea Island.

below Atlantic 75 B-761 Dignity being launched across the tidal mud flats into the sheltered waters by the boathouse.

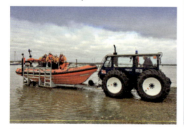

1963 An inshore lifeboat station was established in July; it was one of the first ten ILB stations in the UK and Ireland opened by the RNLI. The first ILB, a D class inflatable, was kept in a shelter next to the Yacht Club until a boathouse was built, adjacent to the local Yacht Club, opposite The Hard.
1972 The D class ILB was withdrawn and the station was upgraded to operate the Atlantic 21 ILB B-506.
1976 A new Atlantic 21, B-529 *Alexander Duckham*, was placed on station on in February.

1981 The ILB house was enlarged and a crew room was added.
1991–2 A new timber-clad ILB house was built on a piled concrete platform 200 metres north-west of the previous house, with a slipway leading down to the tidal mud flats; it housed the Atlantic ILB, a new launch and recovery winch, a crewroom and galley, a souvenir outlet and toilet facilities.
2001 The ILB house was altered to house the Atlantic 75 and launching tractor, with a two-storey extension built for improved crew facilities.

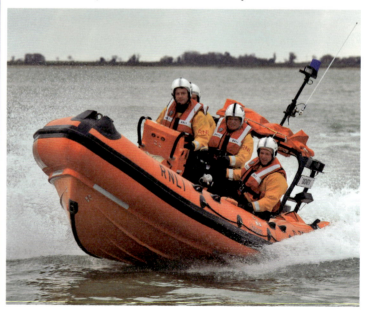

Burnham-on-Crouch

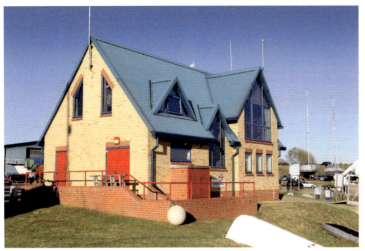

Key dates
Opened	1966
RNLI	1966
Inshore lifeboat	1966, 2nd ILB 1996

Current lifeboats
ALB Atlantic 85
B-849 Tony and Robert Britt
Built 1993
Donor Gift of Mrs Patricia Britt, Beckenham, Kent
On station 11.8.2011
Launch Floating ILB house

ILB D class inflatable
D-672 Ernest and Rose Chapman II
Donor Gift from David and Barbara Chapman, Wickford
On station 19.3.2007
Launch Floating ILB house

1966 An inshore lifeboat station was established in May; it was to have closed at the end of summer 1968, but following the withdrawal of the rescue helicopters from RAF Manston this decision was reversed and the station remained operational; the ILB was housed in a Hardun building adjacent to the Royal Corinthian Yacht Club.

1987 Having been operational during the summer only, it became an all-year station.

1988–9 A new brick ILB house was built on the corner of the Royal Corinthian Yacht Club car park to replace the previous ILB house, which was demolished; this house was used until 2002, when it was sold.

1996 The station was upgraded with the stationing of an Atlantic 75 in addition to the D class ILB; relief B-700 was placed on temporary station duty on 1 October; between May and September a floating boathouse was installed at the newly built Yacht Harbour to house the Atlantic 75; a two-storey crew facility next to the walkway leading to the floating boathouse was constructed between April and October.

2002 A second floating boathouse was installed, adjacent to the first, to house the D class inflatable; it was completed in July at a cost of £73,364.

2011 A new floating boathouse was installed at a of cost of £130,000 for the Atlantic 85 B-849 *Tony and Robert Britt*; built on a steel frame, it was fitted with a hoist powered by an electronic hydraulic system, and the entire cradle can lift and tilt to allow for drainage and easier access for maintenance.

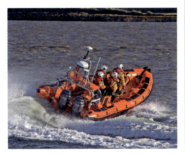

left The crew facility built in 1996 at Burnham Yacht Harbour, which is situated on the north bank of the River Crouch.

left Atlantic 85 B-849 *Tony and Robert Britt* is put through her paces at the end of her naming ceremony, 15 October 2011.

below The two floating boathouses in the Yacht Harbour, for the Atlantic 85 and D class inflatable.

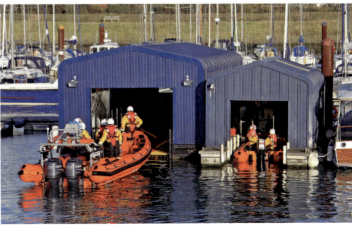

Southend-on-Sea

Key dates
Opened	1879
RNLI	1879
No.2 station	1885–91
Motor lifeboat	1928–76
Inshore lifeboat	1965, 2nd ILB 1969
Third inshore lifeboat (on pier)	1987
Hovercraft	2004

Current lifeboats

ALB Atlantic 75
B-776 Vic and Billie Whiffen
Donor Legacy of Stella 'Billie' Whiffen, Bridport, Dorset
On station 8.12.2001
Launch Davit

ILB D class inflatable
D-633 Pride of London Foresters
Donor The Courts of London United District of the Ancient Order of Foresters Friendly Society
On station 27.1.2005
Launch Davit

ILB D class inflatable
D-682 Essex Freemason
Donor Gift of the Freemasons
On station 5.11.2007
Launch Trolley

Hovercraft Griffon 470TD
H-004 Vera Ravine
Donor Bequest of Vera Ravine, Grays, London
On station 10.7.2004
Launch Slipway

Station honours
Framed Letter of Thanks	22
Thanks Inscribed on Vellum	24
Bronze medal	9
Silver medal	4

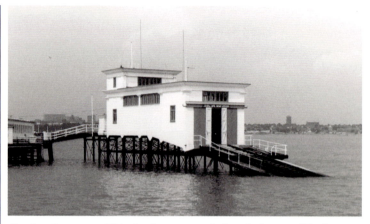

1879 A station was established and the small 25ft self-righting lifeboat *Boys of England & Edwin J. Brett* was provided by the RNLI; the lifeboat was provided to assist vessels and crews that ran aground on Nore and Leigh Middle Sands and other outlying banks at the entrance to the Thames, and the lifeboat was kept near the end of the wooden pier and launched by davit; between 1879 and 1891 it was launched from davits, or moored off the pier.
1885 A No.2 station was established, and a lifeboat, the 34ft self-righter *Theodore and Herbert* (ON.33), was supplied in October. The boat was launched by carriage, often being taken as far as Shoeburyness, four miles away, to be launched. A lifeboat house was built at the bottom of Hartington Road for the No.2 lifeboat, which supplemented the small lifeboat on the pier and was a standard-sized boat, for services on the Barrow, Mouse and Girdler Sands; the house, which cost £319 and was on land the RNLI had to buy, was demolished in the late 1970s.
1891 The small No.1 lifeboat was withdrawn, and the other lifeboat was then kept afloat inside the head of the pier in the winter and in the lifeboat house during the summer.
1915 The Pier Company allowed the use of a small house on the pier for the stowage of lifebelts and other gear.
1928 The station's first motor lifeboat, the 48ft 6in Ramsgate *Greater London (Civil Service No.3)* (ON.704), was placed

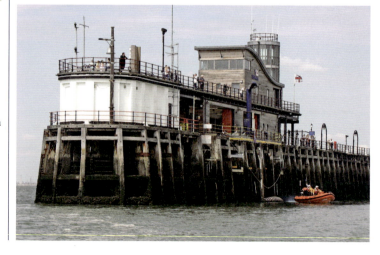

above right The lifeboat house and slipway built in 1934–5 of concrete and timber at the end of the pier. It was officially opened on 23 July 1935 and was adapted for the Atlantic 21 ILB in 1976. It was used until 1986, when it was hit by a motor tanker and damaged beyond repair, subsequently being demolished. Southend Pier, built in 1889 and 1.3 miles in length, is the longest such structure in Britain.

right Atlantic 75 Vic and Billie Whiffen (B-776) sets out on exercise from the ILB house, which was built in 2001 at the end of Southend's famous pier.

Southend-on-Sea

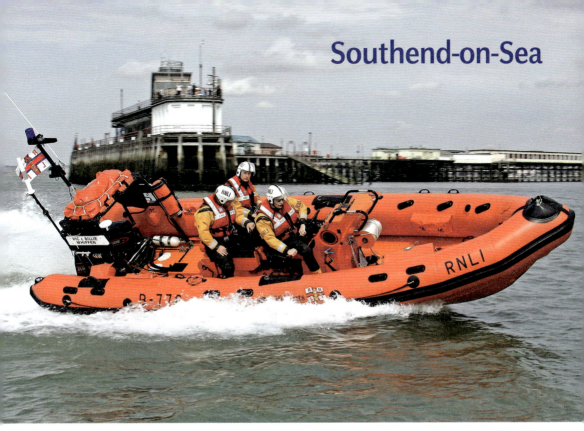

on station in May, and was initially kept afloat off the pier head.

1934–5 A lifeboat house with a roller slipway, 176ft in length with a gradient of one in six, was built at a cost of £15,750 at the east side of the seaward end of the pier, for the motor lifeboat; this was used for the lifeboat until 1976.

1940 The lifeboat *Greater London* (Civil Service No.3) (ON.704) was one of nineteen lifeboats that were taken to Dunkirk to help to bring off the British Expeditionary Force. *Greater London* hauled the destroyer HMS *Kellett* off the beach, saving her and her crew.

1965 An inflatable inshore lifeboat was sent to the station in May; it was housed in a boatshed on a jetty on the

above Atlantic 75 Vic and Billie Whiffen (B-776) on exercise off the pier.

left Atlantic 75 Vic and Billie Whiffen and hovercraft Vera Ravine (H-004) off the pier.

below Vic and Billie Whiffen being recovered by davit at the pier ILB house.

Southend-on-Sea

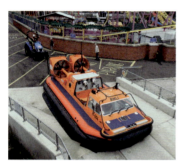

above The Griffon 470TD hovercraft Vera Ravine (H-004) being readied for launching down the slipway; the tractor TA106 is used to lower the craft down the slip.

right Vera Ravine (H-004) was placed on station in July 2004 to cover the extensive mudflats of the Thames Estuary.

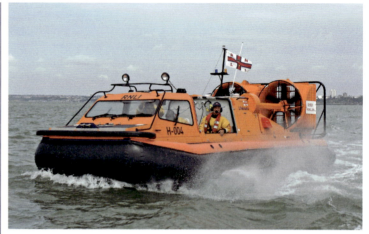

below The hovercraft Vera Ravine (H-004) and D class inflatable Essex Freemason (D-682), with the tractor TA106, outside the boathouse completed in 2013.

promenade to the east of the pier, and lowered into the water by davit.

1969 In April, in view of the withdrawal of the helicopters from Manston, a second ILB was sent to the station; it was housed on the promenade close to the pier.

1976 The offshore lifeboat, the 46ft 9in Watson motor *Greater London II (Civil Service No.30)* (ON.921), was withdrawn on 28 March and the lifeboat house was converted to house the Atlantic 21 rigid-inflatable B-527 *Percy Garon*, which was placed on station on 19 May.

1979 A new ILB house and slipway were built on the promenade just to the east of the pier to replace the former ILB house on the same site.

1986 The 1934–5 boathouse was severely damaged on 30 June when the 180ft coaster *King's Abbey* smashed through the pier, almost completely demolishing the lifeboat slipway; the house was unusable and was

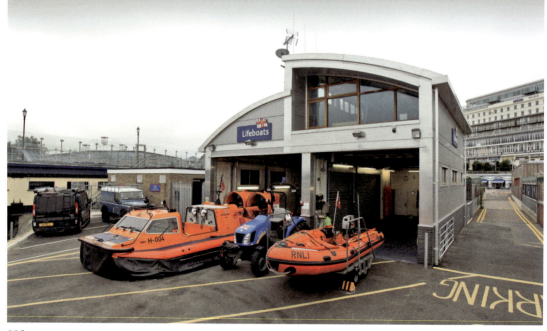

116

Southend-on-Sea

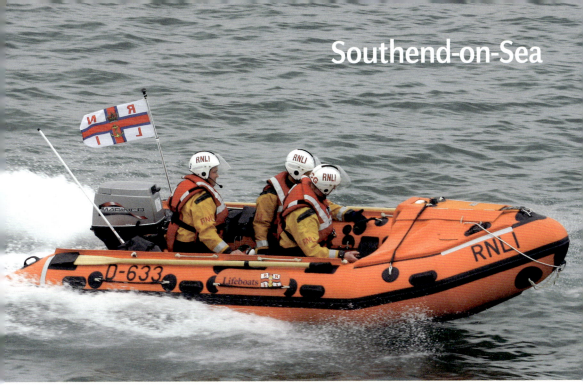

subsequently demolished; a temporary base was found for the pier ILBs.

1987 A new boathouse was constructed, adjacent to the ILB accommodation on the Prince George extension of the pier, and a new davit and winch were installed for launching and recovering both the Atlantic 21 and D class inflatable ILBs.

1989 An extension was added to the boathouse at the end of the pier to house the two D class inflatable ILB as well as accommodate a souvenir outlet.

1995 A fire at the end of the pier restricted access to the station for two weeks, and damaged the RNLI building housing the electric buggy used by the crew to reach the end of the pier.

2000 A new ILB house was built at the end of the pier for the Atlantic and D class inshore lifeboats at a cost of £696,186, incorporating a crew room, operations room, showers and drying facilities, with a public viewing platform and souvenir outlet; it was declared operational on 9 December. The council's sun deck was also incorporated into the structure.

2004 A temporary shore facility was constructed to house the inshore rescue hovercraft H-004 *Vera Ravine*, which was placed on station in July; the building, completed in September at a cost of £86,046, was erected adjacent to the ILB house at the pier head.

2012–3 A permanent combined hovercraft and ILB boathouse was built at the landward end of the pier on the site of the previous buildings; the new facility provided improved launch and recovery procedures and better crew facilities; a new slipway was also built and a launching tractor was provided for use with both ILB and hovercraft.

above D class inflatable Pride of London Foresters (D-633) is the ILB based at the end of the pier, launched by davit.

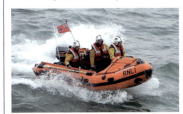

above D class inflatable Essex Freemason (D-682) at sea off the pier.

below Essex Freemason (D-682) being launched down the slipway.

Tower

Key dates
Opened	2002
RNLI	2002
Inshore lifeboat	2002

Current lifeboats
ILB E class Mk.II
Three boats rotate between Chiswick and Tower: E-07 Hurley Burly, E-08 Dougie and Donna B, E-09 Brawn Challenge
Built 2011–12
On station 2012
Launch Afloat

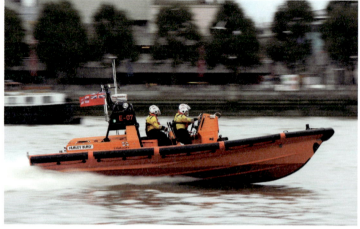

right The first of the E class Mk.2 lifeboats, Hurley Burly (E-07), passing Lifeboat Pier and the Victoria Embankment at speed heading down the Thames.

below Lifeboat Pier at Victoria Embankment on the Thames, with moorings for the E class lifeboats.

2002 A service was established to cover the tidal reaches of the River Thames, of which Tower was one of four stations that were officially opened at noon on 2 January 2002. Facilities were found at Tower Pier, close to the Tower of London, for the full-time crew as the station is manned continuously.

2005–6 The old Waterloo Police pier was renovated to provide improved facilities for the station, and it was renamed Lifeboat Pier. Built of wrought iron dating from the nineteenth century, the pier was dry-docked on a submersible dock at Deverall's yard so that it could be renovated, and was then refloated and placed at Waterloo for the final work to be undertaken.

2011 The first of three new E class Mk.2 lifeboats was delivered to the Thames in November, to be shared between this and Chiswick stations.

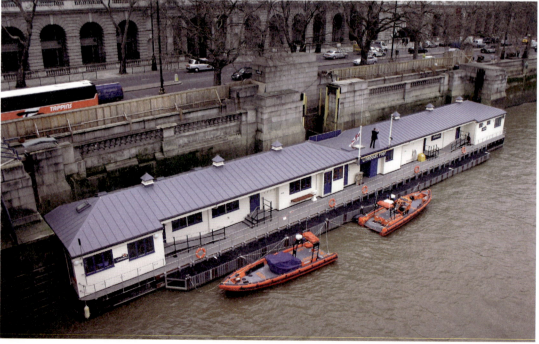

Teddington

Key dates
Opened	2002
RNLI	2002
Inshore lifeboat	2002

Current lifeboats
ILB D class inflatable
D-648 Spirit of Mortimer
Donor Mortimer & District Branch
On station 24.5.2005
Launch Tractor and trolley

ILB D class inflatable
D-743 Olwen and Tom
Donor Gift of Hilary and Peter Saw, Kingston upon Thames
On station 9.12.2010
Launch Tractor and trolley

2001 A new search and rescue service for the River Thames was announced on 22 January, and the RNLI agreed to establish four lifeboat stations; this was the first time the RNLI had covered the river rather than estuarial waters.

2002 Of the four stations, Teddington is the only one to operate a D class inflatable, which was manned by volunteers; the station operates from premises at the bottom of a residential block close to Teddington Lock. The first ILB was the relief D class inflatable *Spirit of Nuneaton and Bedworth* (D-477), which was placed on service on 2 January. A new ILB, *Spirit of the Thames* (D-576), was placed on service on 24 June having been provided by various fundraising activities in the local area, organised by the Twickenham and Teddington fundraising branch.

2005 The station's area of coverage was extended further upstream to Molesey Lock, which meant that Kingston upon Thames was included within the operational area. To ensure operational effectiveness both above and below Teddington Lock, a second D class inflatable was sent to the station, and the new ILB, *Spirit of Mortimer* (D-648), entered service on 20 May.

2010 A new D class inflatable, *Olwen and Tom* (D-743), was placed on service on 9 December.

left The lifeboat crew and station personnel with D class inflatable Olwen and Tom (D-743) after the boat's naming ceremony on 21 May 2011.

below left D class inflatable Olwen and Tom (D-743) being launched into the river.

below The station operates from premises at the foot of this residential block near Teddington Wharf, overlooking the river.

Chiswick

Key dates
Opened 2002
RNLI 2002
Inshore lifeboat 2002

Current lifeboats
ILB E class Mk.II
Three boats rotate between Chiswick and Tower: E-07 Hurley Burly, E-08 Dougie and Donna B, E-09 Brawn Challenge
Built 2011–12
On station 2012
Launch Afloat

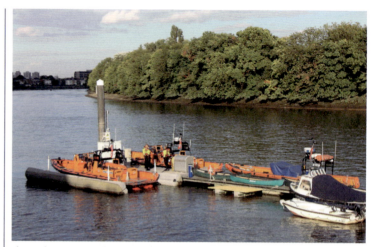

above The pontoon at Corney Reach with the mooring berth for the E class lifeboat.

above The crew facilities in the Pier House at Corney Reach Way.

below One of three E class Mk.2 lifeboats on the Thames, Brawn Challenge (E-09), at speed in Corney Reach.

2002 A lifeboat service was established to cover the tidal waters of the River Thames, of which Chiswick was one of four stations; the lifeboat operated from an afloat berth at Corney Reach, manned by a full-time crew; crew facilities were based in the Pier House overlooking the mooring pontoons on the northern bank of the river. Chiswick lifeboat covers an area between Richmond half-tide lock and Battersea, but goes further up- or downriver depending on the position of the other Thames lifeboats. The purpose-built E class lifeboats were supplemented by standard Atlantic 75 inshore lifeboats until 2005.

2011 A floating cradle was installed for the E class lifeboat, to raise it out of the water when not in use.

2012 Two new E class Mk.2 lifeboats were formally named on consecutive days in September at Chiswick.

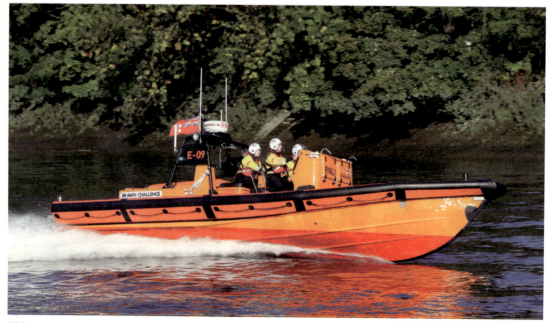

Gravesend

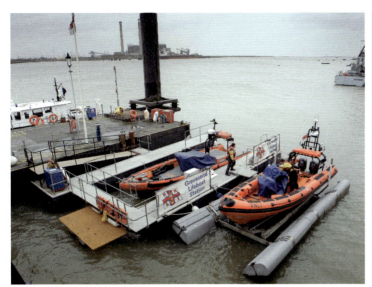

Key dates
Opened	2002
RNLI	2002
Inshore lifeboat	2002

Current lifeboats
ILB Atlantic 85
B-827 Olive Laura Deare II
Donor Bequest of Mrs Olive Laura Deare, Gravesend.
On station 27.11.2008
Launch Afloat

left Atlantic 85 Olive Laura Deare II (B-827) and E class Public Servant (C.S.No.44) (E-001) berthed at the Royal Terrace Pier.

below Crew facilities at the end of the pier.

below Atlantic 85 Olive Laura Deare II (B-827) off the Royal Terrace Pier; the station covers from Holehaven, at the western end of Canvey Island, to the Thames Flood Barrier at Woolwich.

2002 A station was established at Gravesend, the furthest east of the four on the Thames. Temporary crew facilities, including an operations room, mess room and changing rooms, were installed in portacabins in the car park of the Port of London Authority's offices near Royal Terrace Pier, with the lifeboats kept afloat at the end of the pier. An Atlantic 75 was also on station for use alongside the E class lifeboats.

2007 The station moved into new facilities at the end of Royal Terrace Pier on 5 June, which included crew mess room, dormitories, a kitchen and changing facilities. The facilities were closer to the lifeboats and thus reduced the time needed to launch.

2008 The Atlantic 85 *Olive Laura Deare II* (B-827) was sent to the station and became the duty boat in place of the E class lifeboats used hitherto.

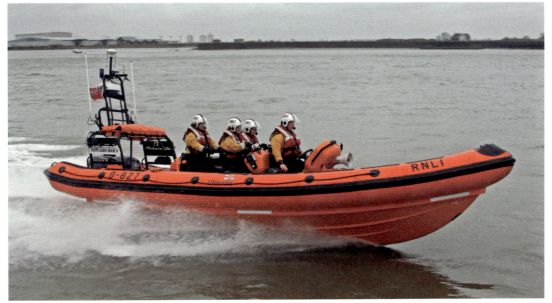

121

Sheerness

Key dates
Opened	1969
RNLI	1969
Motor lifeboat	1969
Inshore lifeboat	1971

Current lifeboats
ALB 14m Trent
ON.1211 (14-13) George and Ivy Swanson
Built 1996
Donor Bequest of Mrs Ivy Ethel Swanson, together with bequests of Miss Joan Dora May Bawden, Miss Joan Harris and Mrs Violet Wigington
On station 19.3.1996
Launch Afloat

ILB D class inflatable
D-662 Eleanor
Donor Gift of Phyllis Wright in memory of her sister
On station 27.9.2006
Launch Davit

Station honours
Thanks Inscribed on Vellum	10
Bronze medals	3
Silver medals	1

right 14m Trent George and Ivy Swanson (ON.1211) moored in Sheerness Docks.

Opposite 14m Trent George and Ivy Swanson (ON.1211) in the Thames Estuary.

Opposite inset Coxswain/Mechanic Robin Castle on board 14m Trent George and Ivy Swanson (ON.1211).

below The crew facility and ILB house in Sheerness Docks completed in 2000.

below right D class inflatable Eleanor (D-662) inside the ILB house.

1969 A lifeboat station was established after withdrawal of the rescue helicopters from RAF Manston in Kent. The first lifeboat, the 40ft Keith Nelson *Ernest William and Elizabeth Ellen Hinde* (ON.1017), was sent in April initially on an evaluation basis until a satisfactory berth became available; the lifeboat was moored in Berth 25, in a part of the docks which has since been filled in, and a boarding boat was used. The 46ft Watson motor *Canadian Pacific* (ON.803) was placed on station in November and stayed for five months.
1970 The 46ft Watson motor *Gertrude* (ON.847), built in 1946, was placed on permanent service on 22 April and was berthed in the Great Basin in the docks.

1971 A D class inflatable inshore lifeboat was sent to the station to operate alongside the offshore lifeboat.
1972 The ILB station was designated for operations all year round, and D-145 was placed on station in July; the ILB was launched from a slipway next to the ILB house.
1974 The first lifeboat built for the station, the 44ft Waveney *Helen Turnbull* (ON.1027), was placed on service on 4 April.
1977 A new ILB house was constructed with crew facilities included over the top; the ILB was kept on a trolley and taken to the quayside to be lifted into water using a davit.
1985 A new berth was found for the

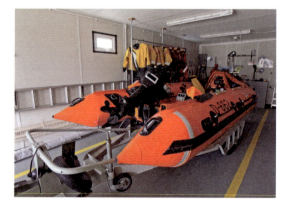

Sheerness

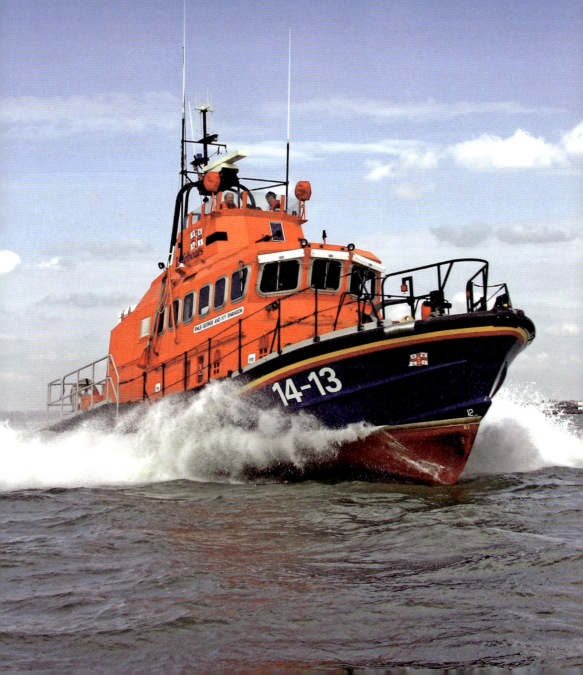

Sheerness

above George and Ivy Swanson (ON.1211) covers the River Medway, the Isle of Sheppey and the Thames Estuary.

right 14m Trent George and Ivy Swanson (ON.1211) at the berth in Sheerness Docks.

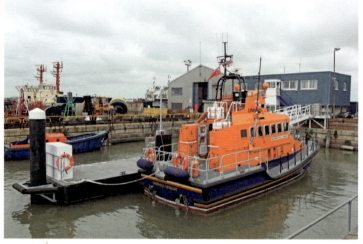

below A view over Sheerness Docks showing the pontoon berth for 14m Trent George and Ivy Swanson (ON.1211) and the shore facility built in 2000.

lifeboat as the old one was no longer tenable; after negotiations with Medway Ports Authority, berthing arrangements were provided at Gun Wharf Steps in Sheerness Docks.

1992 A new davit was installed on the quay to improve launching arrangements for the ILB.

2000 A new combined ILB house and crew building was completed in May at the dockyard providing improved crew facilities and accommodation for the ILB. Completed in May, it was formally opened by Mrs Betty Black, vice-president of Sheerness Guild.

2010 A new mooring pontoon was installed to improve boarding arrangements for the 14m Trent.

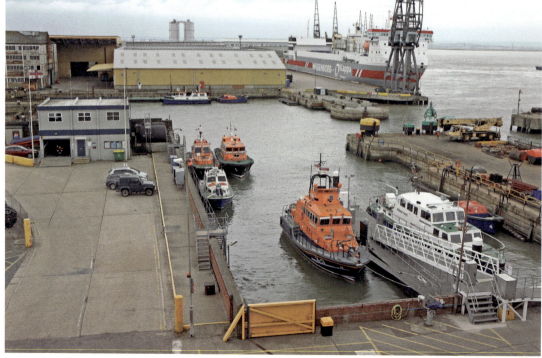

Whitstable

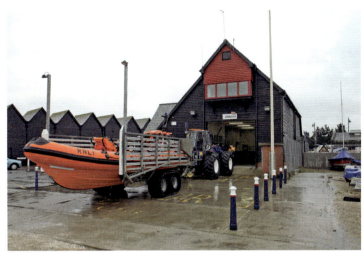

Key dates
Opened	1963
RNLI	1963
Inshore lifeboat	1963

Current lifeboats
ILB Atlantic 75
B-764 Oxford Town and Gown
Donor Gift of the City and University of Oxford
On station 5.7.2000
Launch Tractor and do-do trolley

Station honours
Thanks Inscribed on Vellum	3
Bronze medals	1

1963 An inshore lifeboat station was established in July and the station became one of the first ten to receive an ILB; the first D class inflatable ILB was kept at the East Quay.

1974 The station was upgraded with an Atlantic 21, *Whitstable Branch* (B-516), and a new ILB house was built at the West Gate of the harbour.

1980 A first floor was added to the boathouse to improve crew facilities.

1989 A single-storey extension to the side of the boathouse was constructed, providing improved crew facilities, a fuel store, turntable store, a general storeroom, drying room and a souvenir sales outlet with a display area.

1999 The Atlantic 21 *British Diver* (B-560) capsized on 3 January after being launched in a gale to three angling boats in Herne Bay; all three crew were uninjured.

2000 A new ILB house was built on the same site as the previous building, and was completed in May, for the Atlantic 75 *Oxford Town and Gown* (B-764).

2013 The station celebrated the fiftieth anniversary of its opening.

left The lifeboat house built in 2000 at the south side of Whitstable harbour.

below Launch of Atlantic 75 Oxford Town and Gown (B-764) using tractor TW49H.

below Atlantic 75 Oxford Town and Gown (B-764) on exercise off Whitstable.

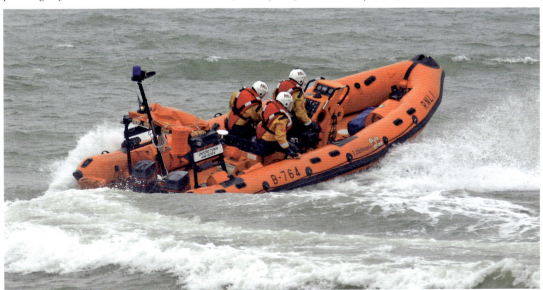

Margate

Key dates
Opened	1857
RNLI	1860
No.2 lifeboat	1898–1927
Motor lifeboat	1925
Inshore lifeboat	1966
Fast lifeboats	1991

Current lifeboats
ALB 12m Mersey
ON.1177 (12-20) Leonard Kent
Built 1991
Donor Bequests of the late Leonard Francis Kent, St Helier; Graeme Edward Godfrey, Ellen Agnes Houghton, Florence Evelyn Rodwell; Margate Branch Appeal; cost of engines £28,700. Funded from the bequest of Cyril George Moore, Canvey Island, Essex, in memory of his wife Gladys
On station 19.12.1991
Launch Tractor and carriage

ILB D class inflatable
D-706 Tigger Three
Donor Gift of John and Wendy Davenport, Surrey
On station 17.12.2008
Launch Trolley

Station honours
Thanks Inscribed on Vellum	18
Bronze medals	1
Silver medals	5

top One of the two 40ft self-righting lifeboats, Eliza Harriet (ON.411), being recovered up the western slipway in the early years of the twentieth century.

below The memorial in Margate cemetery to the nine men lost in December 1897.

below right The seafront memorial to the men lost in 1897 when the surf boat Friend to all Nations capsized.

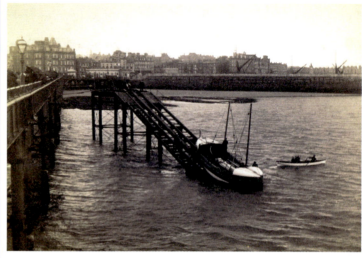

1859 The Margate Boatmen were presented with a lifeboat by Miss Burdett Coutts in March; this boat was kept on the stone pier in a small boathouse, and the RNLI supplied a set of lifebelts. The boatmen purchased a second lifeboat themselves. The Coutts lifeboat carried sails while the other boat was used essentially for rowing.
1860 The lifeboat and station were taken over by the RNLI, and a new launching carriage was supplied.
1861 The boathouse was altered once the RNLI had taken over.
1866 A new lifeboat house, 'an ornate building on the lower promenade', was built on the site of the first house, which had been used by the Beachmen; the Town Council agreed that it could be built on the proviso that it had a flat roof upon which the Town Band could play during the season.
1897 The boatmens' lifeboat Friend to all Nations capsized on service on 2 December with the loss of nine crew.
1897–8 Following difficulties with carriage launching, two slipways were constructed, at a cost of £4,101 10s 6d, on either side of the wooden jetty to improve launching arrangements, and a second (No.2) lifeboat was placed on station; the lifeboats, both 40ft self-righters, were kept in the open at the head of these two slipways.
1923–5 A new lifeboat house for the station's first motor lifeboat, the 45ft Watson motor Lord Southborough (Civil Service No.1) (ON.688), was built on the

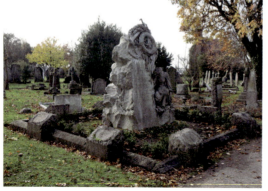

Margate

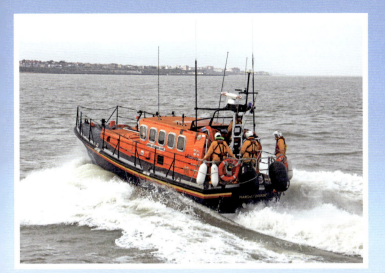

this page 12m Mersey Leonard Kent (ON.1177) on exercise off Margate, with (main picture) a tanker anchored in the Margate Roads awaiting orders.

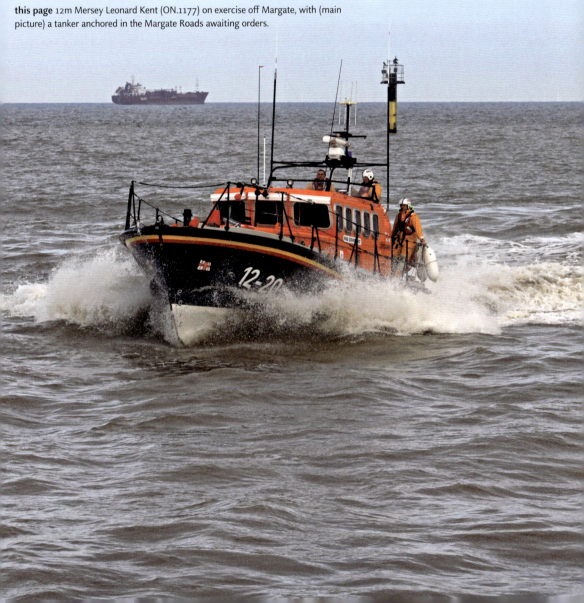

Margate

above Leonard Kent (ON.1177) emerges from the lifeboat house, built at the Rendezvous in 1978 and extended in 1998.

middle Memorial stone on display inside the lifeboat house.

right Leonard Kent (ON.1177) passes the Turner Contemporary Art Gallery at the Rendezvous on her way to the harbour, across which she is launched. The area is dominated by the Turner Gallery, which was completed in 2011.

eastern (No.2) slipway; this house was adapted and altered at various times.
1927 The lifeboat operated from the western (No.1) slipway, *Eliza Harriet* (ON.411), was withdrawn and the station then operated one lifeboat.
1940 *Lord Southborough (Civil Service No.1)* (ON.688) was one of the nineteen lifeboats that went to Dunkirk on 30 May to help in the evacuation of the British Expeditionary Force under the command of Coxswain Edward Duke Parker and brought off 600 men. Coxswain Parker

was one of the two lifeboat coxswains who, for their services at Dunkirk, were awarded the Distinguished Service Medal.
1953 During abnormal high tides in January the lifeboat house was severely damaged and a new floor had to be fitted.
1960 A Centenary Vellum was presented to the station.
1961 Modifications were made to the boathouse so that a lifeboat with a wheelhouse could be accommodated.
1966 An inshore lifeboat station was established in May; the D class ILB

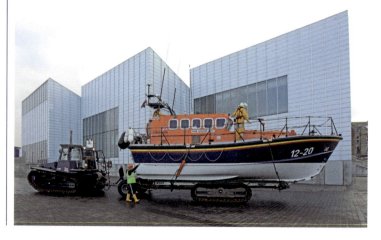

Margate

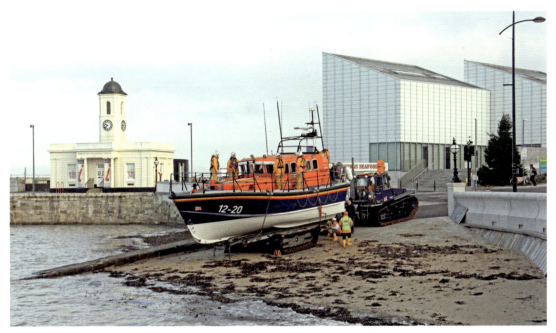

was housed in a small prefabricated building adjacent to the harbour.
1976 With the pier rapidly deteriorating and the cost of building a walkway to the boathouse prohibitive, the possibility of replacing the slipway launch with a carriage launch was investigated; trials were completed in 1977 and tenders were issued in 1978 for construction of a new boathouse.
1978 A new lifeboat house, situated at the Rendezvous, was constructed for a carriage-launched lifeboat and launching tractor. Access to the old boathouse on the town pier became impossible when the jetty was destroyed and the lifeboat house badly damaged by severe gales on 11–12 January 1978; the jetty collapsed and the lifeboat house was damaged beyond repair; after the storm, the crew were taken to the ruined boathouse by helicopter and the ILB. As well as the lifeboat itself, various other items were salvaged and launched with the boat.
1979 The lifeboat house and slipway on the pier were demolished.

1995 The D class ILB D-400 capsized on service, with no casualties to the crew.
1998 An extension to the lifeboat house was built, providing improved crew facilities and ILB accommodation.
2010 A Vellum marking 150 years of service was awarded to the station.
2011 During the building of the Turner Contemporary Art Gallery adjacent to the boathouse site, lifeboat operations were moved to a temporary station on the main sands, with the boats returning to the boathouse in April.

above Leonard Kent (ON.1177) being launched, with the Turner Contemporary Art Gallery in the background.

above D class inflatable Tigger Three (D-706) being launched on exercise.

below Tigger Three (D-706) on exercise.

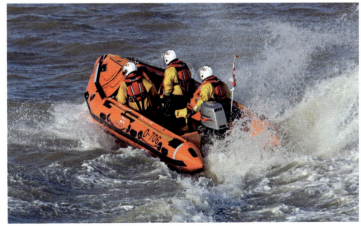

Kingsgate

Key dates
Opened	1862
RNLI	1862
Closed	1897

Station honours
Silver medals	1

right The site of the station and the narrow launchway are still visible at the north side of Kingsgate Bay. The owner of the site of the lifeboat house, Mr J. Friend, purchased it in December 1897 for £20, but it has since been demolished.

below The 28ft eight-oared self-righter Thomas Chapman, the second lifeboat of that name, outside the lifeboat house at Kingsgate. She served from 1880 to 1889 and undertook just one service during that time. (By courtesy of the RNLI)

1860 A local committee wanted a small lifeboat kept at Kingsgate as an auxiliary to the Margate boat, but getting sufficient crew proved difficult.
1861 A small lifeboat house was completed at a cost of £116 7s 0d.
1862 The station was established and the lifeboat, a 28ft self-righter named *Brave Robert Shedden* and built in 1856 for Dungeness, arrived in January.
1864 The launchway for the lifeboat was widened at a cost of £75; several times subsequently improvements had to be effected to the launchway, which made launching problematic.
1897 With insufficient Coastguard to form a crew, and improved links between the stations at Broadstairs and Margate, the station was deemed unnecessary and the lifeboat was withdrawn in July.

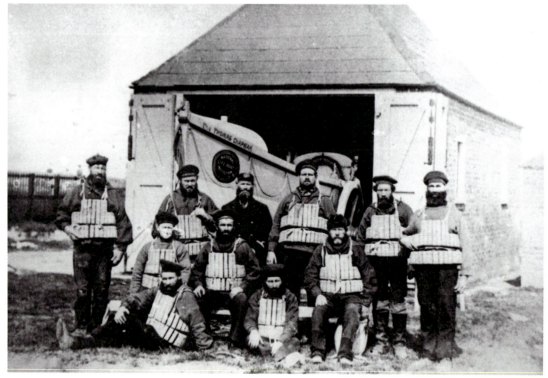

Broadstairs

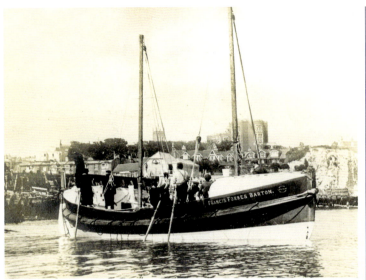

Key dates	
Opened	1850–68 and 1868
RNLI	1868
Boatmen's lifeboat 1850–68, 2nd LB 1853–68	
Closed	1912

Station honours	
Silver medals	11
Gold medals	1

left The last Broadstairs lifeboat, the 40ft self-righter *Francis Forbes Barton* (ON.399), pictured in the harbour off the slipway. She served from March 1896 until the station was closed in July 1912 and saved seventy-seven lives. (From an old postcard supplied by John Harrop)

1850 A small lifeboat, built by White of Cowes, was placed at Broadstairs by a local Boatmen's Committee.

1853 A second White-built boat was built for the station; the White boats were kept on launching trolleys or occasionally at moorings in the harbour. Both of the White boats were unseaworthy by 1868.

1867 The boatmen wanted a better lifeboat and so asked the RNLI to take over the station. The RNLI supplied a 36ft self-righting lifeboat, named *Samuel Morrison Collins*, in November. The boat was kept on the pier under a tarpaulin, and the Harbour Commissioners made available a small shed in which to store the gear.

1868 A slipway was built at a cost of £88 15s 0d to improve launching.

1872 The slipway was extended by 50ft at a cost of £18 10s 0d.

1873 The lower part of the wooden slipway was found to have been completely destroyed by marine insects.

1875 Repairs were made to the slipway by J. Jarman at a cost of £25 15s 0d.

1878 About 93ft of the slipway had to be replaced, and American oak was used by C. White at a cost of £72 10s 0d.

1884 Further repairs were made to the slipway at a cost of £87 10s 0d.

1887 Further repairs were needed to the slipway, which was 220ft in length, but instead a new one, 300ft in length, was built for the new 39ft 2in self-righting lifeboat *Christopher Waud, Bradford* (ON.189) at a cost of £1,350.

1888 Alterations were made to the slipway and rollers were fitted for £116.

1908 Further improvements were made to the launching arrangements at a cost of £105 1s 6d.

1912 The station was closed and the lifeboat was withdrawn in July. The slipway has since been dismantled and there is nothing left of the station, apart from the service boards on display.

above The building which was used as a gear store when the station was operational and on which now are displayed the service boards.

below No remains of the station have survived, but the service boards are displayed in the harbour.

Ramsgate

Key dates
Opened 1802–? and 1851
RNLI 1922
Motor lifeboat 1925
Inshore lifeboat 1969
Fast lifeboat 1976

Current lifeboats
ALB 14m Trent
ON.1197 (14-02) Esme Anderson
Built 1994
Donor Bequest of Mrs Esme Grace Anderson
On station 24.8.1995
Launch Afloat

ILB Atlantic 75
B-765 Bob Turnbull
Donor Legacy from Mr Bob Turnbull, together with a donation from Mrs Jane Turnbull
On station 26.7.2000
Launch Davit

Station honours
Framed Letter of Thanks	5
Thanks Inscribed on Vellum	3
Bronze medals	1
Silver medals	39
Gold medals	2

right The crew facility and ILB house built in 1997 at the end of the Commercial Pier in the middle of Ramsgate harbour, with the 14m Trent Esme Anderson (ON.1197) moored alongside the pontoon.

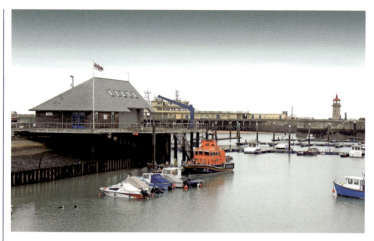

right The crew facility, ILB house and ILB launch davit, with the moorings for 14m Trent Esme Anderson (ON.1197).

below The ILB house built in 1984 on the Western Crosswall for the Atlantic 21; the building was used until 1997.

1802 The first lifeboat was funded by the Trustees of Ramsgate Harbour, and was built by Henry Greathead of South Shields; this boat was no longer in use by 1824 and it is not known whether it ever performed any rescues.

1851 The station was reopened by the Harbour Trustees, who purchased a 36ft self-righting lifeboat built by James Beeching of Great Yarmouth, and was named *Northumberland*. The lifeboats were moored in the East Gully, Royal Harbour, and steam tugs were often available to assist with taking the lifeboats out to rescues on the sandbanks; the crew's equipment and gear were housed on the ground floor of the Clockhouse, which became the East Kent Maritime Museum, until 1993.

1863 The Board of Trade took over the running of the station from the Harbour Trustees.

1865 The station was managed jointly by the RNLI and Board of Trade, with the RNLI supplying the lifeboat and the Board being responsible for the crew.

1922 The RNLI took over sole control of the station and operated it on the same basis as its other stations; the joint arrangement with the Board of Trade, which had been taken over by the Ministry of Transport, ceased but the Ministry continued to provide a steam tug for use by the lifeboat.

1925 The station's first motor lifeboat, the 48ft by 13ft Ramsgate type *Prudential* (ON.697), was placed on station in late December.

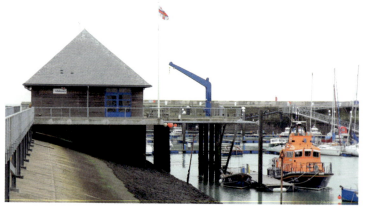

Ramsgate

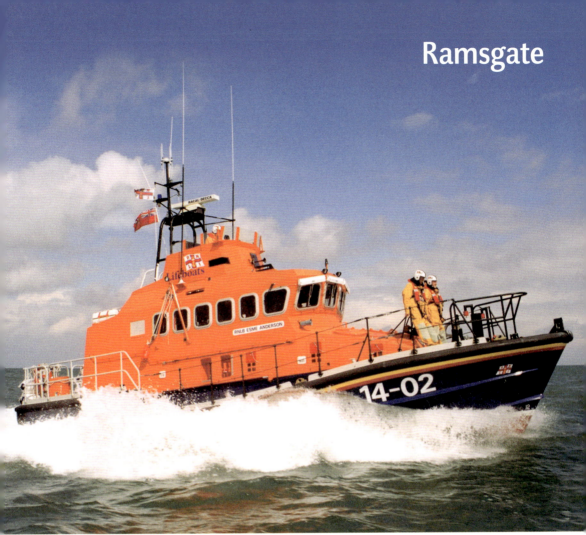

1931 A Centenary Vellum was presented to the station on 17 September; the station's lifeboats up to then had saved 1,346 lives.

1939–45 The lifeboat *Prudential* played a significant role during the war, being launched sixty times on service and saving 170 lives during the conflict, as well as being involved at Dunkirk.

1940 The station's outstanding service of the war came off the beaches of Dunkirk. *Prudential* brought 2,800 men of the British Expeditionary Force to safety. By the time she got returned to Ramsgate, she had been away for over forty hours, having spent thirty hours working on the beaches. Almost all of the time she was off the beaches she had been in the line of fire, and the crew had been without sleep for two nights. Her coxswain, Howard Primrose Knight, was awarded the Distinguished Service Medal for his 'gallantry and determination in this work'.

1940 The station had to be closed on 24 August after the town was bombed from the air. The lifeboat crew took

above 14m Trent Esme Anderson (ON.1197) on exercise off South Foreland.

below Atlantic 75 Bob Turnbull (B-765) passing the South Foreland lighthouse.

133

Ramsgate

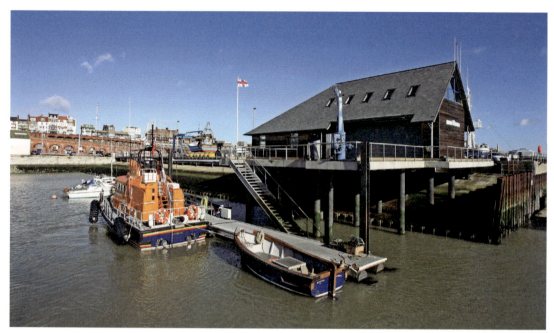

above The crew facility and ILB house built in 1997 at the end of the Commercial Pier, with relief 14m Trent Henry Heys Duckworth (ON.1215) at the pontoon.

below Atlantic 75 Bob Turnbull (B-765) on the cradle inside the ILB house at the end of the Commercial Pier; the trolley is on rails and so, to launch, it is pushed out and the boat is positioned beneath the davit, which then lifts it into the water.

shelter in a cellar near the harbour, but a bomb burst just outside and six of the nine men were wounded. The station was reopened on 11 October, although the coxswain, assistant mechanic and one of the crew were still unfit for duty.

1953 The *Prudential* lifeboat was one of the four that took part in the Coronation Review of the Fleet by the queen at Spithead on 15 June.

1955 The 1,000th launch by the Ramsgate lifeboat was undertaken on 16 July, when the 46ft 9in Watson motor *Michael and Lily Davis* (ON.901), which had been on station since November 1953, went to help the steamship *Husvik*, of Norway.

1969 An inshore lifeboat station was established and the 17ft Dell Quay Dory type ILB 17-001 was placed on station in July; the ILBs were kept moored afloat until 1984.

1976 44ft Waveney *Ralph and Joy Swann* (ON.1042) was placed on station.

1984 A wooden ILB house was built on the Western Crosswall for the Atlantic 21 with a launching davit on the adjacent quayside; this building was used until 1997 and was then sold.

1993 The lifeboat was moved to a pontoon mooring in the Yacht Marina to improve boarding arrangements.

1997 A new lifeboat station was built at the end of the Commercial Pier with a boathall for the Atlantic 21 and its replacement, with improved facilities for the crew and a pontoon mooring berth for the all-weather lifeboat. The ILB was kept on a trolley and launched by davit; the building was funded from bequests and gifts to the RNLI.

North Deal

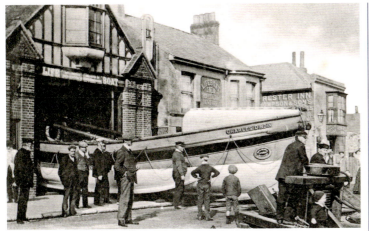

Key dates
Opened	1865
RNLI	1865
Closed	1932
War Emergency Station	1915–21

Station honours
Bronze medals	1
Silver medals	11

left The last North Deal lifeboat, the 43ft self-righter *Charles Dibdin* (ON.552), being hauled out of the boathouse. She served the station from 1905 to 1932 and saved 395 lives. (From an old postcard supplied by John Harrop)

1865 A lifeboat station was established at Deal to help casualties stranded on the Goodwin Sands which the Walmer lifeboat could not reach due to wind and tide; a lifeboat house was built by Denne & Wise at a cost of £340 12s 0d at the northern end of the town so the station became known as North Deal. The first lifeboat, a 40ft twelve-oared self-righter named *Van Kook*, arrived in February and was launched over skids laid on the beach.

1883 Getting the lifeboat into and out of the lifeboat house was not possible following the raising and improving of the roadway, so a new boathouse was built on the same site by J. Wise at a cost of £439 2s 10d.

1915 The former Broadstairs lifeboat *Frances Forbes Barton* (ON.399) was sent to operate as a second lifeboat, known as North Deal Reserve; another lifeboat stationed near the Goodwin Sands was deemed necessary. Both Deal lifeboats were kept in the open and launched across the beach.

1921 The North Deal Reserve lifeboat was withdrawn on 4 May having launched eighteen times and saved twenty-three lives during her six years.

1932 The station was closed as a motor lifeboat was due to go to Walmer and this could effectively cover the area. The last lifeboat, *Charles Dibdin* (ON.552), was withdrawn in September and sold the same month.

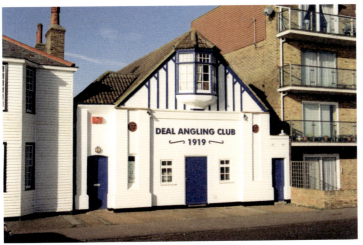

left The lifeboat house on the seafront at Deal built in 1883, used until 1932, and used by the Deal Angling Club.

below The lifeboat house at North Deal pictured in August 1929, three years before the station closed, with the service boards mounted on the doors. (Grahame Farr, by courtesy of the RNLI)

Walmer

Key dates
Opened	1856–1912 and 1927
RNLI	1856
Motor lifeboat	1933–90
Inshore lifeboat	1964, 2nd ILB 1990

Current lifeboats
ALB Atlantic 85
B-808 Donald McLauchlin
Built 1993
Donor Bequest of Lieutenant Commander Arthur Donald McLauchlin, Honorary Treasurer of the RNLI Wimbledon Branch
On station 14.12.2006
Launch Tractor and do-do carriage

ILB D class inflatable
D-663 Duggie Rodbard
Donor Gift of Wendy and John Farley in memory of Duggie Rodbard
On station 13.12.2006
Launch Trolley

Station honours
Framed Letter of Thanks	6
Thanks Inscribed on Vellum	11
Bronze medal	4
Silver medal	4
Gold medal	3

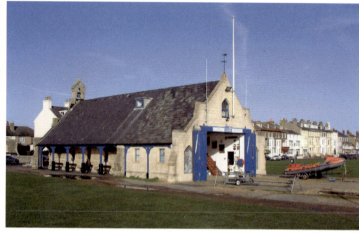

right The lifeboat house built in 1871 and lengthened in 1991, by the removal of the seaward gable wall, and a 6m extension was constructed.

below Walmer lifeboats D class inflatable Duggie Rodband (D-663) and Atlantic 85 lifeboat Donald McLauchlan (B-808).

1856 The RNLI established a lifeboat station to help ships wrecked on the notorious Goodwin Sands, and a wooden lifeboat house was built at a cost of £186 11s 1d; it was used until 1871 and then moved to North Deal. The first lifeboat, a 29ft 6in ten-oared self-righter, was named *Royal Thames Yacht Club* after the organisation that provided the funds to build it. The first lifeboats were launched by carriage.

1861 A larger lifeboat, 37ft and pulling twelve oars, was provided.

1871 A new stone lifeboat house was built on the seafront, about seventy yards to the south of the old house, to accommodate a new lifeboat.

1912 The station was closed, and the 40ft self-righter *Civil Service No.4* (ON.394) was withdrawn on 16 May.

1927 The station was reopened with the intention of operating a motor lifeboat as the launching conditions were better at Walmer than at either of the neighbouring stations of North Deal and Kingsdowne, whose lifeboat, the 1902-built 40ft self-righter *Barbara Fleming* (ON.480), was transferred to Walmer on 8 January.

1933 The station's first motor lifeboat, *Charles Dibdin (Civil Service No.2)* (ON.762), was placed on service; the motor lifeboats were kept on a launching cradle at the top of the beach

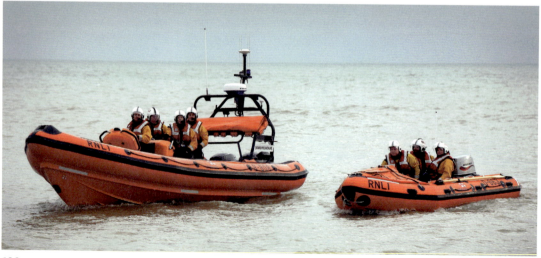

Walmer

above Atlantic 85 lifeboat Donald McLauchlan (B-808) in heavy seas while on exercise south of Walmer.

and launched across skids.

1940 *Charles Dibdin (Civil Service No.2)* was one of nineteen that took part in the evacuation of the British Expeditionary Force from Dunkirk in May. During the Second World War, the Walmer lifeboat answered sixty-one calls and saved 126 lives.

1952 A new platform was built to improve launching arrangements.

1956 A Centenary Vellum was presented by the Queen Mother.

1959–60 Alterations were made to the launching arrangements for the new lifeboat, the 42ft Beach type *Charles Dibdin (Civil Service No.32)* (ON.948).

1964 An inshore lifeboat station was established in April; the first ILB, No.14, was kept in the 1871 boathouse.

1974 Alterations were made to the

left D class inflatable Duggie Rodbard (D-663) on exercise in the Dover Straits with South Foreland in the background.

below The small boathouse used for the inshore lifeboat on the beach, in front of the main boathouse.

137

Walmer

above Case 1150B launching tractor T88 was built to launch all-weather lifeboats, but is used at Walmer for the Atlantic 85 because its extra power is needed to cope with the beach conditions, which can often be too challenging for an ILB tractor.

right D class inflatable Duggie Rodbard (D-663) on exercise off Walmer beach.

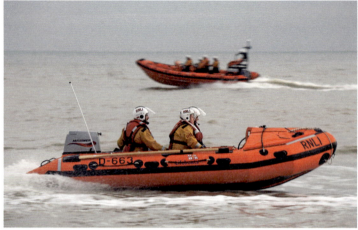

below Atlantic 85 inshore lifeboat Donald McLauchlan (B-808) being launched across the shingle beach using the hydraulic do-do launching carriage.

launching arrangements.
1990 The all-weather lifeboat, *The Hampshire Rose* (ON.1024), was withdrawn in May and replaced by Atlantic 21 *US Navy League* (B-512).
1991–2 The lifeboat house of 1871, used to house the ILB since 1964, was lengthened to accommodate both the Atlantic 21 and launching vehicle; new facilities provided include a souvenir outlet, changing room, toilet, crew room, galley and office; the D class inflatable ILB was kept in a container, situated on the beach in front of the boathouse.
1998 The container on the beach used for D class ILB was cladded with a wooden facade to blend in with the surrounding huts.
2006 The new D class inflatable *Duggie Rodband* (D-663) and new Atlantic 85 lifeboat *Donald McLauchlan* (B-808) were placed on service. A Celebration Vellum was awarded to station to mark its 150th anniversary.

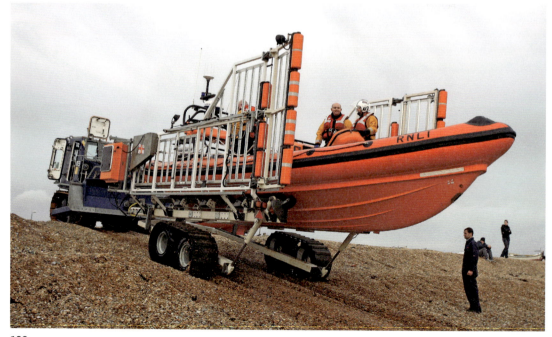

Kingsdowne

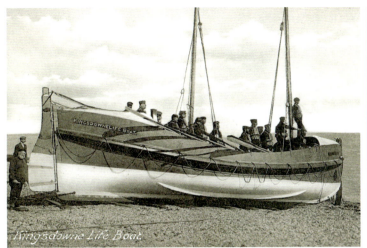

Key dates
Opened	1866
RNLI	1866
Closed	1927

Station honours
Thanks Inscribed on Vellum	2
Silver medal	2

left The 40ft self-righter Charles Hargrave (ON.306) being launched from the beach at Kingsdowne, one of three stations which served the Goodwin Sands. She was on station from 1890 to 1926 and saved 140 lives during that time (From an old postcard supplied by John Harrop)

1865 The RNLI decided in July to establish a lifeboat station to the south of Walmer to provide additional cover for the Goodwin Sands; a lifeboat house was built at Kingsdowne by W. & G. Deane at a cost of £223 on a site granted by the Lord of the Manor.

1866 The first lifeboat, a 33ft self-righter named *Sabrina*, was sent to the station in February. The lifeboat was to have been launched by carriage, but using skids over the shingle beach proved to be more practical.

1902 One of the lifeboat crew, Frederick Arnold, was hit on the head during an exercise on 1 April; he was taken to hospital but never recovered and died a few months later.

1926 The RNLI decided in September that the station should be closed as a motor lifeboat was going to Walmer.

1927 The station was closed and the lifeboat *Barbara Fleming* (ON.480) was transferred to Walmer on 8 January.

below The lifeboat house built in 1866 and used until the station closed in 1927. It has since been converted into a holiday home.

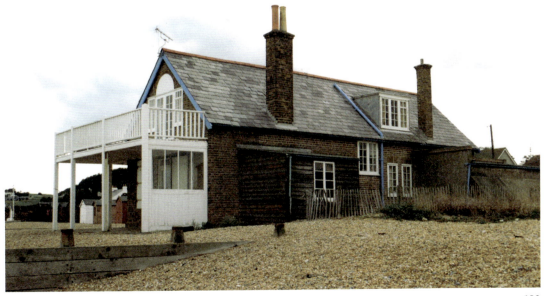

139

Dover

Key dates
Opened	1837–p.1852 and 1853–1914
	1919–22, 1930–40 and 1947
RNLI	1855
Steam lifeboat	1919–22
Motor lifeboat	1930–40 and 1947

Current lifeboats
ALB 17m Severn
ON.1220 (17-09) City of London II
Built 1996
Donor City of London Centenary Appeal, with bequests of Mrs Edna Horsfield, Dover, Mrs Gertrude Koss, and other gifts and legacies
On station 15.3.1997
Launch Afloat

Station honours
Framed Letter of Thanks	4
Thanks Inscribed on Vellum	9
Bronze medals	13
Silver medals	6

opposite 17m Severn City of London II (ON.1220) leaving Dover harbour to escort the ferry carrying Dunkirk veterans across the Channel to France on the occasion of the 70th anniversary, May 2010.

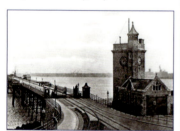

above The lifeboat house of 1878.

right The lifeboat house of 1878 has had various uses since the lifeboat was withdrawn, including being a shop.

below 51ft Barnett Southern Africa (ON.860) moored in the old MTB pens in the Western Docks. (Jeff Morris)

1837 The first lifeboat, a 37ft twelve-oared boat built locally by Elvin, was funded and managed by the Dover Humane Society; a boathouse was situated on the seafront, at Townsend; what became of this lifeboat or whether she made any rescues is not known.

1852 T. C. Clarkson, of London, carried out a series of trials at Dover with a lifeboat he had designed and built. The Dover Humane Society ordered Clarkson to build a lifeboat, which measured 28ft by 7ft 6in and had raised end-boxes fore and aft to give her a self-righting capability.

1853 The Clarkson lifeboat arrived in the autumn and was kept beneath and launched by davits situated on the east side of the Royal Pier.

1855 The station was taken over by the RNLI in April and the lifeboat was altered in London at a cost of £98 0s 4d. However, in December the boat was swept from these davits during a storm, but suffered little damage.

1856 A new 28ft six-oared lifeboat was supplied by the RNLI, together with a launching carriage, and the boat was kept in the 1837 boathouse.

1865 The RNLI built a new lifeboat house close to the clock tower at the western end of the harbour for £244.

1878 The lifeboat house was rebuilt at a cost of £408 to accommodate a new 35ft ten-oared self-righting lifeboat.

1914 The lifeboat was withdrawn in September and the station was temporarily closed because getting a sufficient crew following the outbreak of war proved too difficult.

1919 The station was reopened and the 56ft 6in steam lifeboat *James Stevens No.3* (ON.420) was transferred from Totland Bay in December. She was kept afloat at moorings at The Camber, at the eastern end of the harbour.

1922 The station was again closed and the steam lifeboat *James Stevens No.3* was withdrawn in December.

1930 The station was re-established and the specially designed fast 64ft lifeboat *Sir William Hillary* (ON.725) became

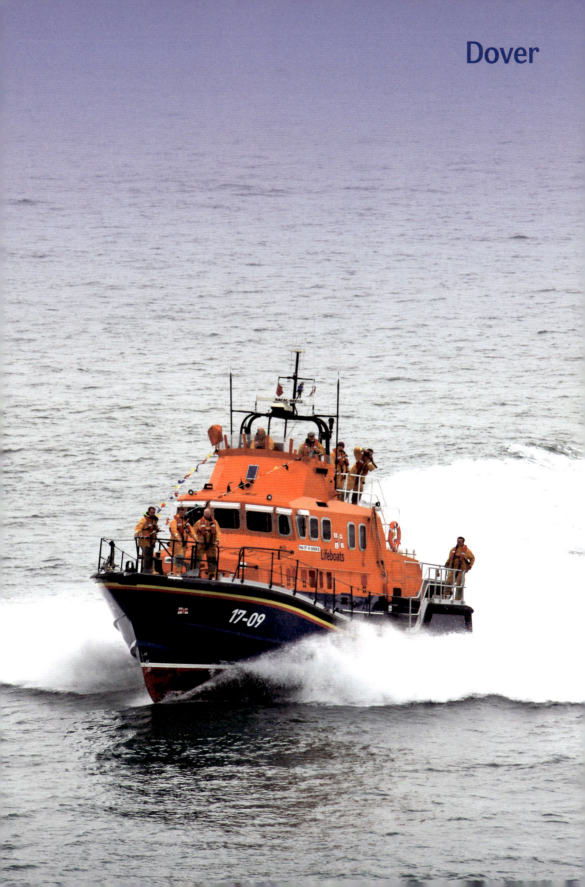

Dover

Dover

below 17m Severn *City of London II* at moorings alongside the pontoon in the Western Docks, with the old lifeboat house in the background, by the clock tower.

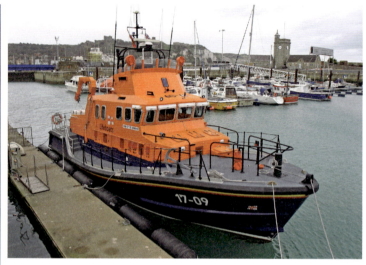

below The crew facility and all-weather lifeboat berth in the Western Docks, where the lifeboat has been based since 2000 having had several moorings around the port up until then.

operational in January. She had a top speed of 17.25 knots and was intended for services to aircraft should they come down in the Channel. She was kept afloat at moorings at the Camber.
1940 *Sir William Hillary* was taken over by the Admiralty, but the reserve lifeboat *Agnes Cross* (ON.663), which had been on station while the fast lifeboat was being overhauled, remained in service.
1941 The station was again closed and *Agnes Cross* was withdrawn.
1947 The station was re-established and the 1928-built 45ft Watson motor lifeboat *J.B. Proudfoot* (ON.694) was placed on station in May; she was moored in a former motor torpedo boat (MTB) pen in the Eastern Docks, a berth that was used until 1984.
1956 On 25 November the Dover lifeboat *Southern Africa* (ON.860) made television history when she was called out on service while returning from the South Goodwin lightship with a BBC camera crew on board; the lifeboat towed in a local motor boat and the incident was broadcast live on TV.
1967 The station was one of the first to receive a new fast lifeboat, with the 44ft Waveney *Faithful Forester* (ON.1003) being placed on station in July.
1979 The 50ft Thames class lifeboat *Rotary Service* (ON.1031) was placed on station in October; only two Thames class lifeboats were built by the RNLI.
1984 Following the development of the harbour to provide new ferry berths including demolition of the MTB pens, a new afloat berth was provided in the Western Docks at the tug berths, with shore facilities on the adjacent quay.
2000 A new crew purpose-built facility, with fuel tank, was constructed in the Western Docks with a pontoon mooring berth at the adjacent Crosswall Quay; it was completed in July.

Dover

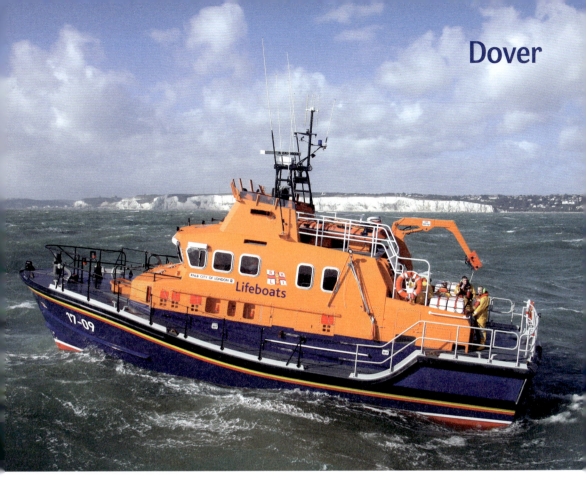

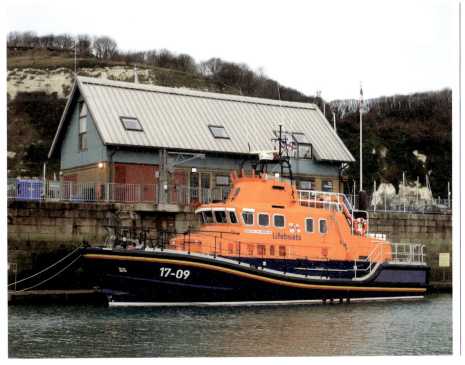

above 17m Severn City of London II (ON.1220) on exercise in the English Channel, off South Foreland.

left 17m Severn City of London II at moorings in the Western Docks.

Folkestone

Key dates
Opened 1893
RNLI 1893
Closed 1930

Station honours
Silver medals (4 for shoreboat rescues) 6

right The ornate lifeboat house can be seen to the far left on this old postcard, which also shows the lifeboat Leslie (ON.508) being launched in the presence of a large crowd, possibly for lifeboat day or another ceremonial event. Leslie, a 35ft ten-oared self-righter, spent twenty-seven years on station and was the last lifeboat to serve at Folkestone.

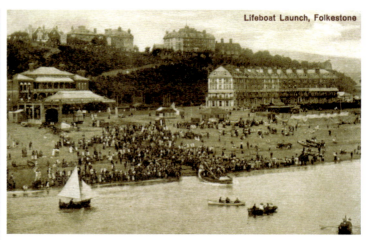

Lifeboat Launch, Folkestone

1891 The RNLI decided to establish a station at Folkestone following the loss of the ship *Benvenue* in November, when both the Dungeness and Sandgate lifeboats capsized in attempting to help the vessel.
1893 The station was established in December when the new lifeboat, *J. McConnel Hussey* (ON.343), was sent to the station. A lifeboat house was built on the foreshore at a cost of £779 5s 7d, by local builders Hayward & Paramor; it was opposite the Bathing Establishment, and east of the Leas Lift and the now demolished Victoria Pier.
1930 The RNLI decided to close the station, and the 35ft self-righter lifeboat *Leslie* (ON.508), which had been on station since April 1903 and launched twenty-three times on service, saving sixteen lives, was withdrawn from service in October. As Dover and Dungeness both had motor lifeboats, with a greater range, the Folkestone area could be adequately covered. In addition, there were problems launching from Folkestone an hour before low water until an hour after low water because of the Church Rocks.
1936 The lifeboat *Leslie* remained in the boathouse for exhibition purposes for six years after the station closed. She was sold out of service on 24 April, and the lifeboat house was demolished, sometime before the 1960s, with no trace of it remaining.

right The ornate lifeboat house, pictured in August 1929, was built in 1893 and used throughout the life of the station. (Grahame Farr, by courtesy of the RNLI)

Hythe and Sandgate

Key dates

Opened (at Sandgate)	1876
RNLI	1876
Moved (to Hythe)	1893
Motor lifeboat	1929
Closed	1940

Station honours

Bronze medals	2
Silver medals	7
Gold medals	1

left The lifeboat house built at Hythe in 1936 and used until 1940; this design of building was used by the RNLI during the 1930s, and the house at Caister was similar in appearance. The Hythe boathouse is a listed building, and is now used by a specialist fish shop.

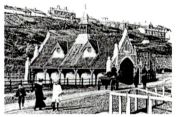

above The ornamental lifeboat house at Sandgate was built in 1875 and used until 1893, after which it became a café until being demolished in 1956.

below The two lifeboat houses at Hythe, with the 1893 building behind the later corrugated iron house.

1875 The RNLI decided to establish a station near Folkestone and Sandgate, to the west, was chosen as the best location. A site for a lifeboat house was found at Seabrook, near Sandgate, on land rented from the War Office. A lifeboat house, designed by the RNLI architect C. H. Cooke, was built by J. Bissenden at a cost of £541. The station was known as Hythe, Sandgate and Folkestone, and the formal inauguration took place on 20 April 1876.

1876 The station's first lifeboat, the 35ft self-righter *Mayer de Rothschild* (ON.58), arrived in April, together with her launching carriage.

1893 The station was moved to Hythe following the opening of the station at Folkestone and because of problems launching at Sandgate, where a sea wall had been built which restricted launching. A new boathouse was built at Hythe on a site obtained from the Hythe & Sandgate Gas Co.; the house, built by J. Scott, cost £570 3s 6d.

1930 A motor lifeboat, the 35ft 6in self-righter motor *City of Nottingham* (ON.726), was sent to the station in January and was launched over skids.

1935–6 A new larger corrugated iron lifeboat house was built at Hythe, closer to the sea and directly in front of the 1893 boathouse. The new building housed the new, larger motor lifeboat, the 41ft Watson motor *The Viscountess Wakefield* (ON.783), which arrived on station on 28 February.

1940 In May *The Viscountess Wakefield* was sent to Dunkirk to help evacuate troops off the beach. The Hythe Coxswain, Harry Griggs, refused to take the boat across the Channel because he realised she would never get off the beaches once laden with troops. He was proved right, as *The Viscountess Wakefield*, manned by naval personnel, having been beached, was unable to get off again and was abandoned near De Panne, to the east of Dunkirk. As a result of the lifeboat being lost, the station was closed, but the two lifeboat houses both remain standing.

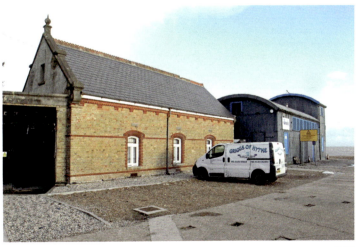

145

New Romney

Key dates
Opened	1861
RNLI	1861
Closed	1928

Station honours
Silver medals	4
Gold medals	1

right The lifeboat house built in 1871 to the north of Littlestone, although the station was named New Romney after the town that stood by the sea when it was one of the Cinque Ports. The house was demolished in 1940 but the small Coastguard station, on the left in this old postcard, remains albeit much improved.

right The scene outside the lifeboat house during the funeral of the three lifeboatmen lost on 9 March 1891 when the lifeboat *Sandal Magna* launched during one of the worst recorded storms to hit the coast to the schooners Echo and Hugh Barclays, reported to be in difficulty in the bay off Lydd. After being swept back to shore three times, the lifeboat succeeded in getting through the surf only to be hit by a large wave which turned her over and threw her crew, S. Hart, W. Ryan, J. Sullivan, into the sea; all but three made it ashore alive, and they were laid to rest in New Romney churchyard.

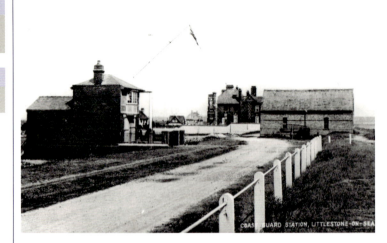

right The oldest of the three New Romney station service boards which are all now mounted in the local Town Hall.

below The plaque on the seafront, at the northern end of Coast Road, is mounted on a concrete bench facing the sea and marks the site of the 1871 boathouse.

1861 The 30ft Peake type self-righting lifeboat *Providence*, built in 1860 for Dungeness, was moved north to Littlestone in August, where wrecks were more frequent, and the lifeboat house built at Dungeness was moved north in November. Although the station was situated at Littlestone, it was known as Dungeness.

1871 A new, larger lifeboat was supplied in August, and a new lifeboat house was built at a cost of £266 1s 0d on ground rented from the Corporation of New Romney, funded by and in the memory of John Hatton; this house was used until the station closed. The station was renamed New Romney.

1883 A slipway was built to improve launching arrangements.

1891 The lifeboat *Sandal Magna* capsized on service on 9 March with the loss of three of her eleven crew.

1928 The station was closed in November; the lifeboat house was demolished in 1940 under Military Defence Orders during the building of wartime coastal defences. A plaque was placed on Littlestone seafront in 1949 to mark the site of the boathouse.

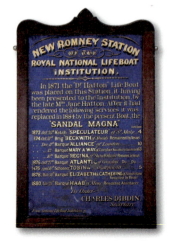

Littlestone-on-Sea

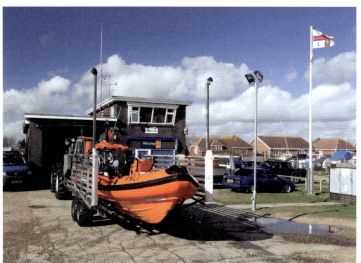

Key dates
Opened 1966
RNLI 1966
Inshore lifeboat 1966

Current lifeboats
ILB Atlantic 75
B-785 Fred Clarke
Donor Donation from Mr and Mrs Roy Glossop of Worthing, in memory of Mrs Glossop's late husband Fred Clarke
On station 19.6.2002
Launch Tractor and do-do carriage

left The ILB house at Littlestone with Atlantic 75 Fred Clarke (B-785) outside.

below The ILB house facing the beach dates from 1977, but has been rebuilt and extended several times.

1966 The RNLI established an inshore lifeboat station with D class inflatable ILB D-90; the ILB was kept in a boathouse on the beach.
1970 A trial inshore lifeboat, B-3, was on station from January to September.
1972 The D class ILB was withdrawn in June and replaced with a B class Atlantic 17 rigid-inflatable, one of the earliest craft of this type. Several experimental B class lifeboats were sent to the station, including B-5.
1973 A new boathouse was built.
1976 The Atlantic 17 was withdrawn and replaced by the Atlantic 21 B-533 in August. This new ILB was funded by St Martin's school, Walton-on-Thames.
1977 A new purpose-built brick ILB house, paid for by local funds, was built on the beach on the site of former boathouses, for the new Atlantic 21.
1988 A new Atlantic 21, named Lady Dart and Long Life II (B-573) in recognition of fundraising by the New Romney and Littlestone Ladies' Darts team from the Seahorse pub and Allied Breweries, arrived in June.
1993 The ILB house was improved, refurbished and extended to provide better crew facilities.
2004 A new launching ramp was completed in September.

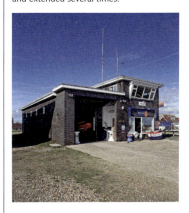

below Atlantic 75 Fred Clarke (B-785) at sea off Dungeness.

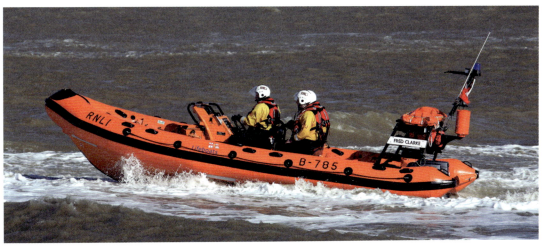

147

Dungeness

Key dates
Opened	Dymchurch (No.27 Tower) 1826–39
	Dungeness (No.1 Battery) 1854–71
	Dungeness 1874
RNLI	1826
Motor lifeboat	1933
No.2 station	1892–1939

Current lifeboats
ALB 13m Shannon
ON.1309 (13-02) The Morrell
Built 2013
Donor Legacy of Mrs Barbara Morrell, Bromley, Kent
On station 3.2014
Launch Supacat L&R system

Station honours
Framed Letter of Thanks	2
Thanks Inscribed on Vellum	6
Bronze medals	3
Silver medals	12
Gold medals	1

opposite 13m Shannon The Morrell (ON.1309) arriving at Dungeness for the first time on 21 February 2014.

below The lifeboat house built in 1977 for the carriage-launched lifeboats, and subsequently altered and extended.

1826 A 20ft lifeboat was placed at Dymchurch, to the north of Dungeness point, by the RNIPLS; the lifeboat, to cover the dangerous spit on which vessels were frequently wrecked, was managed by the Dover & District Lifeboat Association.

1836 The first lifeboat was damaged on service on 13 October and so was replaced by a 25ft Palmer type, which had been built in 1833; the station's name was changed to Dymchurch.

1838 The lifeboat was withdrawn on 10 December and the station was closed.

1854 The station was re-established and a new lifeboat house was built, by J. Judge & Sons at a cost of £97 6s 0d, close to the Coastguard station at No.1 Battery, on a site granted by HM Board of Ordnance.

1861 Due to problems with launching, the lifeboat was moved north, to a new location close to New Romney, where wrecks were also more frequent; the boathouse was dismantled and rebuilt at the new site.

1871 The station was effectively closed when a larger lifeboat was supplied in August; a new lifeboat house was built for the new boat, the 32ft self-righter *Dr Hatton*, and the station was then known as New Romney.

1874 The station at Dungeness was re-established and a boathouse was built by W. Robins, at a cost of £277 1s 0d, on a site granted by Sir Henry Tufton, and the new lifeboat, the 33ft self-righter *David Hulett*, arrived in September. The new station was located at Lydd-on-Sea and was known as Lydd (Dungeness).

1892 As it was difficult to launch a large boat over the shingle, when a second, larger lifeboat, the 44ft self-righter *Thomas Simcox* (ON.312), was placed on station in December 1892, she was kept afloat near the lighthouse, off the east side of the Point; after 1894 she was taken off moorings and kept on a carriage in the open. In October the station's name was changed from Lydd (Dungeness) to Dungeness.

1894 To try to overcome the launching problems, a railway of about a mile in length was laid down running north to south, from close to the lighthouse to just north of the Britannia Inn; the lifeboat was moved along this on a specially built six-wheeled trolley

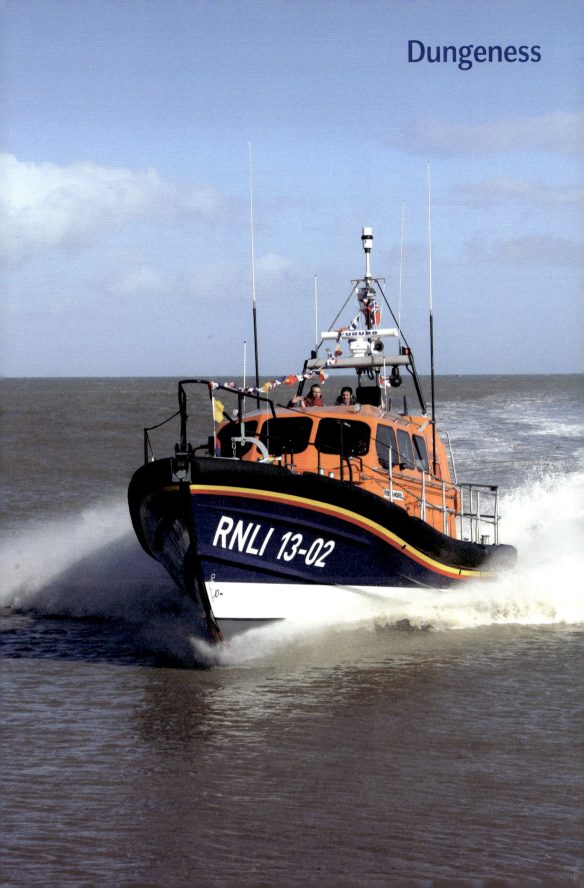

Dungeness

Dungeness

right These two buildings were used as the gear store (on left) and the winch house for the motor lifeboats from 1966 until 1977, and are sited half a mile to the south of the present lifeboat station. The motor lifeboat was kept on a raised hard-standing (to the right in this photo) and launched across the beach down a slipway and on skids, but nothing remains of this slipway, or of any of the other slipways built to try to overcome the difficulties of launching across the shingle at Dungeness.

below The lifeboat house built in 1977 for carriage-launched lifeboats, seen from the south-west looking towards the sea. The house has been altered and extended since being built, with additional tractor houses and crew facilities added. The separate building, to the right, houses a bulldozer necessary for flattening the shingle.

enabling it to reach one of three launching sites depending upon which was most suitable; this unique launch system cost £1,494 3s 4d to build.
1905 The railway trolley launch system was abandoned in March and work began on a special hard-standing area on the beach, at about the centre point of the railway track, for the No.2 lifeboat *Thomas Simcox* which was kept afloat, then on a railway trolley and finally on the beach. The smaller No.2 lifeboat remained in the house.
1912 The hard-standing, with the turntable for the No.2 lifeboat, was moved closer to the sea to make launching easier, at a cost of £215 5s 0d.
1928 Centenary Vellum was awarded.
1933 The first motor lifeboat, the 41ft Beach type *Charles Cooper Henderson* (ON.761), was placed on station, which was launched over skids on the beach.
1938 A new corrugated iron lifeboat house, and a new launchway across the beach, were built at a cost of £1,934 13s 10d. Throughout the station's existence, much work has been undertaken to improve the launching arrangements necessitated by the ever-changing shingle, and during this latest work the lifeboat *Charles Cooper Henderson* was kept in storage between April 1938 and January 1939, when the new boathouse was completed.
1939 The original No.1 station was closed and the lifeboat *Mary Theresa Boileau* (ON.635) was withdrawn on 31 March, leaving only one lifeboat.
1947 The slipway was extended to improve launching arrangements over the ever-moving shingle.
1953 The lifeboat house and slipway were resited.
1966 The station was resited, as severe gales had undermined the previous location, and a new hard-standing for the lifeboat cradle, winch house and store were constructed closer to the sea, just to the south of the existing lifeboat house, which became redundant in 1967 after which time the lifeboat was kept in the open; the house was demolished a few years later.

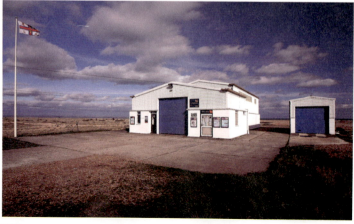

Dungeness

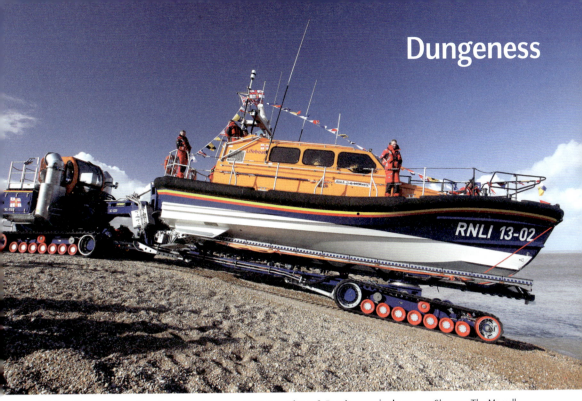

1974 Trials with a tractor and carriage launch system were undertaken in September to determine if this method of launching was feasible; the most suitable launch site was found to be north of Dungeness Point.

1976–7 A new lifeboat house, built to the north of the slipway site, was constructed to house the carriage-launched 37ft 6in Rother lifeboat *Alice Upjohn* (ON.1048); carriage launching alleviated the problems caused by the ever-shifting shingle beach; the new house cost £45,000. The 42ft Beach motor *Mabel E. Holland* (ON.937) was kept on station following the arrival of *Alice Upjohn* until the winch could be resited at the new lifeboat house.

1979–80 A new house was built for the bulldozer which was needed to flatten the shingle and ease launching.

1989 The boathouse was extended to provide improved crew facilities.

1994–5 The boathouse was extended again and a new crew room was added on the north side.

above 13m Shannon The Morrell (ON.1309), the first of this type of lifeboat to go to a lifeboat station, being launched using the Supacat Launch & Recovery rig.

below left 13m Shannon The Morrell (ON.1309) dressed overall on the day she arrived at Dungeness, February 2014.

below 13m Shannon The Morrell being recovered onto the sophisticated Supacat L&R rig, which is used to launch the boat and operates as a mobile slipway.

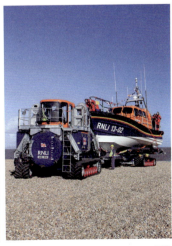

Appendix 1 • Bibliography

Biggs, Howard (1977): *The Sound of Maroons* (Terence Dalton, Lavenham, Suffolk).

Cameron, Ian (2009): *Riders of the Storm: The Story of the Royal National Lifeboat Institution* (Weidenfeld & Nicolson, London).

Haydon, A. L. (1909): *The Book of the Lifeboat* (The Pilgrim Press, London).

Lane, Anthony (1997): 'Friend to All Nations', in *Bygone Kent* magazine (Part One, October, Vol.18, No.10, pp.593–603; Part Two, November, Vol.18, No.11, pp.667–679).

Leach, Nicholas (1999): *The Happisburgh Lifeboats* (2nd edition, Norfolk & Suffolk Research Group).

— (2005): *RNLI Motor Lifeboats* (Landmark Publishing Ltd)

— (2011): *Harwich Lifeboats: An Illustrated History* (Amberley Publishing, Stroud)

— (2013): *Clacton-on-Sea Lifeboats* (Foxglove Publishing, Lichfield).

Leach, Nicholas, and Russell, Paul (2004): *Cromer Lifeboats 1804–2004* (Tempus Publishing Ltd, Stroud).

— (2006): *Wells-next-the-Sea Lifeboats* (Tempus Publishing).

— (2009): *Sheringham Lifeboats* (Landmark, Ashbourne).

Malster, Robert (1968): *Wreck and Rescue on the Essex Coast: The Story of the Essex Lifeboats* (D. Bradford Barton Ltd, Truro).

— (1974): *Saved from the Sea: The story of Life-saving Services on the East Anglian Coast* (Terence Dalton, Lavenham).

Morris, Jeff (1987) *An Illustrated Guide to Our Lifeboat Stations, Part 2: Grimsby to Southend.*

— (1988) *An Illustrated Guide to Our Lifeboat Stations, Part 3: Sheerness to Poole.*

— (1993): *The History of the North Deal, Walmer and Kingsdowne Lifeboats.*

— (1995): *The Story of the Ramsgate Lifeboats* (2nd ed).

— (1998): *The Story of the Dover Lifeboats* (3rd edition).

— (2000): *The Story of the Aldeburgh Lifeboats* (4th edition).

— (2001): *The History of the Dungeness Lifeboats.*

— (2004): *The Closed Lifeboat Stations of Kent.*

— (2006): *Winterton Lifeboats 1823–1924.*

— (2007): *Palling Lifeboats 1852–1930.*

Softley, Michael (2000): *The Brancaster Lifeboats 1874–1935* (Norfolk & Suffolk Research Group).

Walters, A. P. (1997): *The Margate RNLI Station and Its Lifeboats from 1860* (A. P. Walters, Margate).

Zeller, Gordon R. (1981): *The Story of the "Bolton" Lifeboats at Kessingland.*

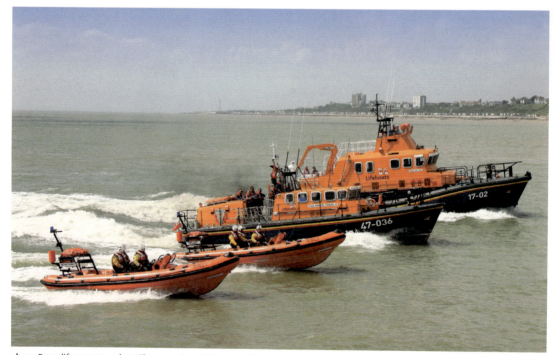

above Essex lifesavers together: Clacton-on-Sea, Walton and Frinton and Harwich lifeboats undertake a joint exercise in June 2009. From front to back: Atlantic 75 Sure and Steadfast (B-789) from Harwich, Atlantic 75 Robert George Alexander (B-744) from Clacton, 47ft Tyne Kenneth Thelwall II from Walton (ON.1154, on station 1996–2011) and relief 17m Severn The Will (ON.1201) from Harwich.

Appendix 2 • Independent lifeboats

Mundesley

Following an incident in 1971, resulting in a drowning and near drowning of a man and his wife while sailing half a mile off the beach at Mundesley, the Mundesley Parish Council called a meeting to discuss the feasibility of establishing an inshore lifeboat at Mundesley. The RNLI and Coastguard were approached but were unable to help. It was therefore decided to set up an independent rescue unit, funded and manned from within the village.

The Mundesley Volunteer Inshore Lifeboat Service Ltd, a Limited Company and registered charity, was subsequently formed, with a board of directors elected from a broad section of the community. The volunteer crew take care of the day-to-day running of the boat and the directors manage the policy making and finances.

In the spring of 1972 a Zodiac inflatable was borrowed from a local businessman and established in a temporary boathouse on the promenade at the east end of the village. Extensive fundraising followed, which resulted in the purchase of a 4m Avon Sea Rider semi-rigid inflatable. A wooden site hut was donated by a Bacton Gas Site contractor and converted into a boathouse. Since then the service has gone from strength to strength and has rescued over 100 people in trouble. In 2006 a new lifeboat station was built, funded by public donations and built by Blyth's & Sons, of Sheringham.

Palling

Palling Volunteer Rescue Service was set up in 1974 because of an increasing number of tourists visiting the area, and local residents felt a lifeboat was needed. Money was raised to build a new station and a buy an outboard-engined inshore rescue boat, which was named *Hearts of Oak*.

There is a strong tradition of independent sea rescue operations in East Anglia and the South East. For many years during the first half of the nineteenth century the Associations in Norfolk and Suffolk funded and operated lifeboats in those counties, while the beachmen and fishermen of Norfolk organised themselves into Beach Companies. More than a century later, lifeboat stations being operated independently of the RNLI have once again become common, with developments in technology during the second half of the twentieth century making independent volunteer lifeboat stations feasible. This appendix provides a brief overview of the main organisations.

A private company, Palling Volunteer Rescue Service Ltd, administered entirely by local volunteers, was formed as a registered charity to operate and finance the new independent lifeboat service. The area of service was intended to save lives along the coast between Eccles-on-Sea and Winterton.

In 1981 the Service purchased a new rigid-inflatable vessel, named *Leo*, and

above The lifeboat house built at Mundesley in 2006 provides good crew facilities, a lookout post above the beach and housing for the ILB and launch vehicle.

below The Mundesley lifeboat Footprints on exercise off the beach. This Tornado rigid-inflatable was replaced in October 2012 by a new and slightly larger lifeboat.

153

Appendix 2 • Independent lifeboats

above The boathouse used by the Sea Palling ILB service overlooks the beach.

below The Hemsby Lifeboat boathouse. The service has been fully operational since 1977 and covers both local beaches and incidents on the Norfolk Broads.

this boat remained in service until 10 February 2008, when a new boat, named *Lions Roar*, entered service. The boat was named to acknowledge the support of the Hoveton and Wroxham Lions Club, the major benefactors to support the station's activities.

Hemsby

The Hemsby Volunteer Inshore Rescue Club was formed in 1976. Its foundation came about as the result of nine people drowning off the villages of Scratby, Hemsby and Winterton between 1973 and 1975, but the service has a dual role because it covers the Norfolk Broads as well as the North Sea beaches. Since then it has undertaken more than 12,000 callouts both at sea and on the Broads. The service operates a rigid-inflatable for sea rescue and smaller craft for use on the Broads.

The first lifeboat was set up with funding from the Community Services Section of the Norfolk Broads Lions Club, which provided sufficient funds to purchase an inflatable craft, engine, a boat shed and the other equipment necessary to operate a rescue service. The optimum place for the new station was Hemsby Gap. At a meeting on

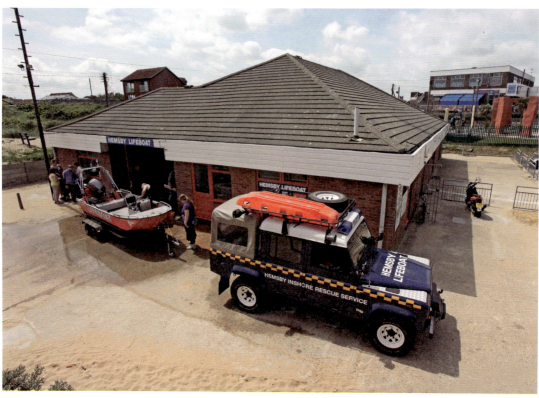

Appendix 2 • Independent lifeboats

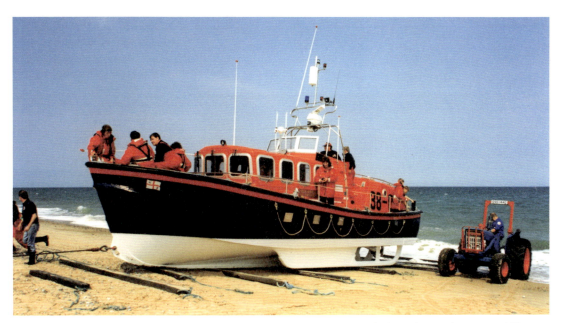

2 June 1976 it was decided that the organisation would be called Hemsby Volunteer Inshore Rescue Club. Great Yarmouth Borough Council were responsible for the running costs and the crew for the boats' maintenance.

Caister

After 124 years of lifeboat operations at Caister, the RNLI withdraw its lifeboat in October 1969, much against the wishes of local people. There was a public outcry as the town's volunteer crew then held the record for the most lives saved by any lifeboat station in the British Isles. As a result, the crew, led by the veteran mechanic Jack 'Skipper' Woodhouse, decided to establish an independent station, which effectively took over on the day the RNLI withdrew.

A small fibreglass boat was placed on station initially, and this was replaced by an inflatable. The Caister Volunteer Rescue Service, which later became the Caister Volunteer Lifeboat Service, was formed to maintain the long tradition of lifesaving, and fundraising began to acquire an offshore lifeboat.

In 1973 the Service purchased the ex-RNLI lifeboat and named her *Shirley Jean Adye*. She was replaced in 1991 by the purpose-built 38ft 6in Lochin type *Bernard Matthews*. This £400,000 lifeboat was operated until 2004, when she was replaced by *Bernard Matthews II*, a Netherlands-built 10.6m Valentijn class rigid-inflatable. Powered by waterjets, this boats can reach speeds well in excess of thirty knots. The Service also operates a smaller rigid-inflatable inshore lifeboat.

above The second Caister VRS lifeboat Bernard Matthews, on station from August 1991 to 2004, being recovered on the beach following an exercise.

below The current Caister lifeboat, the Dutch-built Bernard Matthews II, arriving on station on 29 August 2004. She is launched and recovered by a Caterpillar Challenger 65C tractor, built in 1991 and on station since 1996, on a non-powered hydraulic HLRT-Valentjin 2000 trailer which is similar to that used by the Netherlands lifeboat service.

Appendix 3 • Lifeboats on display

A good number of historic restored lifeboats are on display in and around Norfolk, Suffolk and Essex, with the RNLI Historic Lifeboat Collection at the Historic Dockyard in Chatham being the main one. The following entries provide a brief guide to where they can be seen, but check opening times first while planning a visit.

above 37ft Oakley Manchester Unity of Oddfellows (ON.960) on display inside the Sheringham Museum at The Mo on the seafront of the popular Norfolk town.

Wells

The station's former 37ft Oakley *Ernest Tom Neathercoat* (ON.982), which served from 1965 to 1990, has been restored and has been kept afloat in the harbour since June 2012.

Sheringham

A unique collection can be found at The Mo Museum, where three of the station's former lifeboats, fully restored, are on display. The museum, which is situated on the seafront, was opened in 2010 by HRH The Duke of Kent. The Liverpool type sailing lifeboat *J.C. Madge* (ON.536, on station 1904–36), the station's first motor lifeboat *Foresters' Centenary* (ON.786, 1936–61) and the station's last offshore lifeboat, *Manchester Unity of Oddfellows* (ON.960, 1961–91), are all fully restored and displayed inside. [See sheringhammuseum.co.uk]

Cromer

The station's most famous lifeboat, *H.F. Bailey* (ON.777), is on display in the purpose-built Henry Blogg Museum at the East Gangway. The museum illustrates the history of Cromer's lifeboats and tells the story of Coxswain Henry Blogg's most famous rescues.

Gorleston

Inside the old lifeboat house is the station's first motor lifeboat, *John and Mary Meiklam of Gladswood* (ON.670), which served from 1924 to 1939; she has been on display since 1993.

Caister

Inside the lifeboat house built in 1941 is *Shirley Jean Adye*, which was built in

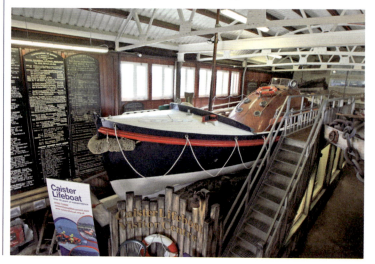

right The 1952-built 35ft 6in Liverpool motor lifeboat Shirley Jean Adye (ON.906) inside the old lifeboat house at Caister. She is the centrepiece of the display which explains the story of the Caister Volunteer Lifeboat Service and the famous Beach Companies of Norfolk.

Appendix 3 • Lifeboats on display

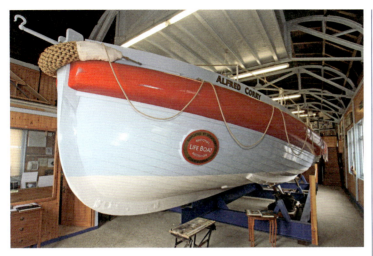

left The former Southwold lifeboat Alfred Corry (ON.353) on display having been fully restored. She is the centrepiece of a locally managed museum housed in the old Cromer lifeboat house, which stood on piles at the end of Cromer pier from 1923 to 1997. It was brought to Lowestoft by sea and came to Southwold harbour in April 1998.

1952 by the RNLI as *W. Ross McArthur of Glasgow* (ON.906) for the St Abbs station in Scotland. She served as Caister's first independent offshore lifeboat from 1973 to 1991, and was fully restored at Falmouth before being brought to Caister for display. [See www.caisterlifeboat.org.uk]

Southwold

The former Norfolk & Suffolk sailing lifeboat *Alfred Corry* (ON.353) is the centrepiece of a museum which has displays about the Southwold lifeboats and their crews from 1893 to 1918, as well as the history of the boat itself, which was in private hands for many years before coming back to Southwold. The museum is housed in the historic former Cromer lifeboat house, which dates from 1923, and is located to the north of the harbour wall, on the beach car park. Entry to the museum is free.

Harwich

The former 37ft Oakley lifeboat *Valentine Wyndham-Quin* (ON.985), which served at Clacton-on-Sea from

below The historic former Walton & Frinton motor lifeboat James Stevens No.14 (ON.432) on the River Thames participating in the Diamond Jubilee Pageant in June 2012, with the former Hoylake lifeboat Mary Gabriel (ON.1000), a 37ft 6in Rother which is based on the River Medway at Chatham Historic Dockyard.

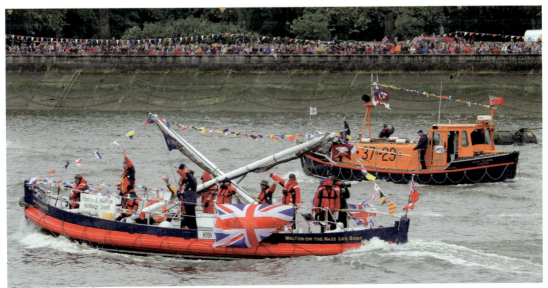

Appendix 3 • Lifeboats on display

right The 38ft twelve-oared Norfolk & Suffolk sailing lifeboat St Paul (ON.406), which served at Kessingland for over thirty years and was sold out of service in 1931, on display at Chatham Historic Dockyard. Built in 1897, she is one of the oldest lifeboats in the collection at Chatham.

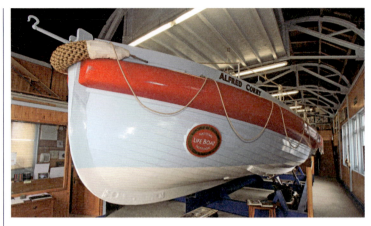

1968 to 1983, is displayed inside the old lifeboat house on The Green, having been displayed at Cromer before that.

Walton-on-the-Naze

The oldest surviving motor lifeboat, *James Stevens No.14* (ON.432), has been restored and is in full working order. Since 1998 the Frinton & Walton Heritage Trust has maintained and operated the lifeboat, which is based at Titchmarsh Marina.

Chatham

Chatham Historic Dockyard is home to the RNLI Historic Lifeboat Collection, which is managed in partnership with the RNLI Heritage Trust. The extensive collection consists of eighteen historic lifeboats from nineteenth-century pulling and sailing lifeboats to Watson motor lifeboats and a 54ft Arun class lifeboat, as well as various inshore lifeboats and other displays.

below The former Margate lifeboat North Foreland (Civil Service No.11) (ON.888), a 46ft 9in Watson motor type, on display at the entrance to the RNLI Historic Lifeboat Collection at Chatham Dockyard, Kent.

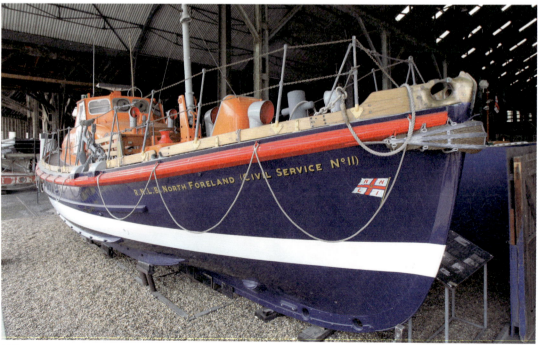

Appendix 4 • Lifeboat types

Severn
Introduced 1991, last built 2004, 46 built
Dimensions 17.3m (55ft 9in) x 5.5m (18ft) x 1.68m (5ft 6in)
Engines Twin 1,200hp Caterpillar, or twin 1,500hp MTU diesels
Stationed Dover, Harwich

Trent
Introduced 1991, last built 2004, 38 built
Dimensions 14.26m (46ft 9in) x 4.53m (14ft 10in) x 2.5m (8ft 4in)
Engines Twin 808bhp MAN D2840LXE diesels, speed 25 knots
Stationed Great Yarmouth & Gorleston, Sheerness, Ramsgate

Tamar
Introduced 2005, last built 2013, 27 built
Dimensions 16m (45ft 11in) x 5m (14ft 10in) x 1.35m (4ft 3in)
Engines Twin 1,015bhp (746bkW) Cat C18 diesels, 25 knots
Stationed Cromer, Walton & Frinton

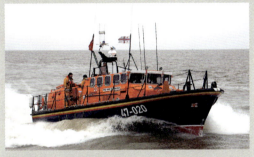

Tyne
Introduced 1982, last built 1990, 40 built
Dimensions 47ft (14.3m) x 15ft (4.6m) x 4ft 2in (1.27m)
Engines Twin 425hp G 8V-71, or twin 565hp DDEC diesels, 17 knots
Stationed Lowestoft (due to be replaced by 13m Shannon in 2014)

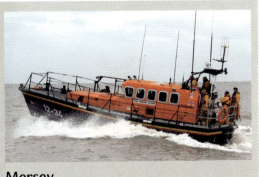

Mersey
Introduced 1986, last built 1993, 38 built
Dimensions 38ft (11.57m) x 12ft 6in (3.81m) x 6ft (1.86m)
Engines Twin 285hp Caterpillar 3208T diesels, 16 knots
Stationed Aldeburgh, Dungeness, Margate, Wells

Inshore lifeboats

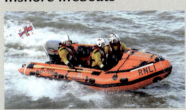

D class inflatable Introduced in 1963, size 5m by 2m, single 50hp outboard engine, three or four crew

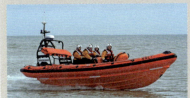

Atlantic 75/85 Atlantic 75 introduced in 1993, Atlantic 85 in 2004, twin outboard engines, three or four crew

159

Index

Abdy Beauclerk (ON.751) 30, 98
Agnes Cross (ON.663) 34, 87, 142
Albert Brown (ON.1202) 48, 49, 101, 103, 105, 152
Albert Edward (ON.32) 19
Albert Edward (ON.463) 27, 109
Aldeburgh (ON.304) 23, 30, 39, 98
Aldeburgh 16, 22, 23, 24, 48, 96–100
Alexander Duckham (B-529) 112
Alfred and Patience Gottwald (ON.946) 99
Alfred Corry (ON.353) 41, 93, 157
Alice Upjohn (ON.1048) 151
Annie Tranmer (B-868) 44, 92, 93, 94
Augusta 11
Bacton 71
Baltic (ON.375) 17, 25
Barbara Fleming (ON.480) 139
Barham (ON.1068) 47
Bawdsey 100
Beauchamp (ON.327) 24
Beeching, James 16
Benjamin Bond Cabbell 17, 66
Bernard Matthews 79, 155
Bernard Matthews II 77, 79, 155
Blakeney 62
Blogg, Coxswain Henry 35
Bob Turnbull (B-765) 132, 133, 134
Bolton (ON.25) 91
Boreham Wood depot 36
Bradford (ON.350) 27
Brancaster 57
Brawn Challenge (E-09) 51, 118, 120
Braybrooke 12
Brightwell 62
British Diver (B-560) 125
Broadstairs 10, 16, 21, 131
Burnham-on-Crouch 41, 113
Caister 10, 15, 24, 76–9, 155
Cecil Paine (ON.850) 36, 45
Charles and Susanna Stephens (ON.537) 21
Charles Bury (ON.27) 91
Charles Cooper Henderson (ON.761) 150
Charles Deere James (ON.516) 75
Charles Dibdin (Civil Service No.2) (ON.762) 33, 37
Charles Dibdin (Civil Service No.32) (ON.948) 137
Charles Dibdin (ON.552) 135
Charles Hargrave (ON.306) 139
Chiswick 50, 51, 120
Christine (D-673) 96, 100
Christopher Waud, Bradford (ON.189) 131
City of Glasgow (ON.362) 82, 102
City of Leicester (boarding boat) 106
City of London II (ON.1220) 48, 140, 141, 142, 143
City of Nottingham (ON.726) 30, 145
City of Winchester (ON.482) 39
Civil Service No.4 (ON.394) 136
Clacton-on-Sea 23, 27, 33, 37, 109–11
Corton 85
Covent Garden (ON.17) 17
Cromer 9, 17, 29, 35, 36, 41, 49, 52, 66–70, 156
Damarkand IV (D-723) 109, 111

David Porter MPS (B-863) 109, 110
Deutschland, steamship 101
Dignity (B-761) 112
Donald McLauchlin (B-808) 43, 136, 137, 138
Doris M. Mann of Ampthill (ON.1161) 22, 25, 48, 58, 59, 61
Dougie and Donna B (E-08) 118
Douglas Paley (B-742) 72, 73
Dover 26, 29, 37, 46, 48, 140–3
Duggie Rodbard (D-663) 43, 136, 137, 138
Duke of Northumberland (ON.231) 26, 102
Dungeness 23, 148–51
Dunwich 95
E.M.E.D. (ON.705) 108
Edward Birkbeck (ON.397) 75
Edward Z. Dresden (ON.545) 98
Edward Z. Dresden (ON.707) 98
Eleanor (D-662) 122
Eliza Avins 22
Eliza Harriet (ON.411) 128
Ernest and Rose Chapman II (D-672) 113
Ernest Tom Neathercoat (ON.982) 156
Ernest William and Elizabeth Ellen Hinde (ON.1017) 46
Esme Anderson (ON.1197) 48, 49, 132, 133
Essex Freemason (D-682) 114, 117
Folkestone 144
Foresters' Centenary (ON.786) 156
Frances Ann 7, 8, 11, 86
Francis Forbes Barton (ON.399) 131, 135
Fred Clarke (B-785) 147
Freddie Cooper (ON.1193) 96, 97, 98, 99
Frederick Edward Crick (ON.970) 31
Friend of All Nations 13, 22, 81
Frinton-on-Sea 13
George and Ivy Swanson (ON.1211) 122, 123, 124
George and Muriel (D-734) 66, 69
Gertrude (ON.847) 122
Gorleston 14, 22, 28, 41, 42, 46, 81–5
Gravesend 50, 121
Great Yarmouth 80
Greater London (Civil Service No.3) (ON.704) 5, 30, 38, 115
Greater London II (Civil Service No.30) (ON.921) 116
H.F. Bailey (ON.670) 68
H.F. Bailey (ON.777) 35, 40, 66, 156
Hampshire Rose (ON.1024) 138
Happisburgh 43, 72–3
Harriett (ON.29) 92
Harwich 12, 23, 49, 101–5, 157
Hearts of Oak (ON.656) 74
Helen Turnbull (ON.1027) 47, 122
Hemsby 154
Henry Blogg (ON.840) 36, 68
Henry Ramey Upcher 64
Hugh Taylor (ON.629) 90, 91
Hunstanton 52, 54–5
Hunstanton Flyer (Civil Service No.45) (H-003) 52, 54, 56
Hurley Burly (E-07) 118, 120

Husband (ON.16) 85
Hythe 24, 145
Irene Muriel Rees (ON.1299) 106, 107, 108
J. McConnel Hussey (ON.343) 27, 144
J.B. Proudfoot (ON.694) 142
J.C. Madge (ON.536) 20, 156
J.H. Elliott (ON.261) 71
Jacob and Rachel Valentine (ON.580) 72, 74
James Cable (ON.1068) 39, 48
James Leath (ON.607) 18, 90
James Stevens No.14 (ON.432) 26, 106, 157, 158
James Stevens No.3 (ON.420) 82, 140
Jane Ann III (D-661) 58, 59, 61
Jean Ryall (D-714) 899
John and Mary Meiklam of Gladswood (ON.670) 28, 85, 156
John Burch (ON.329) 19
Jose Neville (ON.834) 78
Kenneth Thelwall II (ON.1154) 152
Kentwell (ON.543) 29
Kessingland 23, 91
Khami (ON.1002) 45, 84
Kingsdowne 139
Kingsgate 130
Lady Dart & Long Life II (B-573) 147
Landguard Fort 12, 101
Legacy (E-005) 50
Leonard Kent (ON.1177) 126–9
Leslie (ON.508) 144
Leslie Tranmer (B-750) 44
Lester 49, 66, 67, 70
Lily Bird (ON.370) 95
Littlestone-on-Sea 147
Lloyds II (ON.986) 64
Lord Southborough (Civil Service No.1) (ON.688) 28, 32, 128
Lowestoft 29, 30, 31, 46, 47, 86–8
Mabel E. Holland (ON.937) 151
Macara, Charles 20
Manchester Unity of Oddfellows (B-702) 64
Manchester Unity of Oddfellows (ON.960) 38, 156
Margate 23, 28, 32, 34, 37, 45, 126–9
Mary Gabriel (ON.1000) 157
Mayer de Rothschild (ON.58) 145
Michael and Lily Davis (ON.901) 38
Michael Stephens (ON.838) 29
Morrell (The) (ON.1309) 149, 151
Mundesley 71, 153
Nancy Lucy (ON.506) 15
New Romney 146
North Deal 131
North Foreland (Civil Service No.11) (ON.888) 37, 38, 158
Oddfellows (The) (B-818) 63, 65
Olive Laura Deare II (B-827) 121
Olwen and Tom (D-743) 119
Orford 100
Oxford Town and Gown (B-764) 125
Pakefield 90
Palling 14, 74, 153
Pride of London Foresters (D-633) 114, 117
Prudential (ON.697) 132, 133

Public Servant (Civil Service No.44) (E-001) 51
R.A.O.B. (ON.130) 23
Ralph & Joy Swann (ON.1042) 134
Ramon Cabrera (ON.263) 106
Ramsgate 18, 22, 33, 38, 42, 48, 132–4
Rescuer 15, 22, 81
Rotary Service (ON.1031) 46, 142
Royal Thames (ON.978) 79
Royal Silver Jubilee 1910–1935 (ON.780) 29, 60
Ruby and Arthur Reed II (ON.1097) 41, 68
Sailor's Friend 13
Samarbeta (ON.1208) 81, 82, 83
Samuel Plimsoll (ON.22) 87
Scratby 75
Seahorse IV (B-786) 81, 84
Sheerness 43, 46, 47, 48, 122–4
Sheringham 38, 63–5, 156
Shirley Jean Adye (ON.906) 79, 155
Silver Jubilee (Civil Service No.38) (ON.1046) 45
Sir Godfrey Baring (ON.887) 37
Sir William Hillary (ON.725) 30, 140
Sizewell 95
Solebay (B-518) 43
South Broads 89
Southend-on-Sea 52, 114–17
Southern Africa (ON.860) 142
Southwold 11, 22, 23, 33, 43, 44, 92–4, 158
Spirit of Berkhamsted (D-607) 72
Spirit of Lowestoft (ON.1132) 31, 47, 86, 87, 88
Spirit of Mortimer (D-648) 119
Spirit of West Norfolk (B-848) 54
St Paul (ON.406) 158
Storm Company 81
Suffolk Humane Society 11, 86
Sure and Steadfast (B-789) 101, 104
Teddington 50, 51, 119
Thomas Chapman 130
Thomas Simcox (ON.312) 20, 148
Thora Zelma (ON.326) 82
Thorpeness 95
Tigger Three (D-706) 126, 129
Tony and Robert Britt (B-849) 113
Tower 50, 188
Two Sisters, Mary and Hannah (ON.23) 90
US Navy League (B-512) 138
Valentine Wyndham-Quin (ON.985) 157
Vera Ravine (H-004) 52, 114, 116
Vic and Billie Whiffen (B-776) 114, 115
Viscountess Wakefield (ON.783) 33, 35, 145
Walmer 37, 43, 136–8
Walton and Frinton 26, 27, 106–8
Wells 22, 23, 25, 29, 41, 45, 48, 58–61
West Mersea 41, 112
Whitstable 41, 42, 125
Whitstable Branch (B-516) 125
William Henry and Mary King (ON.980) 68
Winlaton (ON.666) 57
Winterton 10, 75
Woodbridge 100

160